ARSHILE GORKY

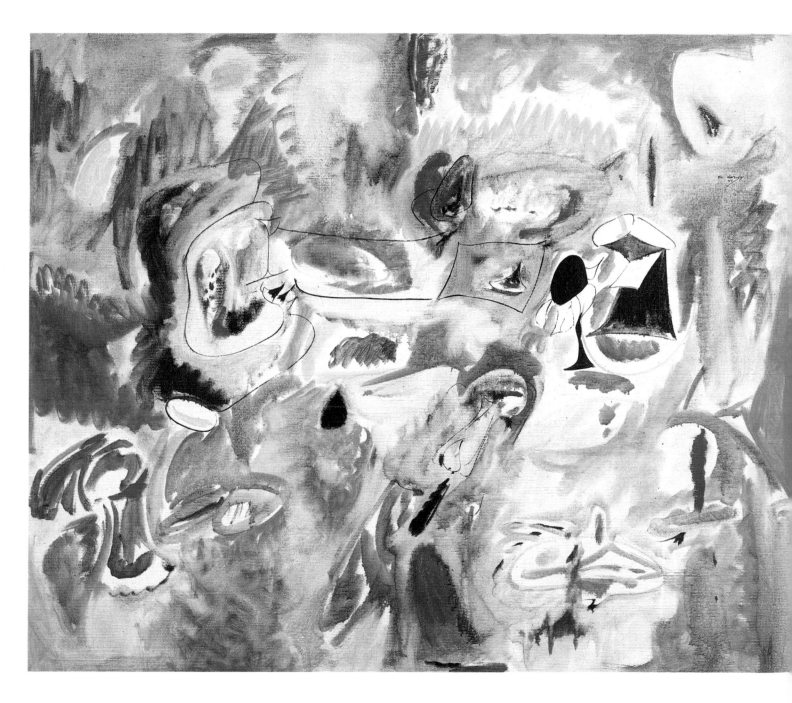

Year after Year, 1947
Oil on canvas, 34 x 39 in.
Mr. and Mrs. Gifford Phillips, New York

MODERN MASTERS

ARSHILE GORKY

MELVIN P. LADER

Abbeville Press · Publishers
New York · London · Paris

Arshile Gorky is volume eight in the Modern Masters series.

Series design by Howard Morris
Designer: Gerald Pryor
Editor: Nancy Grubb
Picture researcher: Amelia Jones
Production manager: Dana Cole
Chronology, Exhibitions, Public Collections, and Selected Bibliography
compiled by Anna Brooke

FRONT COVER: *The Artist and His Mother,* c. 1929–36. Plate 28 (detail).
BACK COVER: *The Betrothal II,* 1947. Plate 103.
FRONT END PAPER, left: Arshile Gorky and his mother in Van, Armenia, 1912.
Courtesy the Arshile Gorky Adoian Amalgam (1908–47). © 1982 by Gilgamesh
Press, Ltd.
FRONT END PAPER, right: Arshile Gorky, 1937. Courtesy the Arshile Gorky and 36
Union Square Archives (1922–44) by Moorad Mooradian. © 1982 by Karlen
Mooradian.
BACK END PAPER, left: Arshile Gorky working on *Organization,* 1934–35.
BACK END PAPER, right: Arshile Gorky working on *Aviation* mural, 1934–35.

Marginal numbers in the text refer to works illustrated in this volume.

Library of Congress Cataloging-in-Publication Data

Lader, Melvin P.
 Arshile Gorky.

 (Modern masters series, ISSN 0738-0429; v. 8)
 Bibliography: p.
 Includes index.
 1. Gorky, Arshile, 1904–1948. 2. Artists—United
States—Bibliography. I. Title. II. Series.
N6537.G65L33. 1985 759.13 84-24268
ISBN 0-89659-525-0
ISBN 1-55859-249-0 (pbk.)

First edition, second printing

Contents

Introduction 7

1. The Armenian Years 11

2. The 1920s 15

3. The 1930s 37

4. Maturity 63

5. The Last Works 91

Artist's Statements 109

Notes on Technique 113

Chronology 117

Exhibitions 119

Public Collections 123

Selected Bibliography 124

Index 127

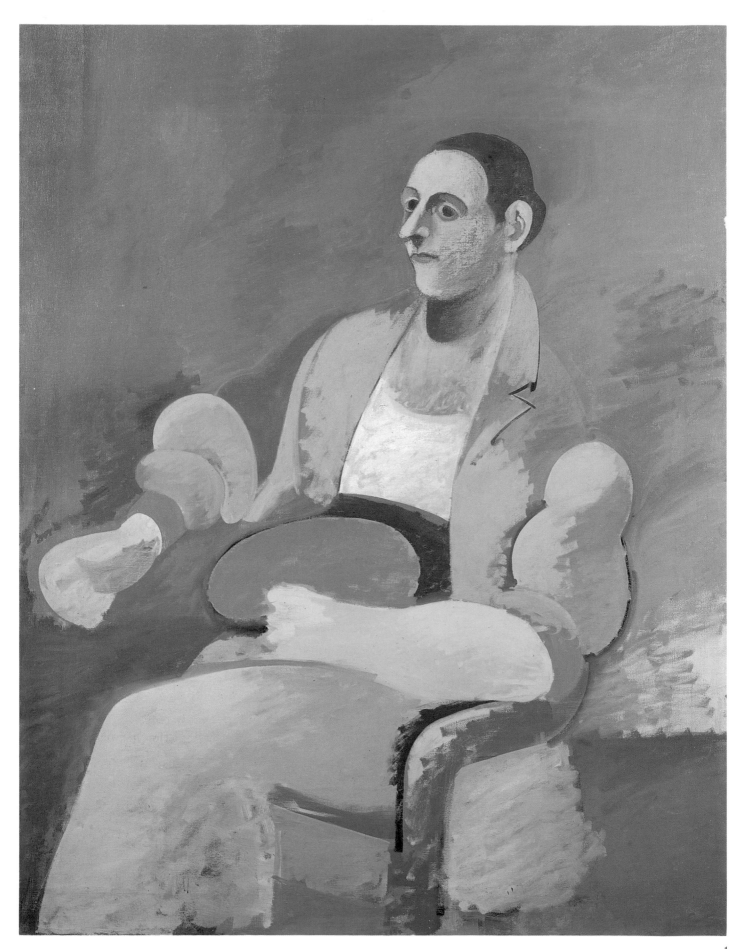

1

Introduction

Arshile Gorky's status as a painter essential to the development of contemporary art is indisputable, and he has long been acknowledged as the vital link between European modern art and American Abstract Expressionism.[1] Stylistically, as well as chronologically, he fits that role perfectly, having reached artistic maturity in the 1940s by blending certain elements of Cubism and Surrealism into his own unique style of painting. Gorky, in turn, provided inspiration and stylistic direction for the painters of the New York School that followed.

Gorky's historical importance has not always been perceived this clearly. In fact, prior to the 1950s he was frequently regarded as a highly eclectic painter showing little promise of originality. His devotion to a succession of late nineteenth- and twentieth-century artists—including Paul Cézanne, Pablo Picasso, Wassily Kandinsky, and Joan Miró—was generally misconstrued as mere imitation by those critics and the public who did not perceive the purposefulness of Gorky's eclecticism. Harold Rosenberg in 1962 attempted to put this criticism of Gorky in a more positive light when he stated that the artist's originality lay in his deliberate rejection of that concept.[2] Furthermore, Gorky's preference for modern European art at a time when native subject matter and realism prevailed in this country was in itself a form of originality and a sign of independence.

Gorky's passionate interest in the European masters reflected his old world concept of art education. Traditionally, painters had been trained by serving as apprentices to recognized masters. Because America had not yet produced any great modern artists, this type of training was not available to Gorky. To learn modern painting, he had to educate himself in the next best manner: by analyzing the works, imitating the styles, and reading about the ideas of the European artists he venerated. In borrowing their styles and perfecting his technique, Gorky hoped to cultivate his own style, which would then advance the history of art. As his sister Vartoosh has said, Gorky wanted to add his name to those of Cézanne and Picasso as part of the progression of great modern masters.[3]

1. *Portrait of Master Bill*, c. 1937
Oil on canvas, 52⅛ x 40⅛ in.
Private collection

Gorky achieved his ambition of becoming a link in the art historical chain. Maturing between Surrealism and Abstract Expressionism, he was connected to both movements without belonging entirely to either one. In his use of certain Surrealist techniques and imagery he clearly relates to the Europeans, but his goal of translating into poetic vision his feelings, memories, and responses to the natural world was a far cry from the theories of the Surrealist painters. The fact that he painted his personal visions in highly abstract forms, evocative colors, and painterly strokes associates him with the Abstract Expressionists, but Gorky's images and colors are based on nature and did not arise spontaneously from unconscious impulse. Moreover, Gorky's work descends from the European tradition in which beauty and craftsmanship are primary concerns, as opposed to the rawness of Jackson Pollock's canvases and those of some other New York School painters.

In spite of these differences, Gorky exerted a considerable influence on the Abstract Expressionists. His commitment to self-expression, his individuality, his idealism, and his courage to forge a new style inspired others. Without Gorky's heroic example, the art of Jackson Pollock, Willem de Kooning, Mark Rothko, Adolph Gottlieb, Robert Motherwell, William Baziotes, and Clyfford Still would be almost unimaginable. Yet the direct impact of his style has been comparatively modest. Of the primary Abstract Expressionists, only de Kooning has visually and verbally acknowledged his debt to Gorky's shapes and line.[4] It was not until the 1950s that Gorky's stylistic influence became more obvious in the lyrical abstractions reminiscent of natural landscapes that were created by such second-generation Abstract Expressionists as Helen Frankenthaler, Joan Mitchell, and Sam Francis. Gorky's style was also indirectly perpetuated through de Kooning's monumental impact on others of the second generation.

Gorky's position as a pivotal figure in art history became apparent only after Abstract Expressionism had been recognized as the first American movement of international importance. Such an assessment based principally on style is accurate, but it represents only one approach to Gorky's art. Any comprehensive account of Gorky and his work must consider many factors rather than depending exclusively on one single element that would distort rather than clarify.[5] A purely stylistic evaluation, for example, ignores the significance of Gorky's Armenian heritage in determining the course of his artistic development. The painter's nephew Karlen Mooradian has provided valuable information about Gorky's early life in Armenia and has presented a persuasive case that this heritage lay at the heart of Gorky's creativity. On the other hand, Harry Rand and a few others have offered thought-provoking iconographical interpretations. Such an approach to Gorky's art is appropriate but problematical, for Gorky left few clues, either visual or written, that enable us to identify the specific meanings of his abstract images or to trace the transformations from what he observed to what he painted. The process of abstraction seems to have been an intangible interaction of vision, fantasy, memory, and emotion, with no intermediate stages made

2. *Drawing*, 1946
Pencil on paper, 18⅞ x 24⅞ in.
Yale University Art Gallery, New Haven, Connecticut; Gift of Julien Levy

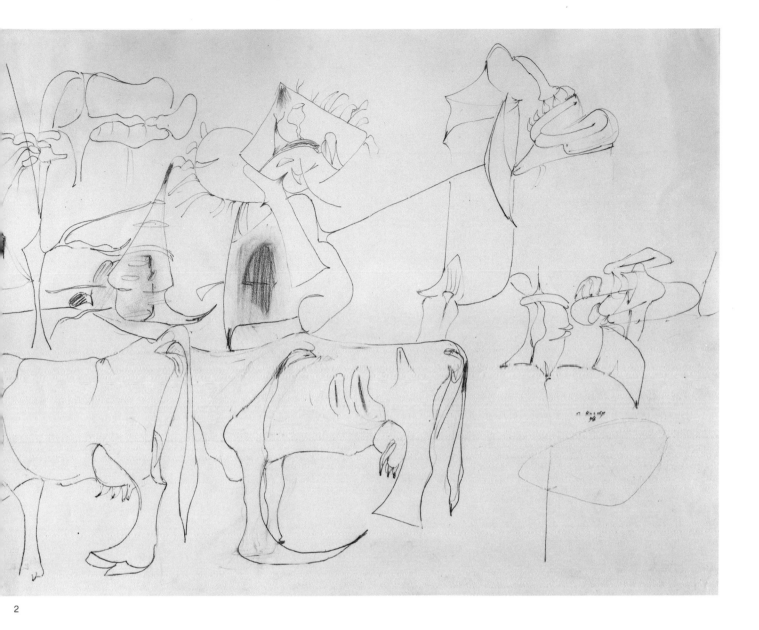

2

visible. A rare exception is *Drawing* (1946), which reveals how 2
some of Gorky's images evolved during the process of abstraction.
The cows in the lower half of the picture have been drastically
simplified, with their udders, legs, and tails so distorted in shape
and size that they are virtually unrecognizable out of context.
There is no doubt that Gorky's other images are similarly rooted
in nature, but without visual or documentary evidence, specific
readings of his images must remain speculative. As for Gorky, he
was content to let the viewer see and feel what he or she wished,
though he was hopeful that the message conveyed by his paintings
would parallel the feelings he had experienced while creating
them. [6]

Arshile Gorky's canvases have enduring power, as evidenced by
the fact that nearly forty years after his death his pictures speak
poignantly to new generations of viewers. But they also beckon
those who have seen them many times before to look again and
again, and each time something new is revealed.

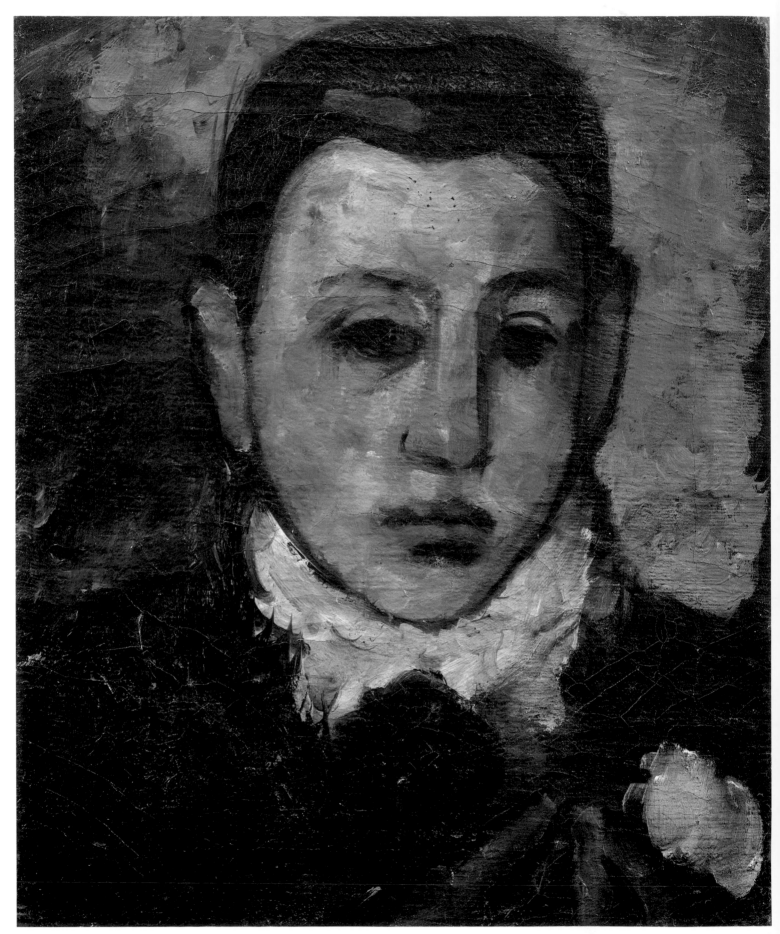

3

1 The Armenian Years

Vosdanik Manuk Adoian (as Gorky was originally named) was born in 1904 at Khorkom, Armenia, the third of four children and the only son of Lady Shushanik der Marderosian and Sedrak Adoian. He was heir to a distinguished family history, with his mother the descendant of generations of Armenian Apostolic priests and his father a farmer who owned an extensive rural estate. Such background details would be of only passing relevance to the career of a modern artist whose reputation was made in New York City had Gorky himself not spoken so often and so passionately about the influence of his Armenian legacy on the development of his art.

Throughout his life Gorky frequently shared recollections of his youth and his native culture with friends and family. Though he had lived in Armenia for only about sixteen years before coming to the United States in 1920, these were his formative years, in which he had absorbed the language, culture, and thought processes of his native country. Specifically what he saw and what he experienced there are questions with only fragmentary and, in some cases, merely speculative answers. The fact remains, however, that the artist felt deeply that his Armenian heritage helped shape his response to the world and thus played an undeniable role in determining his subject matter and his aesthetics. Moreover, religion and nature, which were so much a part of his early life, were crucial to the development of his mature style: Gorky's paintings of the 1940s are, in a sense, the visual manifestations of a "religious" response to nature, combining the romantic and visionary with the real.

Gorky, his parents, and his three sisters were a close-knit family, living together in Khorkom until 1908. That year, Sedrak Adoian reluctantly decided to leave his wife and children in Armenia, making his way to the United States in order to avoid conscription into Turkish military service, which would have forced him to fight against fellow Armenians. Turkey's attacks on Armenia escalated during the years before World War I, and they soon developed into a systematic attempt to exterminate the Armenian people.

3. *Self-Portrait at the Age of Nine,* c. 1927
Oil on canvas, 11¾ x 9⅝ in.
Nicholas Wilder

Because Sedrak Adoian disappeared from his son's life when Gorky was only four years old—not to reappear until some twelve years later in the United States—his role in Gorky's early development was peripheral. Lady Shushanik, on the other hand, was central to the formation of her son's personality and interests. All accounts portray her as a lovely, gentle, and devoutly religious woman, who took great pride in being Armenian. She adored nature and beauty, and adhered to high moral standards that she passed on to her son. In later years Gorky remembered her reverently: "Mother's thoughts were so correct, so valid for so many things in life and especially nature. . . . She was the most aesthetically appreciative, the most poetically incisive master I have encountered in all my life. . . . Mother was a poetess of aesthetics. Mother was queen of the aesthetic domain."[7]

While he was still a young boy, Gorky's creative abilities became evident in the wooden flutes and tops that he carved for his sisters and friends. He also modeled sculptures from the yellow clay on the shores of Lake Van, and he is said to have begun drawing and painting by age six, becoming particularly adept at decorating raven eggs with flowers, fruits, and animals.[8] In 1910, two years after the departure of Sedrak Adoian, the family moved from Khorkom to the ancient city of Van, about twenty miles away, where they resided for the next few months. They then relocated to Aikesdan, the eastern suburb of Van, where they stayed until 1915. During the years at Van and Aikesdan, Gorky was fascinated by the skill of the numerous silversmiths he saw at work; he was equally intrigued by the workmanship he detected in the peasants' primitive wooden plows and in the churn his mother used to make butter. The forms of both the plows and the churn later became the basis for some of Gorky's major paintings and a few pieces of sculpture.[9]

In his letters of the 1930s and 1940s Gorky reminisced about the

4. *Haikakan Gutan I (The Armenian Plow I),* 1944
Wood, 7⅝ x 6⅞ x 4⅝ in.
© 1982 by Karlen Mooradian

5. *Baptism,* 14th-century Gospel, Armenian manuscript illumination

4

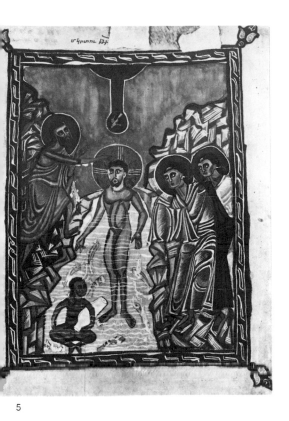

5

art he had observed during his youth, including medieval churches, illuminated manuscripts, and decorative objects. For example, he recalled that at his mother's ancestral *vank* (an Apostolic church-school-monastery complex) in Vosdan, he had stood in awe before the great golden wall paintings in the church as they were dramatically lit by processional candles, revealing images of kings, horses, and enemies engaged in battle.[10] He recalled as well the abstract cuneiform inscriptions on the huge ancient stone slabs that served as tombstones, and he singled out for special praise the monumental Church of the Holy Cross (Surp Khatch) on the island of Akhtamar in Lake Van. In 1941 he wrote: "But if one were, on the pain of death, to select precisely the one edifice that remains the master of all art, the choice could only be Akhtamar, that jewel established in our crown of beauty. I bow before it."[11]

Because of Lady Shushanik's priestly lineage, her son was allowed to examine sacred art treasures that were ordinarily inaccessible to the populace. These included Armenian manuscript illuminations from the Middle Ages, some encountered at his mother's *vank* and others seen later at the cathedral at Etchmiadzin. The nature of the memories that Gorky retained from these experiences may be gathered from a passage written in 1945: "I remember the cool sunlight filtering through Varak's halls at dawn . . . and the medieval Armenian manuscript paintings with their beautiful Armenian faces, subtle colors, their tender lines, and the calligraphy. And to this day I can still feel the chill of excitement at being introduced to a whole new world of plasticity."[12] This quotation, and others like it, suggests that Gorky remembered few, if any, specific examples of Armenian manuscript painting. What he did recall was their general style, particularly the use of color and line to build up form and to create powerful images.

The comparatively pleasant years of Gorky's youth were abruptly ended by war. Late in 1915 Aikesdan came under attack by the Turks, forcing Gorky and his family, along with thousands of other Armenians, to abandon their homes and flee from Van to Caucasian Armenia to escape the Turkish massacres. The grim journey of over a hundred miles took more than a week, and many of the refugees, exhausted by the march, soon died of disease or starvation. The Adoians and other survivors sought refuge in the courtyard of the cathedral at Etchmiadzin, where the death rate by December of 1915 had reached nearly 400 per day.[13] The family stayed only about three weeks before traveling to nearby Yerevan.

In 1916 Gorky's half-sister, Akabi, and his sister Satenik, both older than he, managed to leave Armenia to join their father in America. Gorky, his younger sister Vartoosh, and Lady Shushanik remained, managing to survive despite the scarcity of food and money. Late in 1918 Gorky's mother became seriously ill, and she died of starvation in her son's arms on March 20 of the following year. At the time, Gorky was about fifteen and his sister thirteen. With great fortitude and persistence, and aided by friends and relatives, Gorky and Vartoosh made their way to the United States to join their father and sisters.

2 The 1920s

Gorky and Vartoosh arrived in New York aboard the S.S. Presidente Wilson on February 26, 1920. In a few days, after clearing immigration at Ellis Island, they went with Mkrdich Amerian, Akabi's husband, to the Amerians' home in Watertown, Massachusetts. Shortly thereafter, Gorky went to Providence, Rhode Island, to live with his father, who worked at a factory. Gorky's relationship with Sedrak Adoian, whom he had not seen for more than a decade, proved difficult, for the young man could not forget the suffering that he and his family had endured in Armenia in their father's absence. Nor did he agree with Adoian's belief that he should seek practical employment rather than pursue a career in the arts. Gorky's father was not alone in this opinion; most of the family felt that it would be difficult, if not impossible, to make a living in America by painting and drawing. Only Vartoosh, who always remained the closest to her brother, supported Gorky's decision, though the memory of his mother's encouragement must also have sustained him.

Gorky stayed with his father in Providence until the spring of 1921, when he completed the year at Bridgham Junior High School and returned to Watertown. There, he worked at the Hood Rubber Company factory, but after about two months was fired for drawing on the wooden racks that were used to transport the factory's products. In 1922 Gorky enrolled as an art student at the New School of Design in Boston, where he soon became a part-time instructor. Having achieved this degree of success, Gorky must have been even more determined to live by his artistic talent alone. Indeed, his dedication to art was so total that he seems never to have considered any other alternative.

A photograph taken in about 1923 shows the young painter at [7] his easel in his half-sister's backyard in Watertown. A painting in its beginning stages sits on the easel, and the rudimentary elements of this landscape composition can be seen: the diagonal lines defining the rooflines of the houses, some tree limbs and foliage, and the dominant horizontal of the groundline. Although the painting does not appear very clearly in the photograph, the simplicity and angularity of the forms suggest Gorky's early pre-

6. *Landscape, Staten Island,* 1927–28
Oil on canvas, 32⅛ x 34 in.
Richard Estes

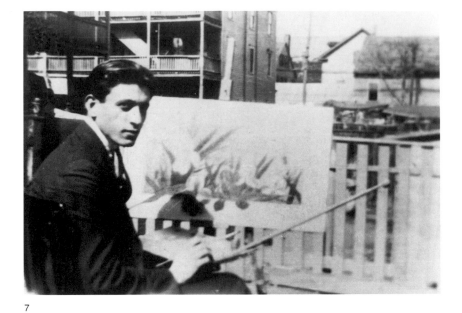

7

occupation with formal composition, while the delicacy of his brushwork implies an Impressionist influence. Just as importantly, the photo documents that Gorky, in these early years, was working from nature, a practice he would return to in the 1940s as his mature style evolved.

Some completed pictures from Gorky's Boston period have survived, including *Park Street Church, Boston* (1924) and probably *Beach Scene* (c. 1925), both of which seem to have been painted outdoors. In each, the paint is applied in thick, short, loose brushstrokes that tend to dissolve any illusion of concrete form. *Park Street Church*, in particular, seems to have been an attempt to capture specific effects of light and climate and so is similar in spirit to paintings by the nineteenth-century French Impressionists. It seems safe to assume, in the absence of evidence to the contrary, that Gorky had not been familiar with Impressionism in Armenia and that he first encountered it in Boston, which had been a center for one American branch of the movement. On the whole, however, Gorky's work is more crudely rendered, lacking the subtlety and uniformity that characterize the brushwork of Claude Monet or Auguste Renoir. Moreover, his forms do not seem to dematerialize completely, but rather preserve the underpinnings of solid, realistic structure.

Impressionism, of course, was neither new nor controversial in America during the 1920s. If anything, *Park Street Church* might be considered a very late manifestation of the Impressionist style that had been favored in this country at the turn of the century. John Twachtman, for instance, had painted poetic Impressionist landscapes from the late 1880s to 1902. In fact, Gorky, in 1926, named Twachtman and James McNeill Whistler as American artists who were notable for having captured universals in their art, explaining, "Your Twachtman painted a waterfall that was a waterfall in any country, as Whistler's mother was anyone's mother. He caught the universal idea of art."[14] Gorky's emphasis on uni-

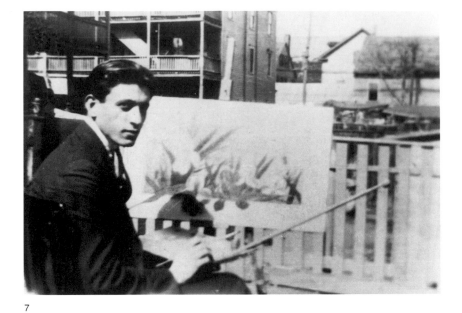

7. Arshile Gorky painting in the backyard of his sister's house in Watertown, Massachusetts, c. 1923. Courtesy the Arshile Gorky and 36 Union Square Archives (1922–43) by Moorad Mooradian. © 1982 by Karlen Mooradian

8. *Park Street Church, Boston,* 1924 Oil on canvasboard, 16 x 12 in. Lowell Art Association, Lowell, Massachusetts; Gift of Katherine O'Donnell Murphy

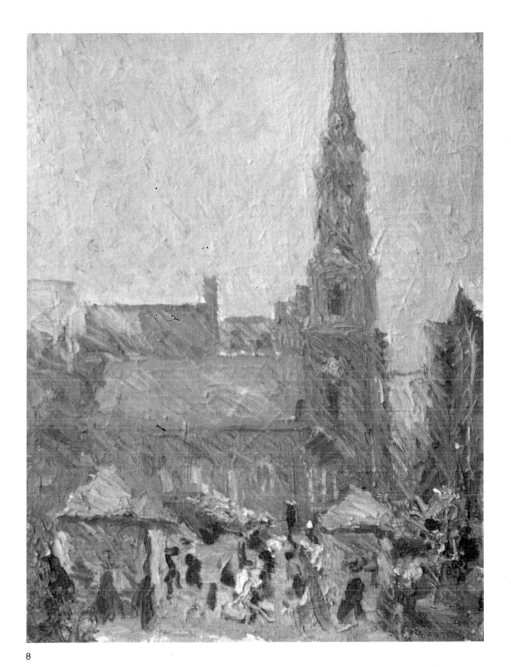

8

versality, of course, was antithetical to Impressionism's goal of embodying a vision of a specific but ephemeral moment, and he later denounced the lack of solid form in Impressionist painting. As late and as unorthodox as it was, Gorky's Impressionistic style of the mid-1920s did provide a starting point for his exploration of modern art. Gorky was, for the most part, a self-taught artist. Throughout his life he made frequent visits to museums and galleries, studying works by both modern and traditional artists. At Boston's Museum of Fine Arts he had the opportunity to see numerous examples of Impressionist painting, including works by Monet, Renoir, Alfred Sisley, Camille Pissarro, and Edgar Degas. The growing availability of publications on Impressionism and other modern movements might also have contributed to his education.

Becoming disenchanted with the quality and type of art being produced around Boston, Gorky decided to move to New York City. New York, like the rest of the country in the 1920s, was more conservative politically and culturally than it had been in the preceding decade. The fascination with European modern art—which had been introduced in this country chiefly through the efforts of Alfred Stieglitz and through the 1913 Armory Show—now dimmed in the aftermath of World War I. As the prewar optimism and enthusiasm for experimentation chilled into a pessimistic conservativism, artists recoiled from European culture and turned to the American experience for inspiration. Even when modern styles persisted, they were carefully integrated with peculiarly American subjects: the industrial landscape, engineering marvels like the Brooklyn Bridge, and the new technologies of farming as symbolized by the starkly impersonal grain elevator. Artists such as Charles Demuth and Charles Sheeler captured scenes like these in a Cubist-related style, called Precisionism, that was characterized by clean lines, pristine surfaces, and metallic colors. The Precisionists' adaptation of a modern European style to American subject matter was paralleled by a growing desire among other painters to revive realism. Like the Precisionists, the proponents of this new naturalism found their themes in the society around them, and, in this respect, they anticipated the Regionalists of the 1930s. Edward Hopper and Charles Burchfield, although very different in their approaches to realism, came to represent this return to the familiar and the recognizable. Their art, however, also reflected the disenchantment of the postwar period, and many of their pictures were infused with melancholy, nostalgia, and loneliness. This subdued mood seemed, in fact, to permeate the entire New York art world, which Gorky was nonetheless eager to enter.

Arriving in late 1924, Gorky soon found a large studio in which to live and work on Sullivan Street, near Washington Square in Greenwich Village. He had his mind set on continuing his career as an artist, and he did his best to eliminate any obstacles to his progress. Most revealing, perhaps, was his decision to adopt permanently the fictitious name Arshile Gorky, which he had first used to sign a painting in 1924, thus leaving behind his identity as Vosdanik Manuk Adoian. Various reasons for the name change have been suggested, but the most convincing is that the artist consciously sought to hide his Armenian identity, at least until he had achieved recognition as a painter and could thus bring honor to his people. Moreover, Gorky knew that not only his name but Armenia itself would seem strange to Americans and might hinder his success. Because he could not mask his foreign appearance, accent, or mannerisms, he probably reasoned that a Russian name would suit his ethnic characteristics and would be more familiar to Americans than his own, especially since Russian immigrants were streaming into the country during the 1920s.

The name Arshile Gorky was also literally symbolic. As Karlen Mooradian has pointed out, *Arshile* derives from the Caucasian form of the Armenian royal name *Arshak*,[15] which in Russian translates as "Achilles." *Gorky*, on the other hand, is Russian for

9

9. *Beach Scene*, c. 1925
Oil on canvas, 18 x 22 in.
Private collection

"bitter." The name thus alludes to the hero of Homer's ancient Greek epic, but also suggests a connection with the modern Russian writer, Maxim Gorky—an association the artist exploited. Such a symbolic combination of old and new parallels the artist's search for a style of painting that would evolve from the traditional masters, but that would be characteristic of the contemporary world as well. It has also been said that the choice of name reflects the artist's melancholic personality, which might be compared to that of the sulking Achilles. Whatever the private symbolism might have been, Gorky's new name was purposefully chosen, and he stressed his "Russian" background on several occasions, giving his birthplace as Kazan, Russia, or stating that he had studied art at Nizhu-Novgorod.[16] And at least once he spoke publicly about his "cousin" Maxim.[17] Furnishing himself with a distinguished Russian heritage may, in fact, have made it easier for him to obtain recognition and employment in this country.

To complement this Russian background, Gorky fabricated other credentials to legitimate his training in art. He stated that he had studied in Paris at the Académie Julian under the relatively obscure French academic master Albert Paul Laurens,[18] and on other occasions he claimed to have studied with Wassily Kandinsky in Paris in 1920.[19] Gorky evidently did not expect anyone to discover that he had never even been in France. The painter also said that he had studied at the Rhode Island School of Design, but there is no record of his having attended that institution either.[20] Gorky's mythic identity and background, ingenious as they were, certainly would not have been enough to insure success. Fortunately, he possessed tremendous amounts of talent, self-confidence, determination, and intellect, which proved much more useful to his career.

In January 1925 Gorky enrolled in the life-drawing class taught by Charles Hawthorne at the National Academy of Design but, apparently dissatisfied with his situation, remained there only a month. He subsequently taught an art class at the New School of Design on Broadway at Fifty-second Street, a newly opened branch of the school where he had taught in Boston.[21] He worked there only a few months in 1925 before enrolling in the fall as a student at the Grand Central School of Art. A year later, he joined the faculty there as an instructor of painting, a position he was to hold until 1931.

On the occasion of Gorky's appointment to the Grand Central School of Art, an interview with him appeared in the *New York Evening Post*, which presented the young painter's thoughts on art and culture in his adopted country. The interviewer noted that Gorky's art had remained virtually unaffected by the power of his new environment. Gorky was particularly critical of the American "craze for antiques," which preferred old masters and established names to new artists working in a modern style. Unlike Europe, he maintained, there was little opportunity for a contemporary artist to exhibit his work in America. He spoke also of the commercial enticements that drew young American painters to tried and true styles, to the detriment of modern art, which is

"the greatest the world has known."[22] Gorky's assessment of the American art world would not change significantly over the next twenty years.

As a teacher Gorky quickly earned the respect of the students who were receptive to modernism. He spoke about contemporary styles and theories that were familiar to only a few, if any, of them, discussing the art of Paul Cézanne, Pablo Picasso, Georges Braque, Henri Matisse, and even André Breton at a time when Cubism, Fauvism, and Surrealism were either unfashionable or virtually unknown in America.[23] That Gorky, who had been in the United States for less than a decade, was familiar with these artists and movements is in itself remarkable; that he was able to communicate some of their complex ideas to others and stimulate their interest is even more astounding. His effectiveness was undoubtedly enhanced by his romantic appearance: over six feet tall, he maintained a well-groomed mustache and dark hair, had large dark eyes, spoke heavily accented English, and usually wore neatly tailored blue suits. He carried himself proudly and spoke with such authority to his students that they scurried off to the library or bookstore to learn more about the artists and ideas he mentioned.

Gorky's own absorption of modernism was rapid in spite of the fact that his opportunities for viewing contemporary art were limited. His primary source must have been the French art books and periodicals that were accessible, though not plentiful, in New York. At the Weyhe Bookshop, for example, he became familiar with the avant-garde magazine *Cahiers d'art*, which first appeared in January of 1926, and he may also have discovered there

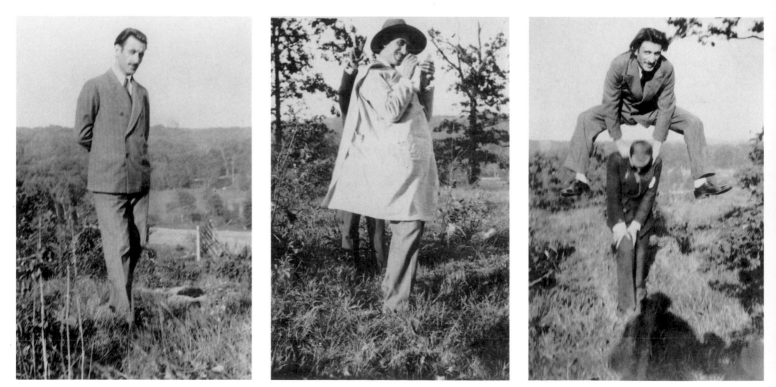

10 11 12

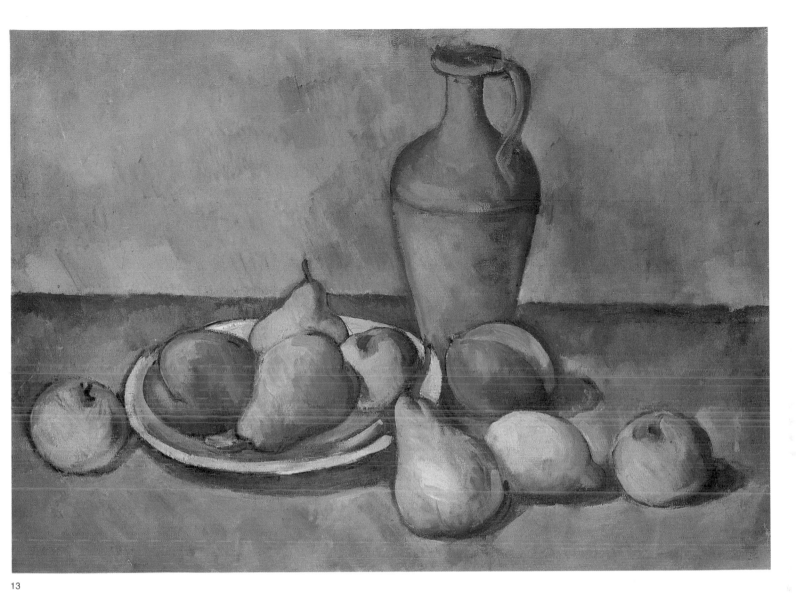

13

La Révolution surréaliste, published between 1924 and 1929. The artist supplemented the information he found in these and other literary publications by viewing the few examples of modern painting that sporadically began to appear in New York. One such show was the *International Exhibition of Modern Art*, held at the Brooklyn Museum in November 1926, where several works by artists such as Braque, Miró, Picasso, and Kandinsky were included. The next year Albert E. Gallatin, himself a painter working in a modernist style, put his private collection on public view in his Gallery of Living Art at New York University.

Gorky probably obtained some of his knowledge of modern painting through friends. By the late 1920s he was socially involved with a group of Russian immigrant artists that included Raphael Soyer and his two brothers, Isaac and Moses, Nicolas Vasilieff, David Burliuk, and John Graham. Burliuk and Graham, in particular, were ardent modernists who may well have played a part in formulating or reinforcing Gorky's ideas about art. Graham's relationship to Gorky has often been discussed, but the pos-

sibility of Burliuk's influence seems almost to have escaped notice. Yet, in most respects, Burliuk would have been just as likely as Graham to convey information to Gorky about developments in modern art. While living in Moscow before the Revolution, Burliuk had organized and participated in several exhibitions of modern art. By 1910 he had gotten to know Kandinsky and had become a member of the Expressionist group *Der Blaue Reiter* ("The Blue Rider"); soon after that he achieved an international reputation as a leading figure of Russian Futurism, a style based partially on French Cubism. These firsthand experiences with the European avant-garde could well have given Gorky a direct source of theoretical as well as stylistic knowledge. Certainly Cubism and Kandinsky were both to have a major impact on the later development of Gorky's art.

At the same time, John Graham's influence should not be overlooked. Born Ivan Dombrovski in Kiev, Graham left Russia for the United States in 1920, after the failure of his efforts as a counterrevolutionary. He studied at the Art Students League under the socialist John Sloan, who had been associated with the progressive group "The Eight" more than a decade before. At about the same time, Graham adopted his new name, just as Gorky was to do a few years later. By the late 1920s Graham was making frequent visits to Paris, where he got to know such prominent members of the European avant-garde as Picasso and Breton. He brought back news about the latest art developments abroad to his friends in New York. By the 1930s these friends included not only Gorky, whom Graham had met in about 1928, but also Stuart Davis, David Smith, Willem de Kooning, and Jackson Pollock.

The paintings that Gorky created during the second half of the 1920s make clear that he had progressed beyond Impressionism into Post-Impressionism (heavily influenced by Cézanne), Fauvism, and Cubism. Later, the artist was to make the comment, often quoted, that "I was *with* Cézanne for a long time, and now naturally I am *with* Picasso."[24] This statement reflects Gorky's view that art history is a succession of links in an unbroken chain, in which all art evolves from past styles and artists. In 1947 he spoke of it in the following poetic terms:

The tradition of art is the grand group dance of beauty and pathos in which the many individual centuries join hands in the effort and thereby communicate their particular contributions to the whole event just as in our dances of Van. They can however be rendered inadequate if the linking hands are broken. For this reason I feel that tradition, namely the related ages of the past and present, are so important for art. The soloist can emerge only after having participated in the group dance.[25]

Gorky's statement that he studied the art of Picasso after he had absorbed the lessons of Cézanne is, however, an oversimplification, for in reality his art followed a more complicated route. Having abandoned Impressionism, which he dismissed because of its lack of form,[26] Gorky worked concurrently on canvases that betray multiple influences. Indeed, some paintings of the period, mainly the portraits, resist neat pigeonholing into any exclusive sphere of influence. Nevertheless, Cézanne was undeniably the

14

14. *Still Life with Skull*, c. 1927–28
Oil on canvas, 33 x 26 in.
Private collection

15. *Still Life*, c. 1928–29
Oil on canvas, 35¾ x 28 in.
Private collection

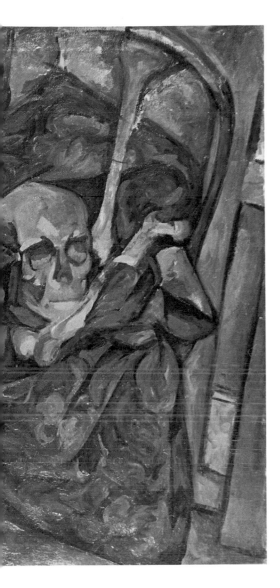

most consistent and pervasive force in Gorky's work during the late 1920s, and this phase represents his first immersion into the study of another master's style and theory. Gorky's Cézanne-inspired paintings surpass his others of the period not only in number but also in the way they demonstrate his wholehearted understanding of the principles at work.

Using Cézanne's paintings as models, Gorky began to place small patches of pigment side by side throughout the composition to build up form and pictorial structure. For subject matter, he chose the still life, the landscape, and the portrait, which were all typical of Cézanne's art as well. In the 1926 newspaper article mentioned earlier, the interviewer noted that Gorky's studio contained many depictions of such subjects, but that no American subjects, and specifically no New York subjects, were to be seen. Gorky explained to him that "Art is always universal. It is not New England or the South or New York. . . . Too many American artists paint portraits that are portraits of a New Yorker, but not of the human being." The artist, Gorky felt, must capture the subject's formal essence and mood, must transform it into a timeless, universally understood image. In the same interview, Gorky proclaimed that Cézanne, who had painted such transcendent compositions, was the greatest artist who had ever lived.[27]

Gorky's thorough assimilation of Cézanne's subjects, style, and ideas can be grasped by looking at his *Pears, Peaches, and Pitcher* 13 of c. 1926–27.[28] Gorky arranged a few objects on a tabletop in a deceptively simple manner, with a blank wall serving as background. Within the still life can be found a variety of shapes, ranging from the broad rectangular compartments of the tabletop and the wall to the circular form of the individual peaches at the far right and left. Between these two extremes are the bulging, organic shapes of the pears, which echo the equally swelling though more rigid cylindrical form of the pitcher. The plate stretches into an oval and provides a visual transition between the circular and rectangular shapes. Though the still life is almost perfectly balanced, it is not stagnant; compositional rhythms and forces are at work in this translation of reality into art.

In *Pears, Peaches, and Pitcher*, Gorky's choice of subject, his technique, and his palette all relate closely to Cézanne's art. Other canvases from the period, such as *Still Life with Skull* (c. 14 1927–28) and *Still Life* (c. 1928–29), also betray their origins in 15 Cézanne, though neither demonstrates so successfully Gorky's profound comprehension of that artist's ideas. It is important to note, however, that *Still Life* and similar compositions from the period often reveal Gorky's effort to assimilate styles of other artists and to combine them with Cézanne's. In *Still Life*, for exam- 19 ple, the Cubist paintings of Georges Braque were influential.

Staten Island (1927) and *Landscape in the Manner of Cézanne* 16, 18 (c. 1927) likewise find their roots in the art of the Aix master, as Gorky readily acknowledged in the title of the latter work. Both paintings seem to be based on motifs or detailed areas from larger compositions by Cézanne. For instance, the architectural forms depicted as if seen from a slightly elevated perspective in *Staten Island* recall the houses in the bottom foreground of Cézanne's

15

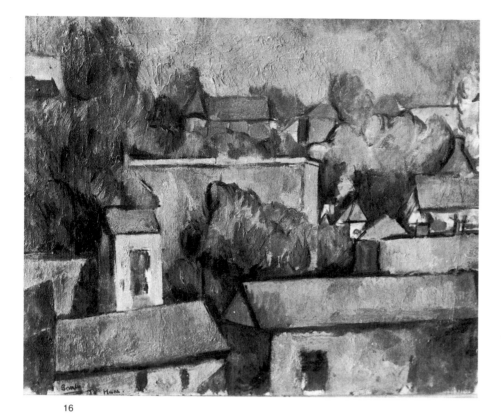

16

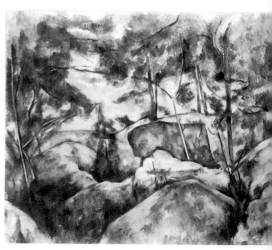

17

The Bay from L'Estaque (1886) and in analogous works. Gorky's reduction of the houses to roughly rectangular, pentagonal, trapezoidal, or parallelogram shapes, interspersed with open brushwork suggesting trees and foliage, is remarkably close to the French painter's process of abstracting. But rarely did Cézanne limit his landscapes to such a confined vista.

Landscape in the Manner of Cézanne closely resembles a section in Cézanne's *Rocks in the Forest* (1894–98), which the Metropolitan Museum of Art acquired in 1929.[29] This section is just to the right of center in the upper portion of the work, where, above the large rocks, two slim tree trunks extend upward to the edge of the picture; to their right is a tall branch stripped of all foliage. Not only did Gorky echo these three dominant verticals, but he suggested the rock at the base of the trees as well. In addition, Gorky depicted the foliage in the sparse hatching technique that is typical of Cézanne's art. An area of this hatched foliage at the left in Gorky's painting finds almost a direct counterpart in shape at the left of the trees in *Rocks in the Forest*. Such a correlation between the two works is probably not coincidental, for Gorky often studied areas of paintings in museums by making a "telescope" with his hands, which enabled him to view certain details in isolation. Often he attracted a large number of people around him and his friends or students as he spoke knowledgeably and expressively about a work or artist.

As the 1920s drew to a close, the influence of Picasso and Braque figured more prominently in Gorky's work as he continued to explore the major directions of modern art, evidently preparing himself to become an important extension of the modern

16. *Staten Island,* 1927
Oil on canvas, 16 x 20 in.
Mr. and Mrs. Hans Burkhardt

17. Paul Cézanne,
Rocks in the Forest, 1894–98
Oil on canvas, 28¾ x 36¼ in.
The Metropolitan Museum of Art, New York;
Bequest of Mrs. H. O. Havemeyer, 1929,
The H. O. Havemeyer Collection

18. *Landscape in the Manner of Cézanne,* c. 1927
Oil on canvas, 20 x 16 in.
N. Elghanayan, New York

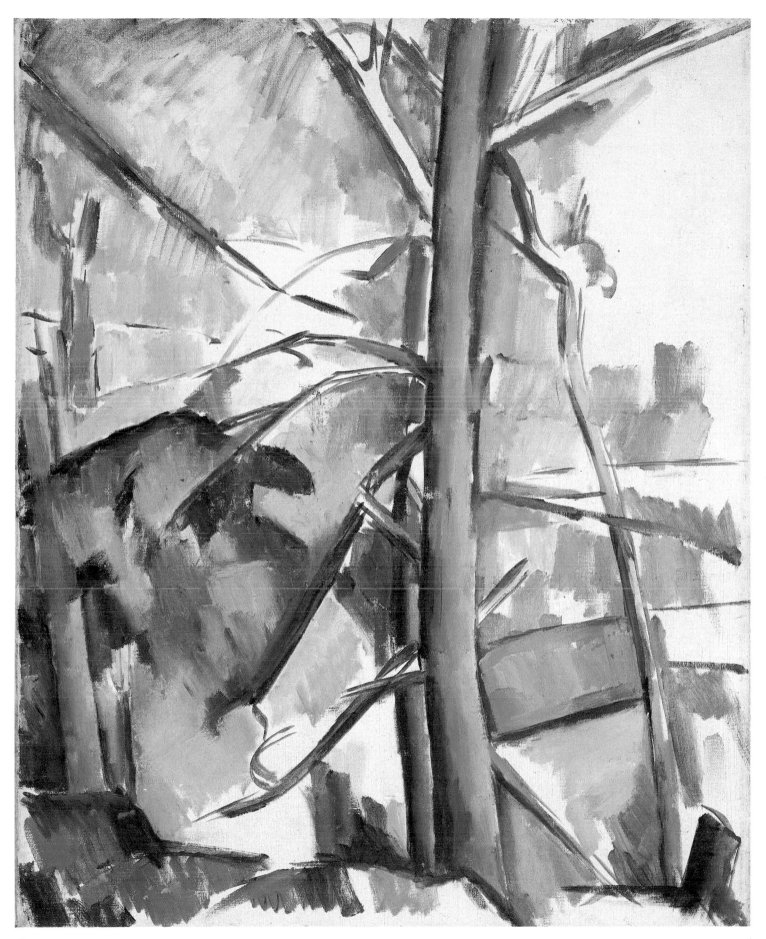

tradition. It has often been noted that Gorky's interest in Cubism was typically confined to its later Synthetic phase, in which color, shape, texture, and an emphasis on two-dimensionality became the primary pictorial components. Gorky based his *Composition* of c. 1928–29 on a canvas by Picasso entitled *Still Life with Fishes* (1922–23) and composed it similarly in broad planes of rich, textural pigment. The objects that Gorky depicted—wine glass, compote, and wine bottle—are the same as Picasso's, but his treatment of them is quite different. His brushwork is looser, thicker, and more vigorous, and he occasionally introduced an element of spontaneity (note the running of the paint along the lower edge of the picture). In addition, his forms are less precisely linear and angular, without the basic geometric structure characteristic of Picasso's objects. Gorky thus gave the work an expressionistic quality that is often lacking in Cubist paintings.

In a second work from the period, *Still Life* of 1929–32, Gorky continued his stylistic interest in Synthetic Cubism, but made the objects in the painting virtually unidentifiable. Meyer Schapiro was the first to discover that this work was based upon Picasso's *Musical Instruments* (or *Mandolin and Music Stand*) of 1923.[30]

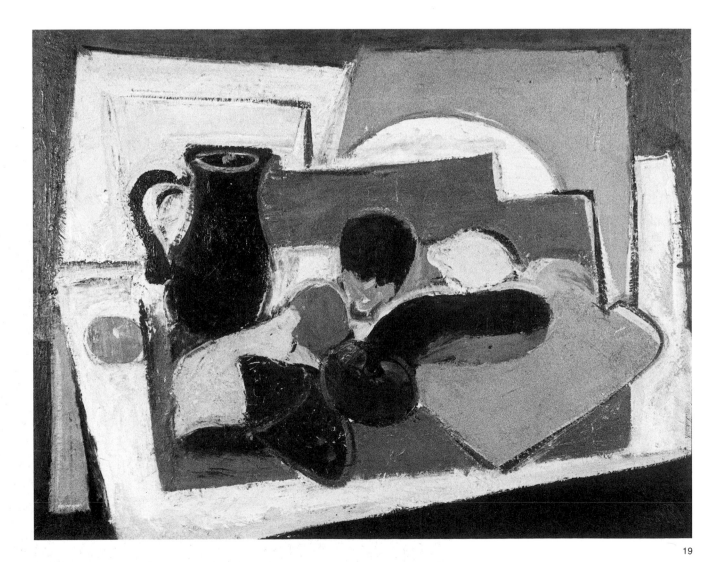

19

19. *Still Life (Composition with Vegetables),*
1928–29
Oil on canvas, 28⅛ x 36⅛ in.
The Archer M. Huntington Art Gallery, The
University of Texas at Austin; Gift of Albert
Erskine to the James and Mari Michener
Collection, 1974

20. *Composition,* c. 1928–29
Oil on canvas, 43 x 33 in.
Private collection

21. *Still Life,* 1929–32
Oil on canvas, 47 x 60 in.
Private collection

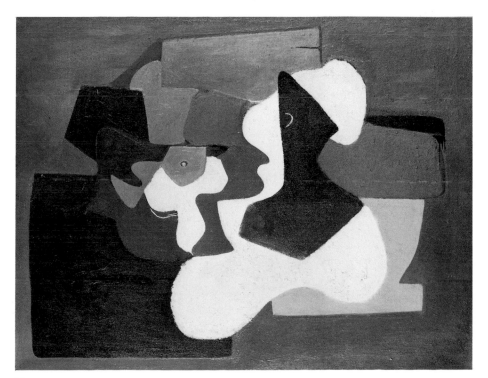

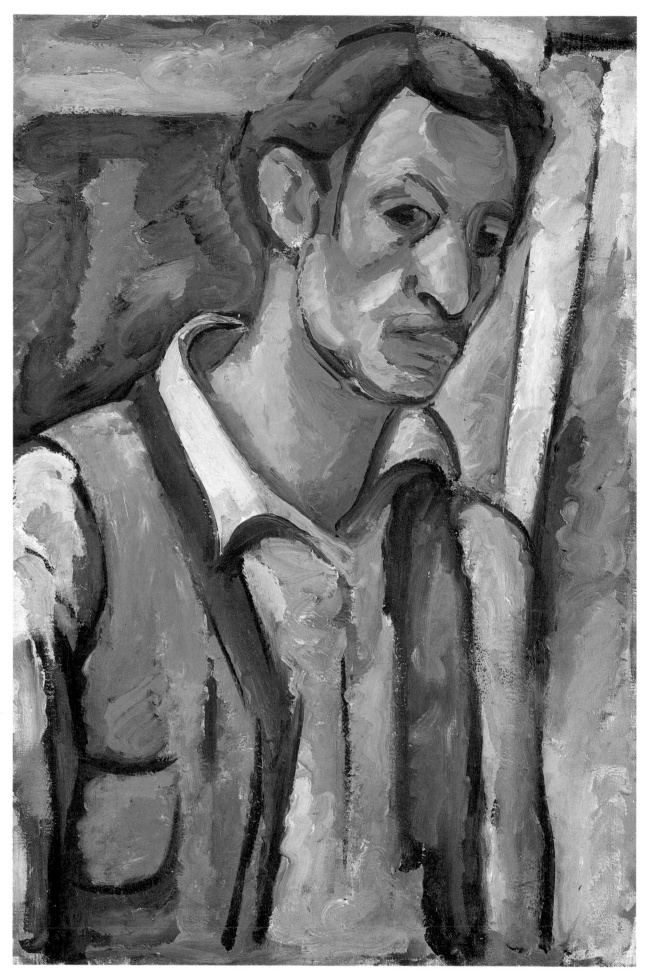

22. *Self-Portrait*, c. 1928
Oil on canvas, 24 x 16 in.
Los Angeles County Museum of Art; Gift of
Mr. and Mrs. Hans Burkhardt

23. *Portrait of Myself and My Imaginary
Wife*, 1933–34
Oil on cardboard, 8 x 14 in.
Hirshhorn Museum and Sculpture Garden,
Smithsonian Institution, Washington, D.C.

By painting only the contours of the objects or combinations of objects found in Picasso's painting, without any identifying details, Gorky abstracted the elements and camouflaged his source. This is one of the first, and one of the comparatively few, times that Gorky is known to have transformed a specific work by another artist into a nearly nonobjective one of his own. It shows that he was willing to learn from the masters, but that he also creatively disguised such study so that the final product was uniquely his own.

The influence of Cézanne and Picasso extended beyond Gorky's abstractions to his figurative works, particularly his self-portraits. There are, in fact, strong affinities between Gorky's *Self-Portrait at the Age of Nine* (c. 1927), *Self-Portrait* (c. 1928), [3, 22] *Portrait of Myself and My Imaginary Wife* (1933–34), and, re- [23] spectively, Cézanne's *Louis Guillaume* (1879–82) and *Boy in Red Jacket* (1890–95) and Picasso's *Tête de marin* (1907).[31] Gorky painted and drew more than a dozen self-portraits in his early career, each of which exceeds physical likeness to reveal the artist's self image. Many self-portraits, like those just noted, depict Gorky in the style or image of the modern masters he chose to emulate. They indicate how closely he identified with Cézanne and Picasso and suggest that he envisioned himself as their successor. Just as importantly, they echo how Gorky felt about himself at various times. *Self-Portrait at the Age of Nine*, for example, de-

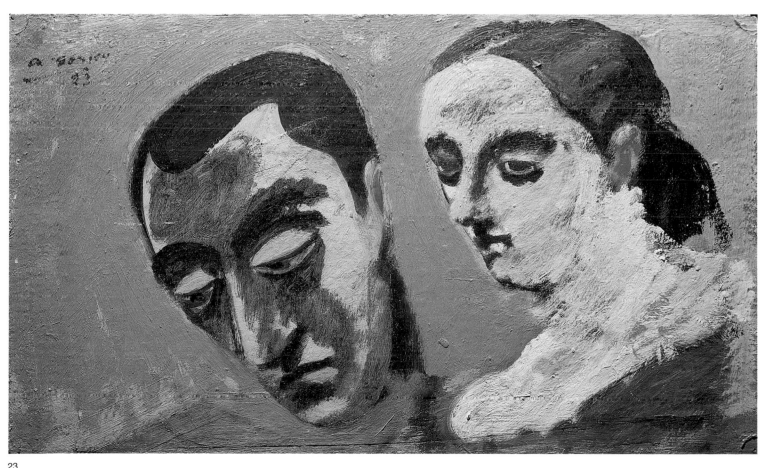

23

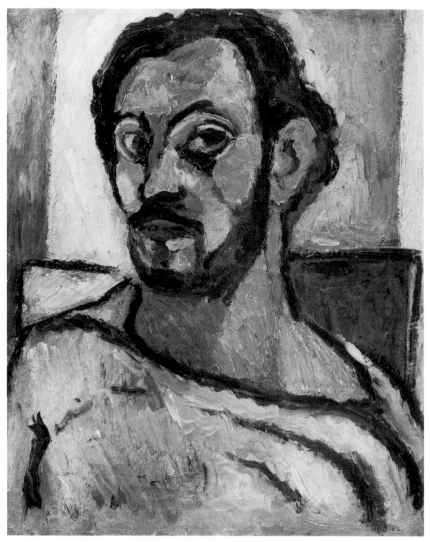

24

picts him as an introspective, melancholic youth, yearning for ful-fillment. In contrast, *Self-Portrait* (c. 1928) shows an older, more serious and more self-confident Gorky, who had arrived at an important position in life as an artist.

24 Still another self-portrait from 1928 is modeled on a 1906 self-portrait by Henri Matisse, another of the modern painters that Gorky emulated. However, Matisse's influence on Gorky, unlike Cézanne's or Picasso's, was quite limited. His more decorative style probably did not satisfy Gorky's quest for profundity, and Gorky dismissed his later Orientalist-style canvases because "They lack the authority of one who has felt them [the Near Eastern qualities] directly."[32]

The fact that Gorky worked in European modernist styles in New York during the 1920s sets him apart from most of his contemporaries. Even those artists who were to become leaders of Abstract Expressionism had not begun painting abstractions; indeed, most of them had not even completed their formal art training and some of them had not yet arrived in the city. Adolph Gottlieb, Barnett Newman, and Mark Rothko, for instance, were

among those attending art schools in New York during the period. Jackson Pollock, William Baziotes, Hans Hofmann, Willem de Kooning, and Ad Reinhardt did not move to New York until the late 1920s or early 1930s, and most of them received their training during the Depression. So, although Gorky and these painters were of the same generation, he was comparatively advanced. Not only did he have an impressive knowledge of traditional and modern art history, but, with minimal formal preparation, he had secured a teaching position while his contemporaries were still students.

Soon after de Kooning arrived in New York in 1927, he met and befriended Gorky. In a statement published in 1980, de Kooning aptly summarized Gorky's advanced position:

He was a fantastically remarkable man. You know, of course, that he came here when he was 16, so he couldn't have studied much here, because at 20 or 21 he was already teaching at the Grand Central School of Art. And I knew some of his students, and he was a very good teacher. I came in 1926 [from Rotterdam] and in a way I had more legitimate

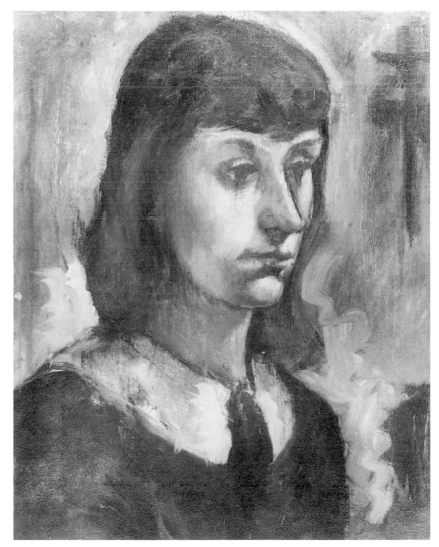

24. *Self-Portrait,* 1928
Oil on canvas, 20 x 16 in.
Mrs. Rook McCulloch, Lyme, Connecticut

25. *Portrait of Mougouch,* c. 1928
Oil on canvas, 18 x 14 in.
Monmouth Museum, Lincroft, New Jersey; Gift
of Mr. and Mrs. Nathan Bijur

25

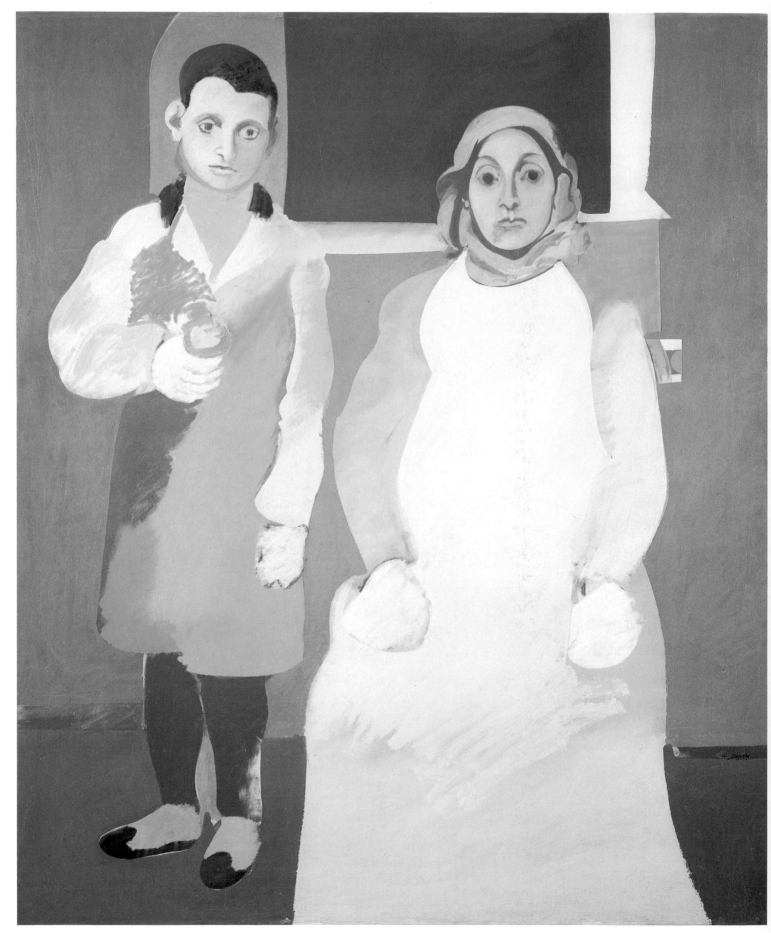

26

26. *The Artist and His Mother*, c. 1926–34
Oil on canvas, 60 x 50 in.
Whitney Museum of American Art, New York;
Gift of Julien Levy for Maro and Natasha
Gorky in memory of their father

27. Arshile Gorky and his mother in Van,
Armenia, 1912. Courtesy the Arshile Gorky
Adoian Amalgam (1908–47). © 1982 by
Gilgamesh Press, Ltd.

28. *The Artist and His Mother*, c. 1929–36
Oil on canvas, 60 x 50 in.
National Gallery of Art, Washington, D.C.;
Ailsa Mellon Bruce Fund, 1979

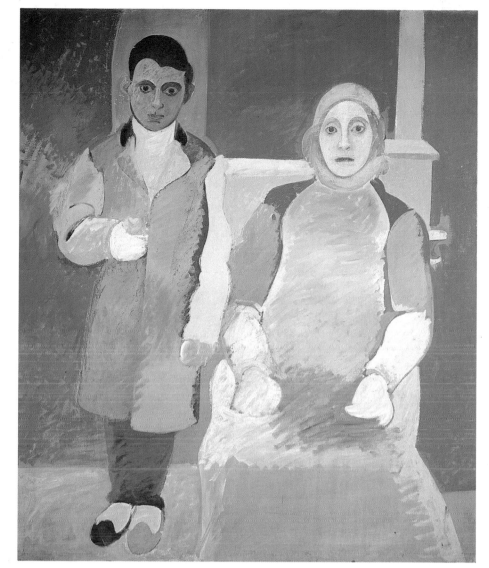

28

27

schooling in Holland but the things I was supposed to know he knew
much better.[33]

Gorky's rapid advancement is perplexing, explicable only if he
possessed both artistic talent and an intuitive understanding of
aesthetics. The artist himself often attributed his gifts to his Ar-
menian background: he believed that great civilizations, such as
Armenia, which had evolved from the ancient Sumerian and Hit-
tite cultures, produced great and innovative art. He felt that
experiencing such a civilization, in both its good and bad aspects,
made the artist more sensitive to the world around him and
intensified his abilities to respond.[34]

Although many of Gorky's statements about the importance of
his Armenian background date from the 1930s and 1940s, the por-
traits of his family members, which he began painting in the
1920s, also reveal the influence of his heritage. Many of them are
done in a rather flat, simplified style that eludes stylistic categori-
zation. To one degree or another, they echo Synthetic Cubism, Ab-

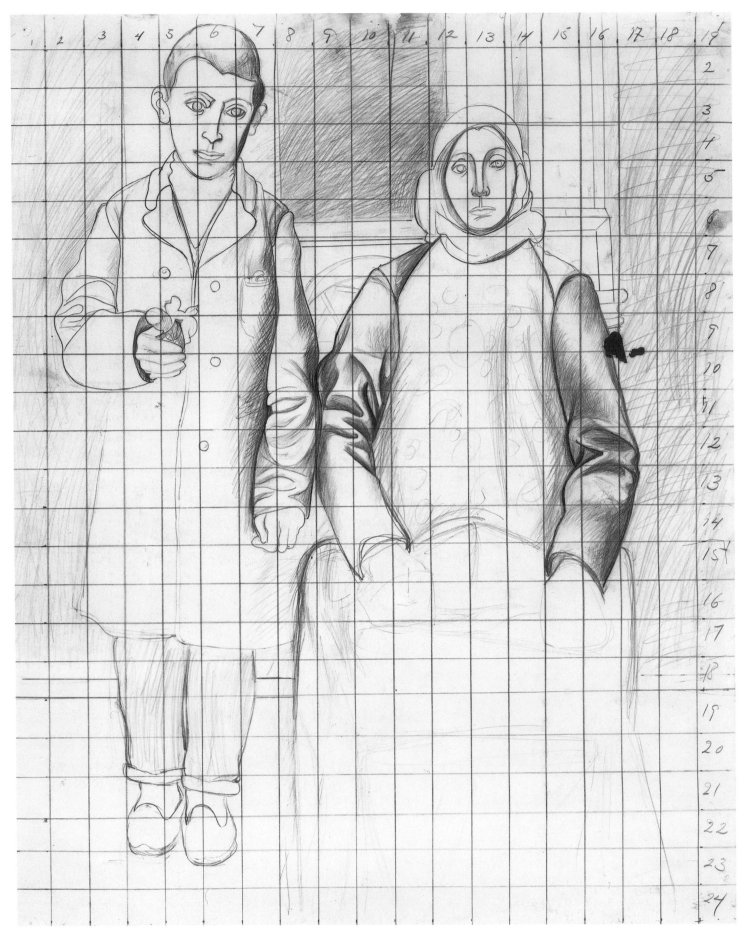

stract Surrealism, or Matisse's post-Fauve portraits, but their mood also vividly recalls medieval icons.

Central to Gorky's development was a double portrait that he began soon after his arrival in New York City, showing himself at age eight standing beside his seated mother. Based on a photograph taken in Van in 1912, this subject was to preoccupy the artist for almost twenty years. The Whitney Museum's canvas, painted between c. 1926 and 1934, is the most finished and resolved of his various compositions on the theme.

The Artist and His Mother is not just a painted version of a photograph: the artist made significant changes for compositional, stylistic, and expressive purposes, resulting in a powerfully moving image. The melancholy young Gorky stands apart from his mother, seemingly saddened by this symbolic separation. The flowers he holds become an offering to the timeless and monumental figure of Lady Shushanik, who calls to mind traditional icons of the Virgin attended by adoring figures. Transformed into a universal symbol, she inspires contemplation and spiritual devotion. This image of his mother memorialized his love for her, but it probably also symbolized for Gorky the beauty and spirit of his native country, which seemed always to be haunted by sadness.

By modernizing and secularizing a time-honored religious theme, Gorky helped bridge the gap between history and modernity, for he believed that art needed to revive traditional themes rather than to invent new ones.[35] By simplifying the forms, eliminating most of the detail, and emphasizing the broad areas of color, Gorky gave this image a timeless quality. The spatial ambiguity he created by denying measurable and logical relationships between the forms leaves them floating and mysterious. His combination of Synthetic Cubist planes with curvilinear, swelling forms that evoke associations with living organisms, like those frequently seen in Surrealism, suggests the influence of Joan Miró (see, for example, Miró's *Dutch Interior*) and predicts Gorky's mature synthesis of these two seemingly opposed tendencies over a decade later.

Gorky considered such "Armenian portraits" to be his first mature works, for they integrate modern pictorial space with highly evocative moods. In so doing, they went beyond Cézanne's formal principles or Cubist spatial precepts. Gorky was later to identify Cubism with the urban environment and the technological world. By softening that cool structure through the use of curvilinear forms inspired by his Armenian background, he could inject an expressive warmth. In that sense, it can be said that Gorky's Armenian heritage, and particularly the tragic and pleasurable boyhood experiences to which he alludes in *The Artist and His Mother*, lay at the heart of his early development as a painter.

26, 28

27

59

29. *The Artist and His Mother,* 1934
Pencil on squared paper, 24 x 19 in.
National Gallery of Art, Washington, D.C.;
Ailsa Mellon Bruce Fund, 1979

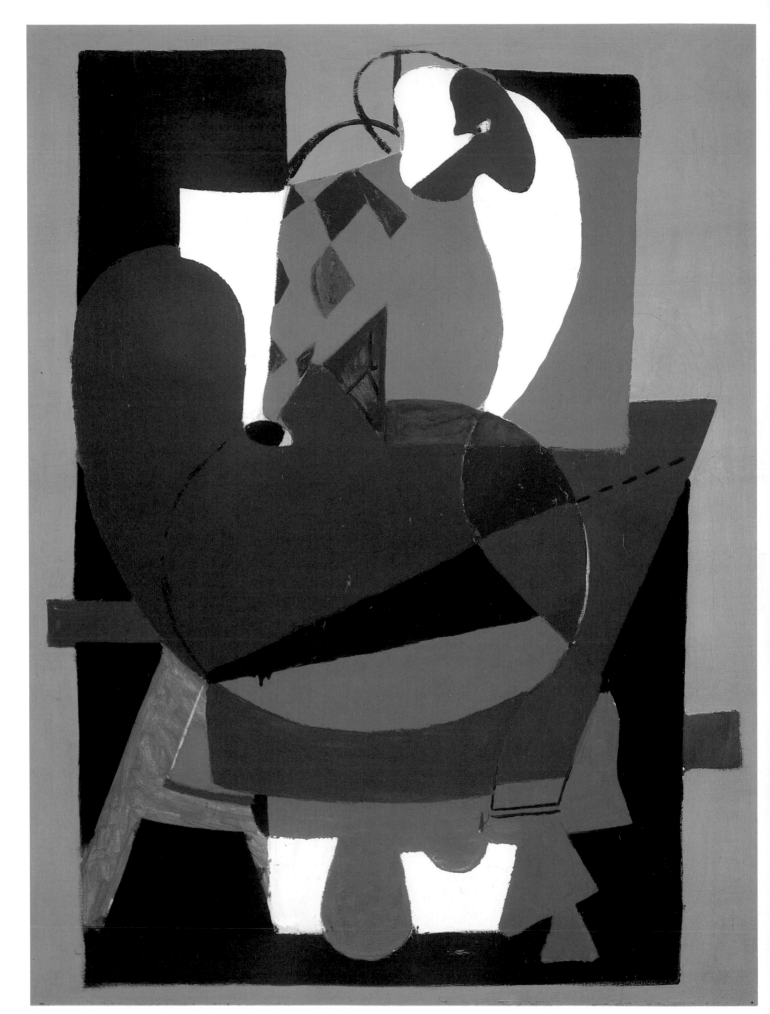

3 The 1930s

Gorky's interest in Cézanne declined in the early 1930s, while his attraction to Cubism intensified. In 1931 the painter presented his views on Cubism in an article he wrote for and about his friend, the American painter Stuart Davis. Gorky wrote, "Has there in six centuries been better art than Cubism? No. Centuries will go past—artists of gigantic stature will draw positive elements from Cubism."[36] In this statement Gorky, in effect, placed the entire Renaissance tradition, which had flourished since the fourteenth century, in a position of secondary importance to Cubism. On the other hand, he also acknowledged that Cubist principles were not completely new, but were rather the most recent step in the development of pictorial logic. Six years later Gorky restated this position more precisely when he wrote, "Cubism . . . does not originate with Braque and Picasso but rather culminates in them."[37] As precursors of the twentieth-century movement, Gorky undoubtedly had in mind the artists of the ancient Urartian, Sumerian, and Hittite cultures, those of the Egyptian, Etruscan, and pre-Greek civilizations, and the artists and artisans of the medieval world. In fact, he viewed his own Armenian cultural heritage as encompassing all of these. His friend John Graham also saw the history of modern art as a succession of related styles, tracing it through the following categories and artists: Prehistoric, Graeco-Egyptian, Pompeian, Byzantine, Gothic, Uccello, Ingres, Cézanne, Picasso, and Mondrian.[38]

Gorky had met Stuart Davis in 1929, probably through Graham, and the three became known affectionately within the art world as "The Three Musketeers." The relationship between Gorky and Davis was based to a large extent on their shared enthusiasm for modern art, particularly Cubism. Davis was ten years older than Gorky and, by comparison, was a seasoned veteran of modern art, who had developed his Cubist style in response to the 1913 Armory Show. Unlike other American modernists of his generation, however, Davis did not renounce or compromise his avant-garde style in the 1920s, but continued to paint Cubist urban street scenes and geometric abstractions. It may have been Davis's unswerving devotion to modernism during the

30. *Abstraction with Palette*, c. 1930
Oil on canvas, 46 x 36 in.
The Philadelphia Museum of Art; Gift of
Bernard Davis

37

reactionary 1920s and 1930s that earned Gorky's admiration and friendship. The bond between them represents one of the few links between the first and second waves of modernism in this country.

Davis's Eggbeater series, begun in 1927, was apparently of special interest to Gorky, representing for him the climactic phase of Davis's art up to that point. For the series, which Gorky cited in his article, Davis had repeatedly painted the unlikely still life of an eggbeater, an electric fan, and a rubber glove. The progressive transformation of these mundane objects into Cubist planes makes the Eggbeater paintings among Davis's most radically abstract works. Gorky praised these "symbols of tangible spaces" for their clarity of definition and lauded the artist's preservation of the picture plane: "One he is, and one of but few, who realizes his canvas as a rectangular shape with two dimensional surface plane. Therefore he forbids himself to poke bumps and holes upon that potential surface."[39] Such works by Davis may have provided Gorky with an immediate theoretical and visual source for some of his own Cubist abstractions of the 1930s, since Gorky's "plastic symbols," as he would later call them, are similarly indebted to Cubism and are, like Davis's Eggbeaters, virtually nonobjective. Neither Picasso nor Braque had ventured this far in the direction of pure visual abstraction, which underlines the innovative nature of Davis's and Gorky's painting.

The termination of Gorky's friendship with Davis in 1934 was caused by political rather than aesthetic differences. The problem was not a disagreement over ideology, since both were oriented to the Left, but a conflict over how much an artist's political activity should impinge upon his commitment to art. For Gorky, there was no question that art was his life and had priority over virtually all else. Although he often attended meetings of artists' political organizations, participated in marches for artists' causes, and followed with great concern such international political events as the Spanish Civil War, he always felt that his primary responsibility was to his painting. Davis, on the other hand, was so politically active—he eventually became secretary of the Artists Union and was responsible for publishing *Art Front*, the union's newspaper—that for months at a time his own work would be pushed aside. Gorky's refusal to participate as an active leader or even as a reliable member of such organizations drew Davis's angry comment that all Gorky wanted to do was play.[40] For Gorky, of course, art was not play, but a very serious attempt to reveal hidden truths. It is "the product of a sensitive artist who is expressing his universal feelings for no reason other than the very human desire to communicate his deepest thoughts to his fellow man."[41]

Gorky was highly principled, especially in matters of art, and he refused to compromise or lie for the sake of friendship. The friends he remained close to over the years accepted Gorky's seriousness, respected his knowledge, and either endorsed his self-confidence, which sometimes was confused with arrogance, or simply overlooked it. De Kooning, for example, resolutely accepted Gorky's superiority as an artist from whom he admittedly

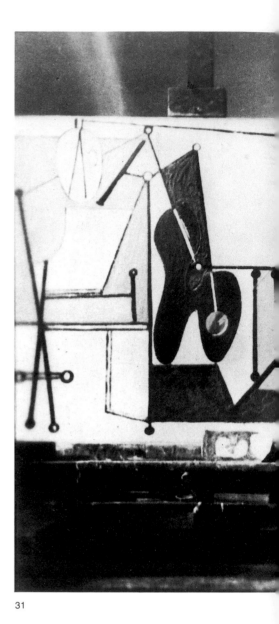

31

31. Arshile Gorky and Willem de Kooning with *Organization*, c. 1934

38

learned a great deal, despite Gorky's often reserved comments on de Kooning's paintings. "Gorky used to say, 'very original,'... but the way he said it didn't sound so good."[42] Gorky also took the liberty of correcting his friend Raphael Soyer's realistic figures, removing details that disrupted composition or destroyed shape.[43] The two sculptors Raoul Hague, who met Gorky in 1927, and Isamu Noguchi remained lifelong friends with Gorky, but they, too, acknowledged that Gorky was always the teacher, who loved to lecture to his friends and students. Other enduring friendships were forged between Gorky and Reuben Nakian, Balcomb Greene, David Smith, and John Ferren. Interestingly enough, with the exception of de Kooning, Gorky never became close to any of the Abstract Expressionist painters.

The Depression proved to be a major factor in determining the course of American art. The demand for a realist style that had reemerged in the 1920s was intensified after the stock market crash of 1929. Artists and the populace rejected the complexities of the world that had brought on this disaster and sought not only to correct society's ills but to return to the simpler values of rural America. Modern art styles, which were generally associated with urban centers and with European culture, were consciously rejected by most American artists. Social Realism, which critically depicted the social and economic problems plaguing the country, prevailed along with the more positive patriotism of the American Scene painters, who depicted melancholic views of small-town America.

In retrospect, both the American Scene painters and the Social Realists have been overshadowed by the Regionalists, who were led by the Missouri-born painter Thomas Hart Benton, with Thomas Craven serving as their literary mouthpiece. The Regionalists scathingly denounced all modern painting as decadent and lacking in significant subject matter; it had reduced art, they argued, to a manneristic mastery of technique. Moreover, they maintained that, because it originated in Europe, modernism could have little relevance to American life. As an alternative, the Regionalists offered uniquely native themes, focusing on the West and Midwest. In particular, they celebrated the old-fashioned pioneer virtues of innocence, hard work, and religious faith.

Gorky's response to such realism was hardly surprising: he thought it was dull, offering little more than a prosaic portrayal of reality, in contrast to what he considered true art, which "must mirror the intellect and the emotion."[44] Such a reportorial style was outdated, he felt, because it could not, and should not, compete with photography. Moreover, he believed that anyone could be trained to paint realistically, while only a true artistic genius could create an imaginary, abstract image.

Abstraction with Palette (c. 1930) exemplifies Gorky's paintings 30 from the early 1930s that are indebted to Cubism. It consists of broad, abstracted planes of color arranged ambiguously to suggest that the subject may be either a still life or a seated figure. Gorky played curved shapes against angular ones, many of them garnished with decorative patterning and textural brushwork. The large curvilinear form at the center, a recurring motif in Gorky's

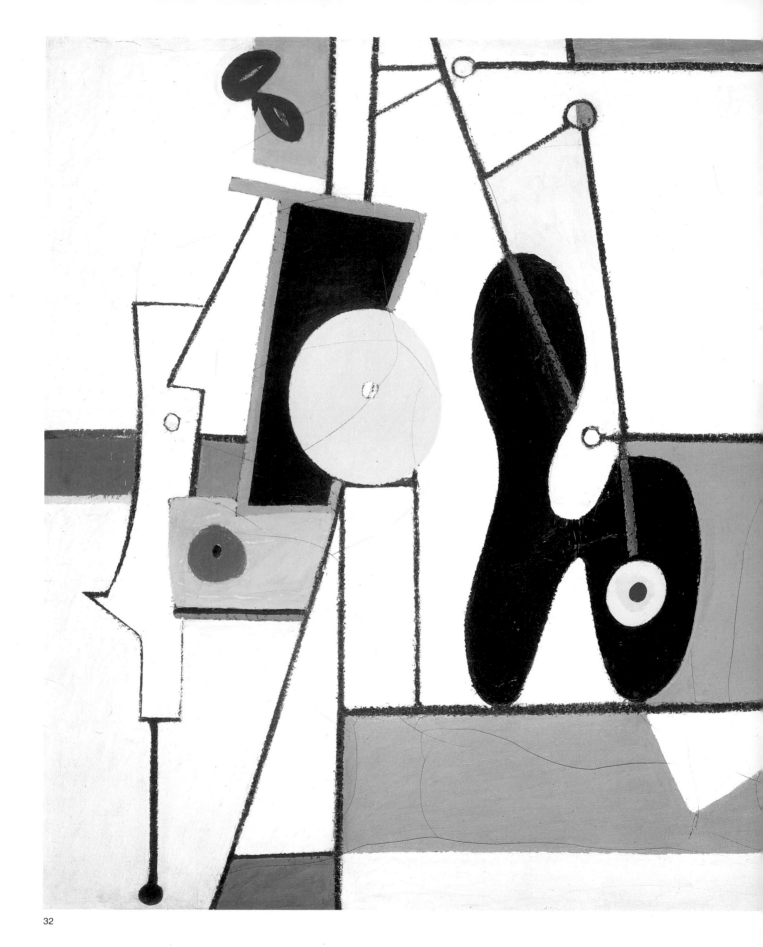

32

32. *Organization*, 1933–36
Oil on canvas, 50¼ x 60 in.
National Gallery of Art, Washington, D.C.;
Ailsa Mellon Bruce Fund, 1979

paintings of the period, may represent a palette and thus serve as a symbol of the artist; or it may be interpreted as a nonspecific biomorphic shape, i.e., a shape whose curvilinear and swelling appearance suggests a living organism. The rounded forms near the top of the painting, which approximate the configuration of a head, again imply the presence of a human being, while the angular forms near the bottom may indicate the legs of an easel, a table, a chair, or some other piece of furniture. The lack of a clearcut and consistent identification of the subject matter makes it nearly impossible to read shapes as either animate or inanimate, natural or manmade. For Gorky, these were universal shapes that characterized both worlds, evidencing the continuity between the two. It was a short step from the ambiguities in this canvas to Gorky's mature works of the 1940s, in which landscape and still life, exterior and interior are inextricably fused.

Picasso's Synthetic Cubist paintings of the late 1920s are frequently more curvilinear in form and organic in subject matter than his earlier abstractions had been, and it has been said that his *Seated Woman* of 1926–27 was the ultimate source for Gorky's *Abstraction with Palette*.[45] In such works Picasso himself had fallen under the influence of another avant-garde movement—Surrealism. Gorky's art of the early 1930s seems to have taken a similar turn, which may have been guided by Picasso's example or possibly by Surrealism itself, since he is known to have discussed the movement with his students at the Grand Central School of Art during the late 1920s.

Based on the belief in the superior reality of the unconscious, the irrational, and the fantastic, Surrealism challenged man's traditional faith in consciousness and reason as the source of all reality. Growing out of the Dada movement, Surrealism was launched officially in 1924 when its self-appointed leader, André Breton, published a manifesto for the group. The Surrealist celebration of the irrational ran counter to the American passion for the practical, and the movement was slow to catch on here. Illustrated articles

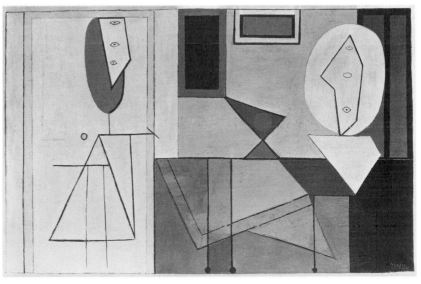

33. Pablo Picasso
The Studio, 1927–28
Oil on canvas, 59 x 91 in.
The Museum of Modern Art, New York;
Gift of Walter P. Chrysler, Jr.

33

34

35

on the movement appeared in European avant-garde periodicals of the 1920s that were available in the United States, and a few Surrealist paintings found their way into public exhibitions such as the 1926 *International Exhibition of Modern Art* noted earlier. In 1928 and thereafter, works by Joan Miró, André Masson, Salvador Dali, and numerous other Surrealists were shown at the Valentine Gallery and the galleries run by Pierre Matisse and Julien Levy. Several other examples of Surrealism, as well as Cubism and Expressionism, could be seen at Gallatin's Gallery of Living Art.

As the 1930s progressed, opportunities to learn about Surrealism increased, while Cubism and abstract art also became more familiar and more acceptable to the American art community. A major force in bringing about this renewed awareness of modernism was the founding of the Museum of Modern Art in 1929, an institution that gave modernism a stamp of authenticity and legitimacy previously lacking in America. The museum's profound contribution to the education of an entire generation of artists is exemplified by the two large-scale exhibitions it mounted in 1936: *Cubism and Abstract Art* and *Fantastic Art, Dada, Surrealism*. Accompanied by elaborately illustrated catalogs, these important shows, which included the work of every major European artist associated with Cubism or Surrealism, proved to be both informa-

tive and controversial. There can be little doubt that Gorky would have gone to see them.

The development of Gorky's painting during the 1930s was much more complex than it had been earlier. Few works of the period are blatantly reworkings of a specific prototype, but many are more generally based on the style of another artist or movement. Cubism, for example, was now being combined with Surrealism within a single canvas. Sometimes the fusion was successful, as in *Abstraction with Palette*; sometimes the mix was uncomfortably out of balance, with one or the other element gaining supremacy.

Of Gorky's canvases based primarily on Cubism, probably the most important and successful is the large *Organization* of 1933–36, which underwent prolonged and varied revisions. As a result, the canvas is covered with several layers of thickly applied pigment, which is typical of Gorky's abstract paintings of the 1930s. The picture is organized into a system of interlocking rectangular and curvilinear shapes and compartments that lie flat on the surface, with no suggestion of three-dimensionality. This visual flatness is reinforced by the white ground and rough-hewn black lines that enclose forms or function independently as a sort of scaffolding that ties the composition together. Piet Mondrian had utilized a similar gridlike structure in his paintings of the 1920s, but Mondrian's forms, unlike those in *Organization*, were explicitly geometric. Later in the 1920s Picasso had also employed a Synthetic Cubist armature in his studio series, which furnishes a closer stylistic source for Gorky's work. Specifically, *Organization* shares with Picasso's *The Studio* of 1927–28 (acquired by the Museum of Modern Art in 1935) some immediately recognizable features: the treatment of space, the choice of color, and the use of angular and curved shapes. On closer examination, it becomes just as apparent that Gorky, although relying on Picasso's prototype, has taken great liberties in introducing new elements into his composition, as well as transforming and rearranging the ones that he had borrowed.

Despite its abstract nature, Picasso's painting quite clearly portrays the artist in his studio. The personage at left is undoubtedly the artist. At right stands a table topped by a sculptural bust and a compote containing a piece of fruit; framed pictures hang on the walls. Gorky's *Organization*, though clearly related to *The Studio*, cannot be deciphered so easily. The white forms outlined in black at the left may indeed suggest a standing figure or perhaps a human profile, but they are difficult to interpret with any certitude. The large organic shape that dominates the center of the canvas is equally ambiguous. Is it an abstracted compote or sculpture, as in *The Studio*? Or could it be some human or animal form? The viewer's uncertainty, reinforced by the absence of a descriptive title, reveals again the artist's penchant for shapes that are decisively neither one thing nor another.

A second work from this informal series is Gorky's large-scale *Composition with Head* (c. 1936–37). Stylistically, it shares a number of characteristics with *Organization*, including the combination of geometric and quasi-organic forms. An important dif-

34. *Composition (The Raven)*, 1931
Pen and ink and oil on wood, 14⅛ x 9¾ in.
Hirshhorn Museum and Sculpture Garden,
Smithsonian Institution, Washington, D.C.

35. *Abstract Composition*, c. 1931
Pen and ink on paper, 8⅜ x 11¾ in.
Mr. and Mrs. Jacob Kainen

32

33

36

43

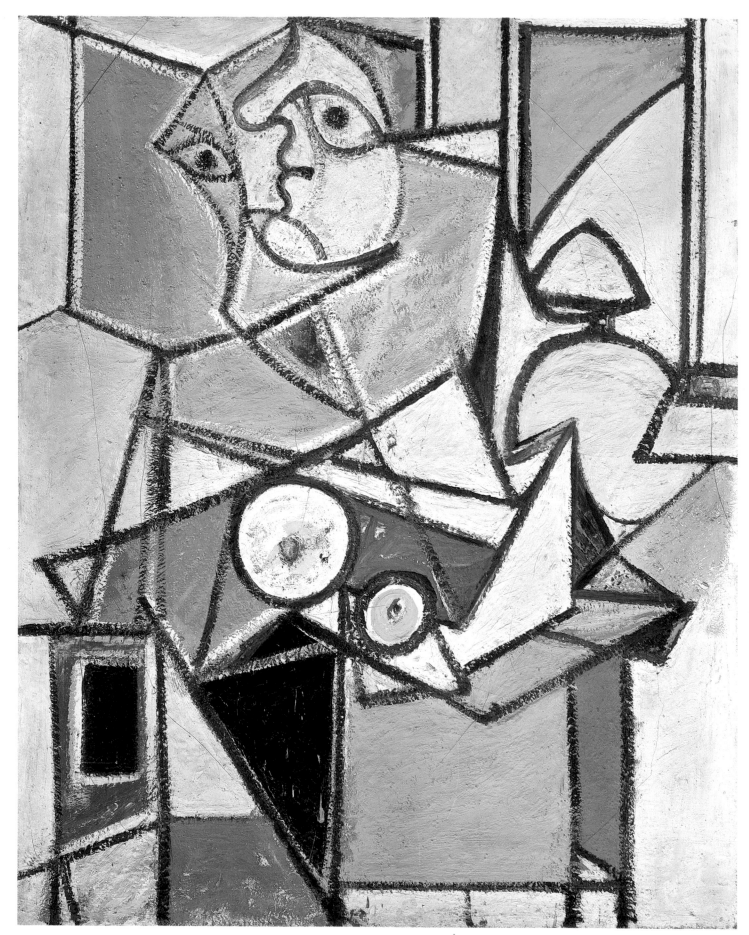

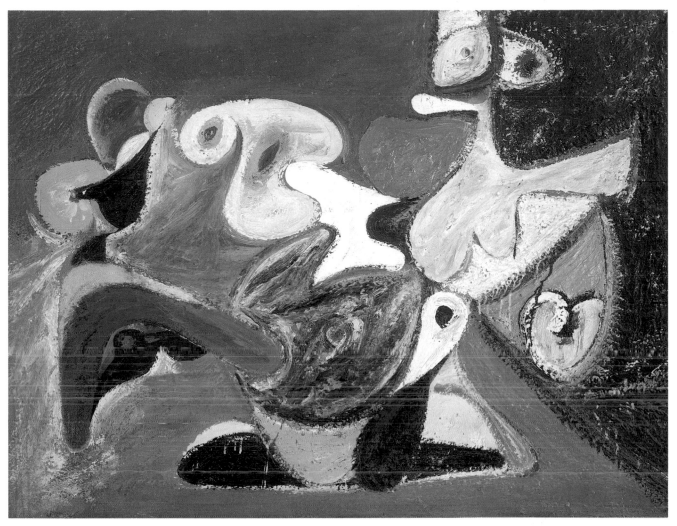

37

ference, however, is that the profile head at the top of this work is easily recognizable. The two circle-within-a-circle motifs below it are less obvious, but because of their relationship to the head, they can be read as breasts, which suggests this form as that of a woman. In some other context, however, these same circles might be interpreted as another part of the human anatomy, as pieces of fruit, or as any number of other animate or inanimate objects.

Organization, Composition with Head, Enigmatic Combat (c. 1936–37), *Image in Khorkom* (c. 1934–36), and similar works by Gorky reflect the widespread increase of interest in formal abstraction that was evident in the work of many artists at about mid-decade. Not only did the *Cubism and Abstract Art* exhibition take place in 1936, but also a number of painters banded together that year to establish the American Abstract Artists group (the "AAA"). They championed an abstract geometric style that betrayed the lingering influences of Mondrian, the French Purists, the Russian Constructivists, and the German Bauhaus masters; ultimately its origins could be found in Synthetic Cubism. The members of the American Abstract Artists met on a regular basis, published catalogs expressing their ideas on aesthetics, and held

36. *Composition with Head,* c. 1936–37
Oil on canvas, 78 x 62 in.
Private collection

37. *Image in Khorkom,* c. 1934–36
Oil on canvas, 33 x 43 in.
Private collection

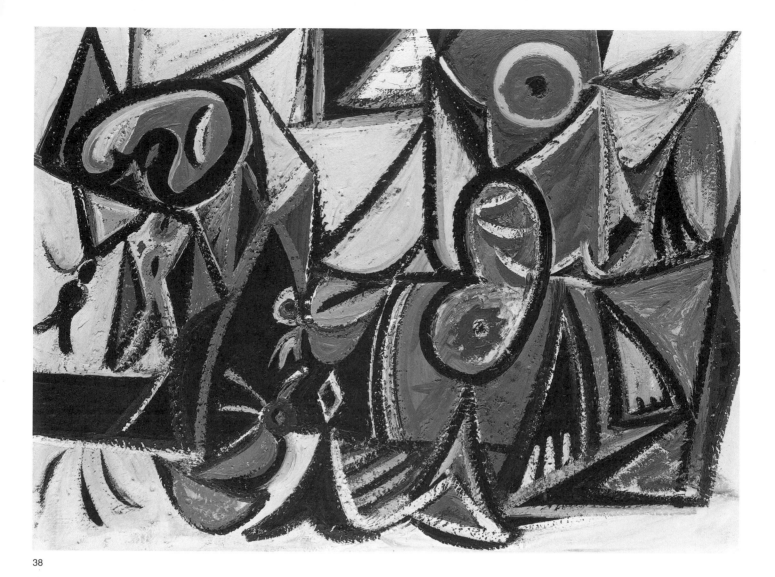

annual exhibitions. Their primary goal was no less than the transformation of New York City into an international center for abstract painting. In retrospect that seems rather naively idealistic, but it does demonstrate a newly ambitious spirit emerging among the American modernists. Gorky and de Kooning attended many of the meetings and discussions of the AAA, but neither became a member. Although Gorky shared an interest in Cubism with the AAA artists, he had a far more sophisticated understanding of the concepts of abstraction and, under the influence of Surrealism, had already begun to break out of its rigid geometric structure.

The Cubist compositions that Gorky created in the 1930s can be thought of as an informal series exploring various possibilities of that style. Often, however, he intentionally created series of paintings that were unified thematically, compositionally, and stylistically in order to elaborate on an already completed picture. In 1942 Gorky stated his purpose:

If one painting . . . is a window from which I see one infinity, I desire to return to that same window to see other infinities. And to build other windows looking out of known space into limitless regions. Continuously imposing new ideas or changes on one canvas mars the window by fogging it. In elaborating upon the completion of one window or canvas.

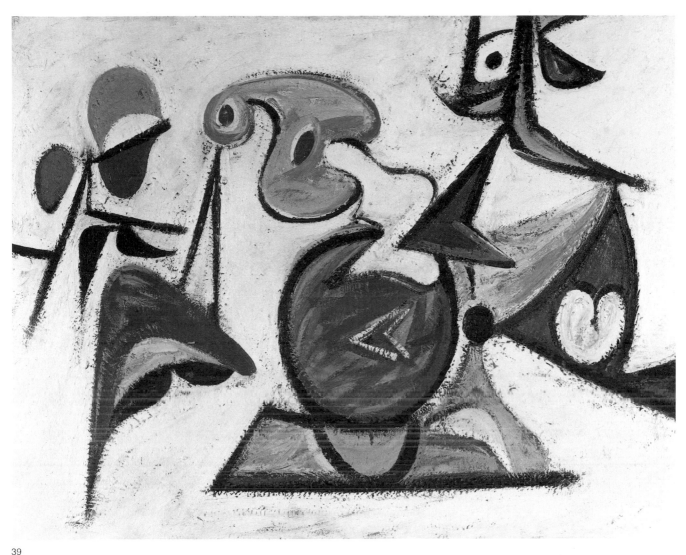

39

38. *Enigmatic Combat*, 1936–37
Oil on canvas, 35¾ x 48 in.
San Francisco Museum of Modern Art;
Gift of Jeanne Reynal

39. *Khorkom*, c. 1938
Oil on canvas, 40 x 52 in.
Private collection

By that I mean one finite. In doing that I attempt to extract additional unknowns. I place air in my works. They are my windows viewing infinity. [46]

Gorky's most elaborate series of the decade is titled Nighttime, Enigma, Nostalgia, which he worked on from about 1930 to 1934. The works in the series vary in media—most are pen and ink on paper, but others are in pencil or in oil on canvas. The fact that Gorky created no fewer than thirteen versions of Nighttime, Enigma, Nostalgia—not to mention numerous mural studies that incorporate the picture—within such a concentrated period indicates that the series must have held special significance for him. Only *The Artist and His Mother*, which continued to preoccupy him throughout the 1930s, received a comparable amount of the painter's time and concern.

The pictures in this series are all horizontal, on average measuring 22 by 28 in. The only exception is the one painting done in oil on canvas, where the proportions are more typical of Gorky's larger canvases of the 1930s (36 by 48 in.). Each of the panels is clearly based on the same composition and imagery. A diagonal line originating at the lower right recedes perspectively to intersect a horizontal line, thus suggesting a tabletop on which

40-42

47

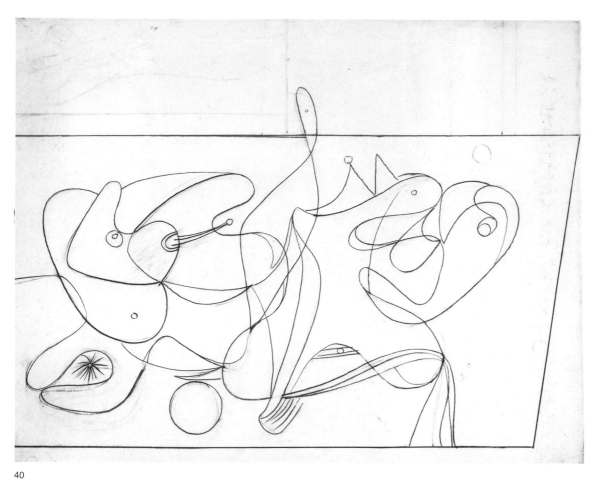

40

41

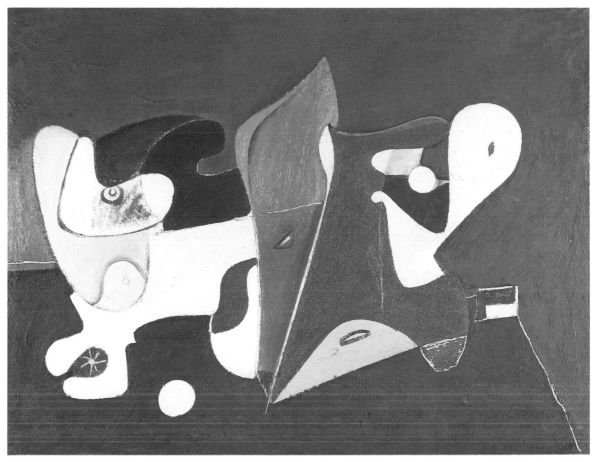

42

40. *Study for "Nighttime, Enigma, and Nostalgia,"* c. 1931–32
Pencil on paper, 22¼ x 28¾ in.
The Museum of Modern Art, New York; Gift of Richard S. Zeisler

41. *Nighttime, Enigma, and Nostalgia,* c. 1931–32
Ink on paper, 24 x 31 in.
Whitney Museum of American Art, New York; 50th Anniversary Gift of Mr. and Mrs. Edwin A. Bergman

42. *Nighttime, Enigma, and Nostalgia,* 1933–34
Oil on canvas, 36 x 48 in.
Private collection

several abstract forms are placed. At the lower left a pincerlike form surrounds a tiny circle with radiating lines. To the right is a rounded shape that calls to mind an isolated apple or orange, like those found so often in Cézanne's still lifes. Above these motifs are curved forms that suggest a breast or head. A lyrical vertical shape separates this portion of the work from the right-hand side, which is similarly composed of ambiguous shapes: an organic form in the shape of the letter E capped with twin pyramids, and a large bulbous motif containing an "eye." From drawing to drawing, Gorky changed the presentation of these images by denying contours and thereby uniting forms, introducing new divisions, varying degrees of shadows, or reversing areas of dark and light.

The organic imagery in Gorky's Nighttime, Enigma, Nostalgia is reminiscent of Surrealism, in which similar pincerlike forms, heads, eyes, breasts, pieces of fruit, and other organically suggestive shapes recur. The fluidity of line and the curvilinear shapes suggest various influences, including the works of Miró, Picasso, Max Ernst, and Henry Moore. The structural grid and the pronounced two-dimensionality of Synthetic Cubism have been replaced by more freely moving forms that are more illusionistically modeled through shading and hatching. The relationship between forms, and between forms and the spaces they occupy, is difficult to determine and results in a shifting, unstable spatial system.

The title *Nighttime, Enigma, Nostalgia* is itself difficult to interpret, since the words do not describe any specific object or event. Evoking mystery, reverie, and longing, the abstract words

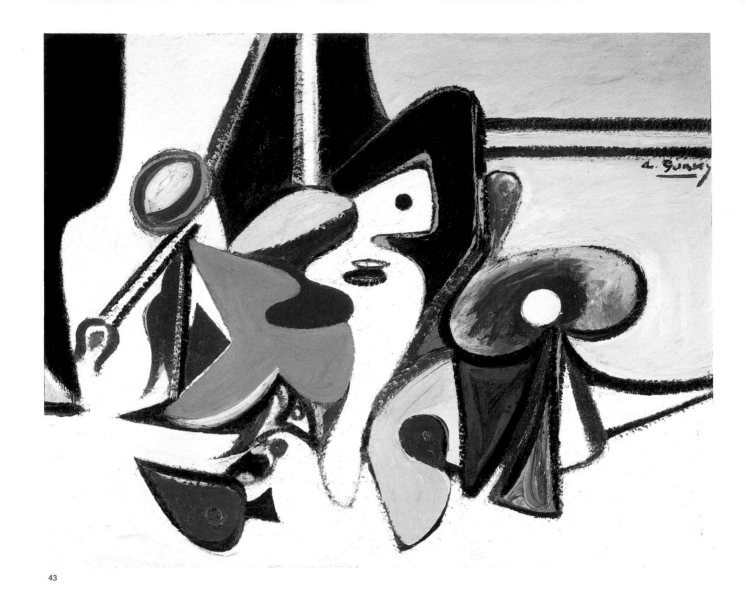

43

44

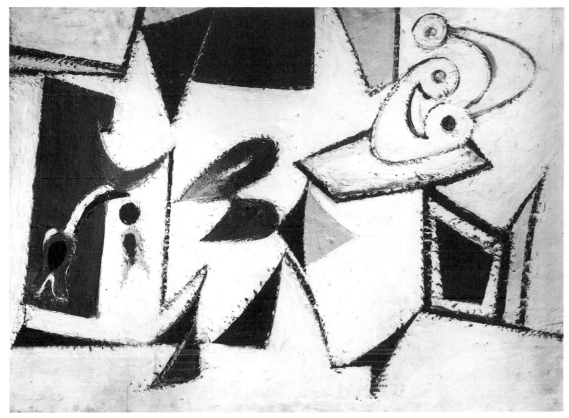

45

of the title complement the elusive imagery of the pictures. This choice of an intentionally ambiguous title indicates an important fact: Gorky was now identifying more closely than ever before with the Surrealist movement. Many writers have observed that the word *enigma* frequently occurs in titles of paintings by Giorgio de Chirico, a precursor of Surrealism. Moreover, the basic compositional layout of Nighttime, Enigma, Nostalgia is indebted to de Chirico's *The Fatal Temple* (1913), in which the word *enigma* actually appears. The word *nostalgia* often shows up in de Chirico's titles as well, such as *The Nostalgia of the Infinite* (1913–14). John Graham, who had long been a proponent of Surrealism, was also fond of the word *enigma* and had once described Picasso's art as "nostalgic and enigmatic."[47]

The composition of Gorky's *Painting* (1936–37) is related to 43 the Nighttime, Enigma, Nostalgia group and may have evolved from it. Here the same vaguely suggestive biomorphic or inorganic forms appear, though in this case they are more structured in their relationships to each other and to their surrounding space. This work had a special importance for Gorky's career, because it was his first painting to enter a major museum collection. The Whitney Museum of American Art in New York purchased *Painting* after it had been exhibited in the museum's *Annual Exhibition of Contemporary American Painting*. Throughout the 1930s Gorky was included in a growing number of group exhibitions in American galleries and museums, both in New York and elsewhere. He also had a couple of one-man shows in Philadelphia,

43. *Painting*, 1936–37
Oil on canvas, 38 x 48 in.
Whitney Museum of American Art,
New York; Purchase

44. *Battle at Sunset with the God of the Maize (Composition No.1)*, 1936
Oil on canvas on board, 8 x 10¼ in.
Hirshhorn Museum and Sculpture Garden,
Smithsonian Institution, Washington, D.C.

45. *Composition*, 1937–38
Oil on canvas, 29 x 40 in.
Sidney Janis Gallery, New York

first at the Mellon Galleries in February of 1934 and then at the Boyer Galleries in the fall of 1935. The New York branch of the Boyer Galleries subsequently gave him an exhibition in 1938.

In spite of this increasing recognition, Gorky's economic situation, like that of most American artists during the Depression, was not good. Painters and sculptors in this country had historically had a hard time earning a decent living, and the Depression made the situation worse. In the early 1930s Gorky had difficulty paying for the enormous quantities of oil paints, canvases, stretchers, and other supplies that he normally kept on hand, though he still insisted on buying quality materials. At times, his expenditures on art supplies left him very little money for food, and he lived from day to day on doughnuts and coffee. His commitment to art undiminished, he insisted on supporting himself by his art: in addition to the money he received from a few sales of his paintings and drawings, he gave private art lessons to a few students to supplement his income. Nonetheless, his economic situation was marginal, and, with the threat of hunger and poverty looming over him in America, the memories of his starving mother and of his own hardships in Armenia must have been very much on his mind.

To alleviate his financial problems, Gorky joined the Public Works of Art Project in 1933. One of the Roosevelt administration's relief measures, this program was designed and implemented to benefit the thousands of unemployed artists in the

46

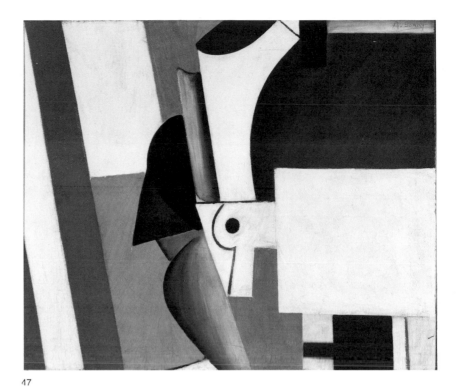

47

country; it was the first time that American artists had been
granted governmental recognition as worthy citizens contributing
to society. Though Gorky was not an American citizen, he began
the naturalization process during this period and was finally
granted citizenship on May 20, 1939. The PWAP enabled Gorky to
live and paint with fewer economic worries, though the pay was
meager. On the average, he earned only about $37 a week, in re-
turn for which he designed a mural, which was never executed be-
cause the program was terminated in June 1934.[48] Regarding
the mural design, which was abstract, Gorky said: "My intention
is to create objectivity of the articles which I have detached from
their habitual surroundings to be able to give them the highest re-
alism."[49] Such an approach, which again corresponds to certain
Surrealist precepts, was to surface again in his next mural project.

Gorky's enthusiasm for creating an abstract mural was no
doubt partly responsible for his placement in the Mural Division
of the Works Progress Administration/Federal Art Project in 1935.
Established in August of that year, the WPA revived the govern-
ment's concern for artists in need of economic relief. Gorky's mu- 48, 50
ral, designed under the WPA/FAP, was originally destined for
Floyd Bennett Field in New York, but was later installed in the
Newark Airport Administration Building in New Jersey. Studies
for the murals, on the subject of air travel, reveal several succes-
sive transformations, at one point incorporating photographs of
airplanes by Wyatt Davis, Stuart's brother. The final product,
however, was composed of ten large-scale oil-on-canvas panels
that were mounted on the walls of the building. Collectively enti-
tled *Aviation*, the panels were completed and installed in 1937, but
soon disappeared when the building was appropriated for military

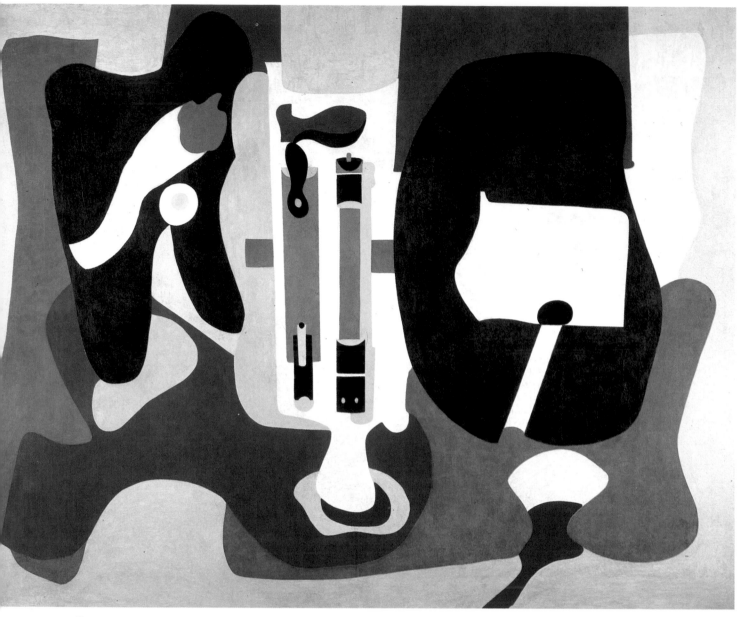

48

operations during World War II. It was not until 1972 that an art historian's search for the murals led to salvaging two of the ten panels from underneath numerous layers of paint. [50]

The objects in Gorky's Newark Airport murals, including technical and mechanical airport equipment and flight maps, all relate to the theme of air travel. Gorky reduced the structures of these objects to a system of planar relationships, which became "plastic symbols" or pictorial equivalents for the real objects. He wrote about two of the panels: "In 'Mechanics of Flying' I have used morphic shapes. The objects portrayed, a thermometer, hygrometer, anemometer, an airline map of the United States, all have definitely important usage in aviation, and to emphasize this I have given them importance by detaching them from their environment." [51]

In the last sentence, Gorky reiterated the concept he had first

48. *Mechanics of Flying,* from *Aviation: Evolution of Forms under Aerodynamic Limitations,* 1935–37
Oil on canvas, 108 x 134 in.
The Port Authority of New York and New Jersey, The Newark International Airport Collection, on extended loan to the Newark Museum

49. *Conquest of the Air,* New York World's Fair Mural, Aviation Building, 1938–39.
Presumed destroyed. This mural is known only from a postcard in the file of the New York Public Library.

50. *Aerial Map,* from *Aviation: Evolution of Forms under Aerodynamic Limitations,* 1935–37
Oil on canvas, 77 x 120 in.
The Port Authority of New York and New Jersey, The Newark International Airport Collection, on extended loan to the Newark Museum

49

stated in his PWAP proposal. By removing the objects from their surroundings and depriving them of their normal context, the painter increased their clarity and emphasized their importance. This recalls the Surrealists' practice of isolating objects, stripping objects of their normal function, or juxtaposing startlingly dissimilar objects in order to evoke a sensation of the miraculous and the unreal. The biomorphic shapes that appear in Gorky's murals suggest that he had been looking at the art of Miró or Jean Arp, where similar forms abound. These shapes, smoothly painted in bright colors, are crisply defined by precise edges, and the resultant mechanistic purity of the forms is in keeping with an airport environment. Their formal purity also betrays the influence of another French artist, Fernand Léger, whose Cubistic, machine-inspired art Gorky greatly admired. The studies for other sections of the mural also show typically mechanistic forms treated in a precise style.

The Newark murals stirred much criticism and controversy because of their abstract nature. Indeed, Gorky was one of only a small number of painters working in a modernist style while on the WPA. Others who dared to flaunt modernism before the public were Stuart Davis and Gorky's immediate supervisor on the Mural Project, Burgoyne Diller.

50

56

52

Gorky's WPA murals were not his last, for he received two subsequent commissions for murals: one in 1938 for the New York World's Fair, and another, completed in 1941, for Ben Marden's Riviera restaurant, in Fort Lee, New Jersey. Neither has survived, but both are known either from photographs or studies. They show Gorky's relaxation of the rigid structure characteristic of much of his works of the 1930s, replaced by a more freely organized space in which forms seem to float, as the artist began to change his painting style. This tendency, especially apparent in the Riviera murals, was to lead to the paintings in Gorky's mature style of the 1940s. [49]

Gorky's belief that all great art is premised upon tradition encompassed not only the modern masters, but the old masters as well. His fascination with great artists of all periods added still another dimension to the already complex interplay of sources and influences in Gorky's work of this period. We have already seen that he traced the roots of Cubism back to ancient and medieval art, but it was perhaps in his figurative works, particularly his drawings of the 1930s, that his own continuation of the old master tradition was most clear. Gorky had always considered good draftsmanship essential, noting that drawing "is the basis of art. A bad painter cannot draw. But one who draws well can always paint. . . . Drawing gives the artist the ability to control his line and hand. It develops in him the precision of line and touch. This is the path toward masterwork." [52] As if to prove to himself his powers of draftsmanship, Gorky occasionally did drawings or sketches after the old masters. Such is the case with his drawings after works by the nineteenth-century French artist Jean-François Millet and by Millet's countryman of the seventeenth century, Louis Le Nain. With his exacting line and eye for detail, his delicate shading, and the overall expressive force of his figures, Gorky rivaled the skill of his artistic ancestors. [52]

Two drawings related to *The Artist and His Mother*, while not based on specific prototypes, exhibit old master characteristics and place Gorky firmly within that tradition. One, a superb pencil drawing of 1934, was probably the last one executed before the completion of the Whitney's canvas, as suggested by the compositional similarities and by the superimposition of a grid on the drawing, which would have facilitated the transfer of the composition to the painting. The other, of 1938, is a detailed drawing of Lady Shushanik's head, probably based on the completed Whitney painting. Of this charcoal portrait, Gorky wrote: "And I have drawn a most priceless picture of Mother in charcoal. It required considerable time and is extremely successful." [53] Indeed, this is a powerfully expressive drawing, as is the earlier sketch of Gorky and his mother. The artist executed both drawings with meticulous draftsmanship, infusing them with the mood of melancholy that characterizes the series as a whole. Particularly interesting in the 1938 drawing is the way Gorky has emphasized certain "abstract" areas, most notably the scarf wrapped around his mother's head and the space around her left ear. In isolation, these forms recall the biomorphic shapes of his abstract paintings of the 1930s. [29] [51]

51. *The Artist's Mother,* 1938
Charcoal on paper, 24 x 18 in.
The Art Institute of Chicago; The
Worcester Sketch Fund Income

52. *Drawing after Millet,* mid-1930s
Pencil on paper, 9 x 6½ in.
Brenda S. Webster, Berkeley, California

Another drawing, Gorky's *Self-Portrait* of about 1936, is deceptively simple, as Gorky's economic line and decisive strokes of the pencil capture his own elegant pose. But here he has elongated and distorted forms in order to maintain compositional harmony. This process is also traditional, having descended from Raphael through his nineteenth-century admirer Jean Auguste Dominique Ingres, who was perhaps the most distinguished draftsman of his time. Gorky, who greatly admired Ingres and often praised his work for its aesthetic and psychological force, displayed in his studio reproductions of Ingres's works, including his *Self-Portrait at the Age of Twenty-Four* (1804), against which Gorky would gauge his own accomplishments.

The abstract forms often found in Gorky's portrait drawings can also be detected in his portrait paintings of the 1930s. Around

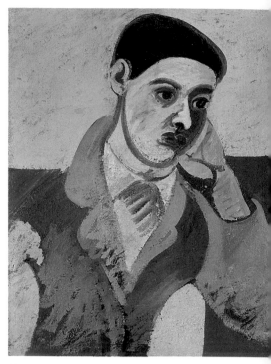

54

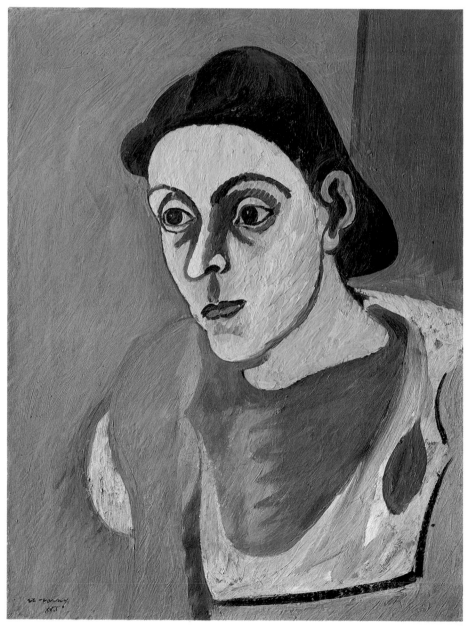

53. *Portrait of Vartoosh*, c. 1933–34
Oil on canvas, 20 x 15 in.
Hirshhorn Museum and Sculpture Garden,
Smithsonian Institution, Washington, D.C.

54. *Portrait of Jacob Kainen*, 1934–c. 1937
Oil on canvas, 22 x 18 in.
Private collection

55. *Self-Portrait*, 1937
Oil on canvas, 55 x 23⅞ in.
Private collection

53

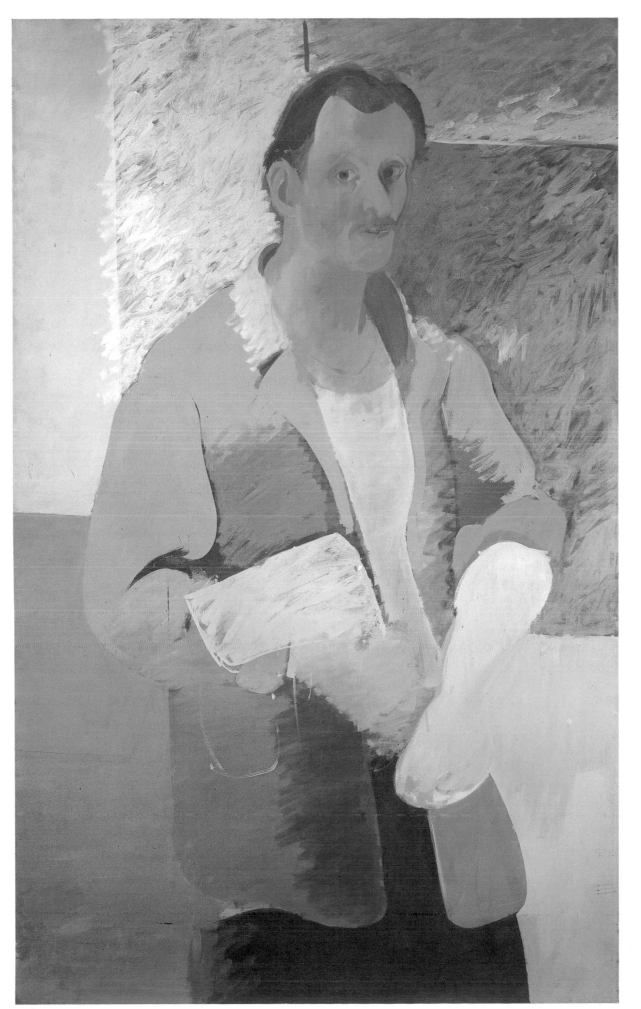

1934 he completed the *Portrait of Vartoosh*, which may have 53 been inspired by such works as Matisse's *Green Stripe* (*Madame Matisse*) of 1905 or by the type of female that Matisse later painted in such works as *Le Luxe II* (1907–8). Gorky's melancholic portrait is built up of broad, painterly areas of color that are organically shaped. In fact, the "leaf" form at the right in Vartoosh's dress, the shape of her neck, and the form of the upper portion of her dress recall similar motifs in *Image at Khorkom* and *Painting*.

As the end of the decade approached, Gorky, after more than fifteen years of painting, had assimilated a number of sources and influences, both traditional and modern, and had begun to combine them in a new and original way. True to his belief that a great artist must build on the past in order to proceed into the future, Gorky now seemed ready to transform his borrowings into his own unique style.

56. *Self-Portrait,* c. 1936
Pencil on paper, 9 x 6½ in.
Brenda S. Webster, Berkeley, California

57

4 Maturity

On February 28, 1938, Gorky wrote to Vartoosh and her family:

... Nowadays an extremely melancholy mood has seized me and I can concentrate on nothing except my work. Dearest ones, lately I have been well and am working excessively and am changing my painting style. Therefore, this constantly gives me extreme mental anguish. I am not satisfied and from now on I will never be satisfied a single day about my works. I desire to create deeper and purer work. [54]

Gorky's compulsion to find a style that embodied his melancholic mood is best seen between about 1938 and 1942 in a group of canvases he called Garden in Sochi. In this series of about six works he continued to use biomorphic motifs but presented them in a more poetic and fantastic manner, having broken loose from the constraints of a strict Cubist grid. Two climactic works from the series, one dating from 1940–41 and the other from 1941–44, are reproduced here. [58, 57]

The title *Garden in Sochi* refers in a roundabout way to Gorky's memories of his native country. In 1943 he explained that the correct title for the series should have been *Garden in Khorkom*, in reference to his birthplace, but he had opted instead for the more familiar Sochi, a Russian resort on the Black Sea. Expressing the same concern that had earlier motivated his change in name, he reiterated his belief that Americans were ignorant of Armenia and preferred names of more popularly known places. [55] To Gorky, however, the title of his series was not nearly as important as the fact that it had been inspired by his Armenian experience.

The garden of the title had been located near the Adoians' home in Khorkom, and Gorky spoke of it fondly: "About 194 feet away from our house on the road to the spring, my father had a little garden with a few apple trees which had retired from giving fruit. There was a ground constantly in shade where grew incalculable amounts of wild carrots, and porcupines had made their nests. There was a blue rock half buried in the black earth with a few patches of moss placed here and there like fallen clouds." [56] Local villagers considered the garden to be a source of magical powers, and the women would go there to ritualistically rub their

57. *Garden in Sochi*, 1941–44
Oil on canvas, 31 x 39 in.
The Museum of Modern Art, New York;
Acquired through the Lillie P. Bliss Bequest

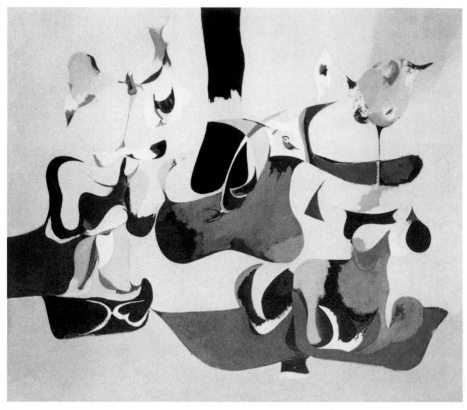

58

bared breasts against the half-buried rocks. Passers-by would tear strips from their colorful clothing and hang them on the denuded branches of the "holy tree" located there in hopes that their wishes might be fulfilled. [57]

Many of the elements named in Gorky's poetic description have been detected in his Garden in Sochi paintings. Using his statement as a guide, it is quite easy to see the form at the lower right in the canvases of this series as some type of playful animal; the winged shape at upper left as a bird; the black vertical at upper center as a tree trunk; the shape at left as a rock near a tree with strips of multicolored cloth fluttering from its branches. The central motif may be a boot or shoe, though this object does not appear in Gorky's description. Gorky has disguised and abstracted all these natural forms so that his brightly colored, fanciful motifs, taken in conjunction with the boundless space that surrounds them, capture the essence of a garden without depicting it literally.

While the Garden in Sochi pictures were evolving, Surrealism was gaining more widespread recognition in America, and it helped Gorky discover the new style he was seeking. The *Fantastic Art, Dada, Surrealism* exhibition at the Museum of Modern Art in 1936 had introduced the movement to New York on a large scale, and although it remained controversial, it could no longer be ignored or dismissed. As the 1930s drew to a close and the number of galleries sponsoring modern art increased, Surrealism became better known through exhibitions of works by Miró, Masson, Ernst, René Magritte, Yves Tanguy, and others.

58. *Garden in Sochi,* c. 1940–41
Oil on canvas, 25 x 29 in.
Private collection

59. Joan Miró
Dutch Interior, 1928
Oil on canvas, 36⅜ x 28⅞ in.
The Solomon R. Guggenheim Museum,
New York; Peggy Guggenheim Foundation,
Venice; Solomon R. Guggenheim Foundation,
New York

60. *Washing of the Feet and Communion of the Apostles,* 1397
Gospel, Van region, Armenian
manuscript illumination

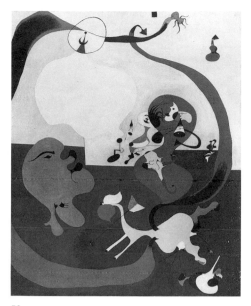

59

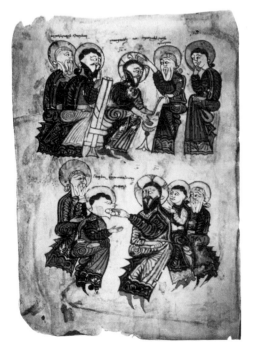

60

The greatest impetus for disseminating Surrealist art and ideas in America came from a political rather than a cultural force— World War II. Breton, Ernst, Masson, Tanguy, Gordon Onslow-Ford, Matta Echaurren, and Wolfgang Paalen all arrived in New York between 1939 and 1942, and they soon attracted publicity to the Surrealist cause. Their encounters with some of the younger American painters stimulated the latter to experiment with various avant-garde materials and techniques (especially ways of creating by circumventing the conscious control of the artist, i.e., automatism) that offered an alternative to Cubism and realism. Gorky became closest to Matta, whom he met in 1941, and to Breton, to whom he was introduced in the winter of 1944–45. It was Miró's pictures of the late 1920s, however, that served as the principal stylistic source for Gorky's Garden in Sochi paintings. In Miró's *Dutch Interior*, for example, fanciful shapes hover 59 above a soft yellow plane; the spatial relationships among the swelling biomorphic forms are not fixed, as they would be in a Cubist canvas, but are in constant, subtle fluctuation. Similar characteristics can be seen in Gorky's Sochi paintings. He had begun to move in this direction with works as early as *The Artist and His Mother, Battle at Sunset with the God of the Maize* (1936), and, to a lesser extent, with the mural *Man's Conquest of the Air*, which he made for the 1939 World's Fair in New York.

Gorky's tendency to synthesize several styles to achieve one that served his needs—so evident in his art since the late 1920s—makes it likely that other forces beyond Surrealism helped shape his evolving mature style. A clue to a second stylistic inspiration may be found in the central boot-shaped motif in *Garden in Sochi*, which has usually been interpreted as an Armenian slipper, as suggested above. Gorky spoke on several occasions about the "beautiful Armenian slippers" that he and his father had worn in Khorkom. The slipper motif, which is disproportionately large and centrally positioned in the Sochi paintings, initially may have been a sort of private symbol establishing the artist's youth in Armenia as the wellspring of this series. The motif may also have been inspired by the already abstracted boots, slippers, and shoes in old Armenian manuscript illuminations. A comparison between the Sochi slipper motif and the footwear of the apostles in a late fourteenth-century illumination from the Van region of Armenia, 60 for instance, reveals how strikingly similar they are in shape and style and also how closely both relate to the fanciful forms found in Miró and Surrealism. The Armenian illuminator used a thin, precise, flowing line that functions quite independently of color, with both used to define forms. Gorky, too, increasingly distinguished between the roles of line and color in his paintings of the early 1940s (see the 1941–44 version of *Garden in Sochi*), which was the time when he apparently borrowed the Armenian slipper motif. It was at this point that Gorky's Armenian cultural heritage, his personal experiences and memories of his native land, and the philosophy and styles of Surrealism were all fused in an art that was far more than simply the sum of those parts.

Since Gorky had been too young when he left Armenia to carry away any but the most generalized impressions of his native art, it

is probable that during the 1930s and 1940s he researched his homeland's contributions to art with the same thoroughness that he had applied to his studies of modern Western art when it, too, was little known in America. Around 1940, particularly, he must have supplemented his youthful impressions and vague melancholic longings with newly discovered, or rediscovered, specifics by searching for information in magazines, books, and museums. Gorky undoubtedly recognized the affinity between that cultural legacy and modern aesthetics. His efforts are made clear by his published correspondence: prior to this time his mention of Armenian art had been quite general, but after 1940 he spoke more knowledgeably about the Armenian cultural tradition, and by about 1944 and 1945 he was well enough informed to cite the importance of the School of Lake Van and the master illuminators Toros Roslin and Sarkis Pidzak. [58]

It should be remembered that Gorky had never relinquished a great many old world traits. In the New York art world he stood out as a flamboyant character who at social gatherings might spontaneously croon an Armenian folksong in a deep, sensitive voice. Just as likely, he might turn his jacket inside out, exposing its colorful lining to suggest the gay outfits of the Armenian peasants, before leaping into a rendition of their rhythmic dances. His heroic figure and elegant moves made a deep impression on those who knew him.

By the late 1930s Gorky's economic situation was improving as the country began to recover from the Depression and as he achieved some limited professional success, including the sale of 43 *Painting* to the Whitney Museum in 1937 and the commission for the 1939 World's Fair murals. But his finances were still shaky, and he sought other ways to earn money. In about September 1940 he approached Edmund Graecen, director of the Grand Central School of Art, and requested a class to teach. Graecen was receptive, but advised Gorky that it would be a couple months before he could accurately assess enrollment at the school, since the war was drawing away so many youths to serve in the armed forces. By late October there were enough students for Graecen to offer Gorky not one but two classes to instruct on the subject of art and camouflage. [59] Gorky accepted. The course description stressed the roles of form, line, and color in defining an object. That insight might be used in the war effort, it suggested, by conversely disguising an object beneath these formal elements so that it would blend with its environment and cloud the vision of the enemy. [60]

In 1941 several more of Gorky's canvases entered public collections as gifts from friends: the mosaicist Jeanne Reynal donated 38 *Enigmatic Combat* to the San Francisco Museum of Art; Bernard 110 Davis presented *Argula* (1938) to New York's Museum of Modern Art, which also accepted *Garden in Sochi* from Wolfgang Schwabacher. That same year, the Modern purchased *Objects* (1932) from the artist. It was also in 1941 that Jeanne Reynal was instrumental in arranging a small show of Gorky's works at the museum in San Francisco. To prepare for the exhibition, the artist, along with his friend Agnes Magruder, the sculptor Isamu Noguchi, Noguchi's sister, and two other passengers, drove across

61

61. *Mojave*, c. 1941
Oil on canvas, 28⅞ x 40⅝ in.
Los Angeles County Museum of Art;
Gift of Burt Kleiner

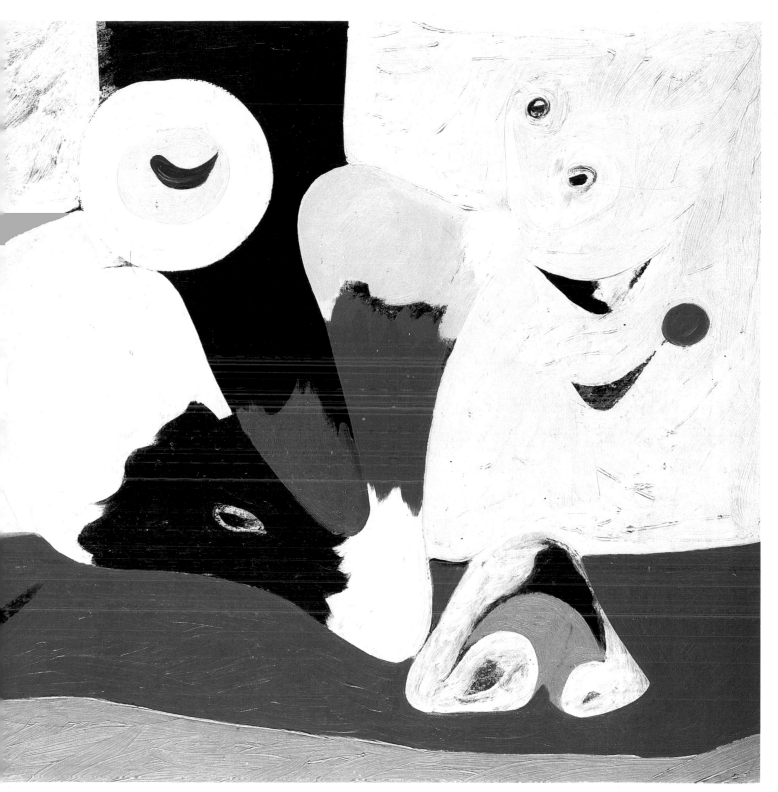

62

the country to California. This was the first time since he had moved there that Gorky had traveled extensively outside of New York City, and he was deeply stirred by the Western landscape. The climate of California reminded him of Armenia,[61] and he was especially struck by the great forests and mountains that he encountered on an excursion beyond San Francisco:

Approximately six hours distance from here is a place replete with enormous forests resting in a region of massive and beautiful mountain chains. And within the forests are large lakes and the brightest rivulets whose swiftly racing waters perpetually charge all over and around the rocks. And on the two sides of these rivulets gigantic poplars stand like warrior guards, their many branches being their heads. It is as though they push the firmament back so that someday the extremely blue sky will not suddenly collapse.[62]

Gorky's renewed contact with landscape and the subsequent reawakening of his feeling for nature were to play a major role in his art and life over the next few years.

61 It seems likely that Gorky's *Mojave*, named after the Southern California desert, was painted on this trip. The horizontal format of the work suggests the broad expanse of the desert terrain, which is countered and stabilized by the central vertical shape. The motifs, which are reminiscent of bones, rocks, or plants, recall the biomorphic images found in his Garden in Sochi series and are similarly built up of loosely brushed patches of pigment that flow one into another. Gorky's use of expressive blacks, yellows, and reds recalls Miró's art of the 1930s, and *Mojave* may, in fact, be based on one of Miró's principal paintings of the period, *Seated Woman* of 1932 (now in the Sidney Janis Collection).

Gorky and Agnes Magruder, whom he had known for only a few months, were married in Virginia City, Nevada, on September

62. *Bull in the Sun*, 1942
Gouache on paper, 18½ x 24¾ in.
The Museum of Modern Art, New York;
Gift of George B. Locke

63. *Mountain Landscape*, c. 1942
Sepia on paper, 10⅛ x 14 in.
Arthur Ross Foundation

13. After they returned from California, Gorky and his new wife settled into his studio at 36 Union Square, where he had lived since the early 1930s. The painter had been living alone for over fifteen years and had often complained about his unbearable solitude. Twice during the 1930s he had tried, unsuccessfully, to develop serious relationships: in 1936 a brief and unhappy marriage to Marny George, a young student of fashion art, had ended in divorce, and soon afterward he was pursuing, again without success, an artist named Michael West. Appropriately enough, given his assimilation of artistic sources, Gorky wooed her with romantic love letters fashioned on those that the English sculptor Henri Gaudier-Brzeska had written to his fiancée in the early 1900s.[63] Gorky's marriage to Agnes Magruder a few years later was therefore a much-desired change in his life. She was several years younger than Gorky and the product of a very different upbringing. The daughter of an admiral, she had spent much of her life in Boston, where she developed a sophisticated air and a wealth of self-confidence. She was full of vitality and courage that undoubtedly served as a stabilizing force for Gorky, who was equally forceful but constantly tormented with doubts and fear.

63

64

64. *The Pirate I*, 1942
Oil on canvas, 29 x 40⅛ in.
Mrs. Julien Levy, Bridgewater, Connecticut

A major change in Gorky's art occurred during the summer of 1942, stimulated mainly by a three-week vacation in New Milford, Connecticut, at the home of his friend the artist Saul Schary. The exposure to the countryside again seems to have prompted Gorky to draw and paint directly from nature, something he had not done regularly since moving to New York in 1925. This rediscovery of nature—coinciding with the improvements in his domestic and professional life—seems to have induced the spiritual and artistic renewal that had been imminent.

The following summer, Gorky, Agnes, and Maro, their three-month-old daughter, again retreated to the country, traveling to Hamilton, Virginia, where Agnes's parents had purchased an estate. The visit to Virginia seemed to have the same effect on Gorky as the Connecticut trip: he produced an increased number of works in a new style that was evidently stimulated by working directly out of doors. Gorky became especially fond of rural Virginia, observing that "The state of Virginia reminds one of Armenia's lowlands, particularly as we descended into the lower Ararat-Arax Valley, although it is considerably less majestic."[64] So productive was their visit that Gorky and his family returned there in the spring of 1944 for a nine-month stay. Then, after only two months in New York City, they spent another nine months at the sculptor David Hare's home in Roxbury, Connecticut. Nature was clearly a potent stimulant for Gorky, and he increasingly reminisced about the Armenian landscape in his letters of the period. "How I love the land, the soil. I long for our beloved homeland's environment and am constantly absorbed by the beauty of Khorkom and Van."[65]

One of Gorky's most beautiful representational drawings of the period is his *Mountain Landscape* (c. 1942), executed in sepia. 63 Here the mountains and foliage are depicted as bulging and writhing shapes. Line is nervous, fast moving, and nearly "automatic" as it defines the forms, which are given substance by varied amounts of hatching and crosshatching. While this composition is perfectly legible as a landscape, certain individual areas take on an abstract biomorphic character and seem to live an independent life. The work exemplifies the ongoing complexity of nature's relationship to abstraction in Gorky's works.

Among the artist's landscape-inspired oil paintings of the period are some of his most striking and best-known works. When Gorky was working at Saul Schary's home in 1942, he began *The* 64 *Pirate I*, which differs markedly in style from the Garden in Sochi paintings. Julien Levy, who was to become Gorky's dealer in 1945, stated that *The Pirate I* was based on natural forms, specifically a mongrel dog (which Gorky identified as "the pirate" that prowled through his backyard) as the central image and, at the upper left, a horse viewed from the rear.[66] However, Gorky carefully camouflaged both the dog and the horse to discourage any such literal reading, transforming them into abstract, phantomlike forms. Delicate washes of blue, lavender, and green hover over the images, which, in turn, are created from thin washes of color and tenuous lines. In several areas Gorky has allowed the paint to drip and run, a technique that helps create a sensation of openness and

71

65

66

freshness reminiscent of nature and natural growth. The result is unlike anything Gorky had done before.

The fluid style that characterizes *The Pirate I* and some other works that followed had been anticipated in the art of Matta, whom Gorky had met in 1941. The Chilean-born architect-turned-Surrealist encouraged Gorky to similarly dilute his paints to a watery consistency in order to heighten the sensation of airy improvisation. He also urged him to exploit the accidental drips and runs of the fluid pigment, either by leaving them in their unaltered state or by using them as a basis for further painterly elaboration.[67] Matta himself was still experimenting with such ideas to achieve a new spatiality, as in works such as *Inscape (Psychological Morphology No. 104)* of 1939. However, Matta's manifestation of space differs from Gorky's in that it suggests some primordial world in a molten state of evolutionary flux rather than a lyrical earthly landscape.

Matta undoubtedly stimulated the more improvisational character of Gorky's abstract style of the early 1940s, but the advanced art of Wassily Kandinsky had also been an important precursor. Although Gorky had earlier maintained that he had studied with this master of twentieth-century Expressionism and had long considered him to be one of the world's great modern artists, he seems not to have been interested in assimilating his style into his own art until the 1940s. This was not for lack of opportunity, for Kandinsky's pictures had been accessible in New York for a number of years through private collections, museum and gallery exhibitions, and reproductions. Gorky may have been stimulated by seeing several of Kandinsky's works at the Museum of Non-Objective Painting (now the Solomon R. Guggenheim Museum) when it opened in 1939. More likely, however, it was Gorky's revitalized response to nature, which required a new pictorial vocabulary, that encouraged him to look harder at Kandinsky. Agnes Gorky recalled that during this period the Russian-born Kandinsky became "as important to Gorky as Picasso."[68] Even though Gorky was evidently familiar with Kandinsky's theoretical trea-

65. Matta Echaurren
Inscape (Psychological Morphology No. 104), 1939
Oil on canvas, 28¾ x 36¼ in.
Gordon Onslow-Ford, Inverness, California;
On long-term loan to the San Francisco Museum of Modern Art

66. Wassily Kandinsky
Untitled Watercolor, 1913
Watercolor on paper, 19¾ x 21⅝ in.
Musée National d'Art Moderne, Centre Georges Pompidou, Paris

67. *Waterfall,* 1942–43
Oil on canvas, 60 x 44 in.
The Tate Gallery, London

tise, *On the Spiritual in Art*,[69] there is no proof that he based any of his own ideas on Kandinsky's theories. Nor did Gorky appear to know that many of Kandinsky's seemingly nonobjective images represented specific objects that he had gradually disguised by abstraction that increased from one picture to another. The relationship between the two artists seems to have been one of kindred romantic spirits, and they both espoused a style distinguished by expressive brushwork, color, and line.

How My Mother's Embroidered Apron Unfolds in My Life 68 (1944) is another example of Gorky's painterly and seemingly improvisational style. According to the artist, the picture was inspired by Lady Shushanik's apron and the memories he associated with it.[70] The painting was not modeled directly on a landscape, but its springlike colors, which recall the warm tonalities of *Garden in Sochi*, and its atmospheric qualities nevertheless suggest

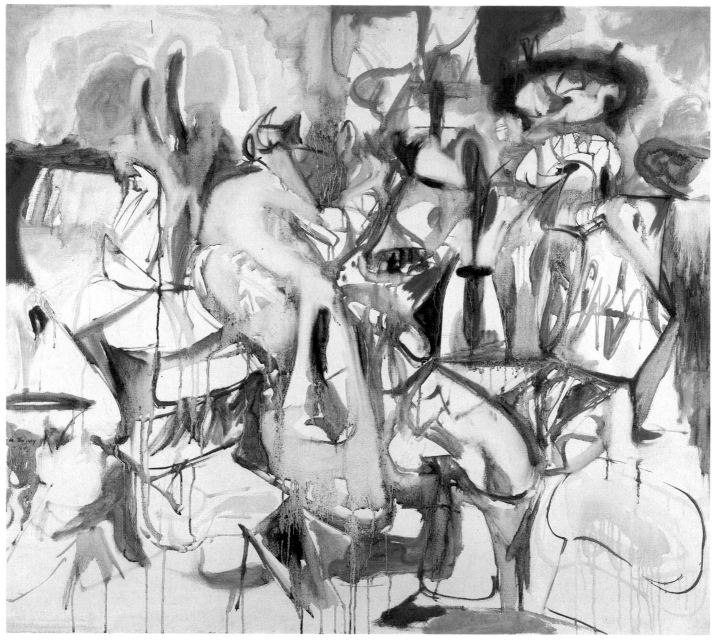

68

associations with nature, as well as Gorky's own dreamy reminiscences of brightly colored embroidery on an apron. A comparison between this work and Kandinsky's *Untitled Watercolor* (1913) documents visually Gorky's stylistic relationship to that twentieth-century master. Working in oil, Gorky has achieved the same transparency and translucency that Kandinsky had obtained with watercolor. The colored forms of both works, similarly unbounded by line, are clearly related in configuration; in addition, both artists have left untouched large areas of the canvas or paper, which tends to open up the space even more. But Kandinsky's work, like Matta's, is more cosmic and infinite.

Gorky's newly achieved painterliness is a dominant feature of many of his works of the 1943–45 period, such as *One Year the*

68. *How My Mother's Embroidered Apron Unfolds in My Life,* 1944
Oil on canvas, 40 x 45 in.
Seattle Art Museum; Gift of Mr. and Mrs. Bagley Wright

69. *One Year the Milkweed,* 1944
Oil on canvas, 37 x 47 in.
National Gallery of Art, Washington, D.C.; Ailsa Mellon Bruce Fund, 1979

Milkweed, Waterfall, and Water of the Flowery Mill, which oth- 67, 72
erwise differ from each other noticeably. *One Year the Milkweed*
(1944) is composed of extremely thinned pigments applied with an
element of spontaneity, like *My Mother's Embroidered Apron*, but
little of the raw canvas shows through. Coloristically it is closer to
Gorky's *Waterfall* of 1942−43, which chronologically and stylis-
tically falls between *The Pirate I* and the very improvisational 1944
works. This particular canvas is said to have been inspired by a
waterfall in the Housatonic River near Saul Schary's home in
Roxbury, but any attempt to locate the specific vantage point
from which Gorky worked would probably prove futile. By limit-
ing his palette to predominantly cooler colors alleviated by foamy
whites and other light hues, by applying the paint in brushy
strokes, and by allowing the thinned pigment to run, the artist has
attained the refreshing sensation of a rushing cascade of water
without portraying a specific falls at a certain time and place. This

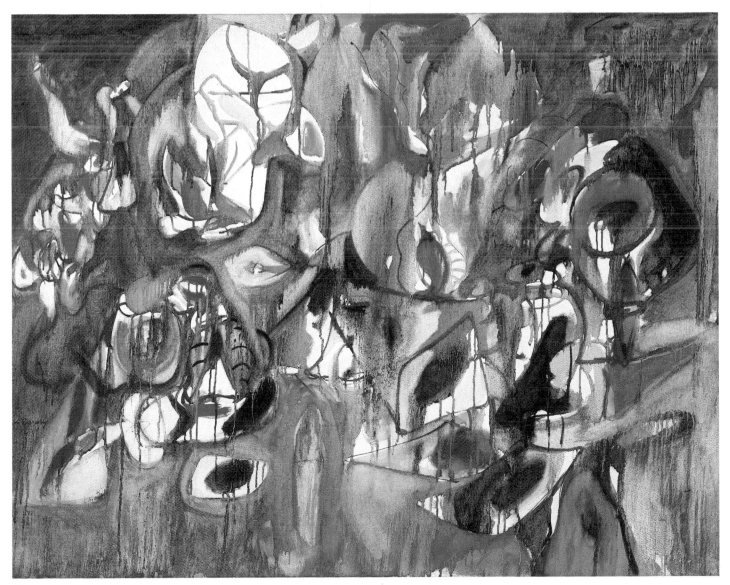

69

could be any waterfall, and it reminds us that Gorky had earlier praised Twachtman's waterfalls for the same reason. [71]

Waterfall is composed of several diaphanous veils of color, ranging from dark green, yellow, fiery orange, and red to softly tinted whites, which gently flow into one another, creating a complex space. Beneath this maze of watery color can be glimpsed a network of lines that occasionally encloses forms, suggesting a more concrete substructure like rock formations beneath the falls, but that more often wanders through the fields of color, disappearing, reemerging, and functioning virtually autonomously. Color and line do imply the presence of certain forms—large bonelike structures, floral motifs, sexual and visceral organs, flames, and human bodies—but such readings are ephemeral, for the painting seems to be in a state of constant flux and redefinition. [72] This thematic, spatial, and temporal uncertainty was the subject of a statement by Gorky in 1944.

Now try to allow your mind the freedom to think in terms of constant motion or flux instead of paralysis. Replace stillness with movement. That is my goal, that is what I am achieving. I am breaching the static barrier, penetrating rigidity. I am destroying confinement of the inert wall to achieve fluidity, motion, warmth in expressing feelingness, the pulsation of nature as it throbs. Dearest ones, my art is therefore a growth art where forms, planes, shapes, memories of Armenia germinate, breathe, expand and contract, multiply and thereby create new paths for exploration. The past, the mind, the present are aesthetically alive and unified and because they cannot rest, are insoluble and inseparable from the future and exist to infinity. [73]

Between *The Pirate I* and such paintings as this, Gorky had

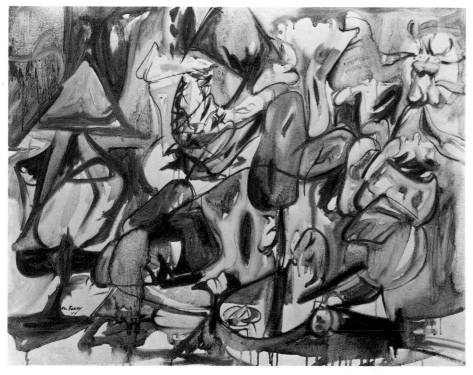

70

arrived at a style not even remotely in the manner of anybody else. It is in the manner of Gorky.

Water of the Flowery Mill (1944) is even more expansive and unstructured than *Waterfall*. The only clue to the meaning of the title comes from a quote that Julien Levy attributed to Gorky: "Down the road, by the stream, that old mill, it used to grind corn, now it is covered with vines, birds, flowers. Flour Mill—Flowery Mill. That's Funny! I like that idea."[74] If this quote is accurate, it reveals the subtle connections that Gorky made between words and images before naming a canvas; his tendency to associate colors and shapes with various objects through free association undoubtedly accounts for the complex and elusive visual imagery in his paintings as well.

Water of the Flowery Mill is a masterpiece of expression, its powerful impact due largely to its coloration. Replacing the cooler and generally more opaque colors found in *Waterfall* are rich reds, oranges, yellows, whites, and high-keyed lavenders, with subtle accents of blue and green. This warmer palette, reminiscent of Kandinsky's pre–World War I *Improvisations*, creates a more emotional and passionate effect, as clouds of pigment seem to hover, expand, overlap, and drift nebulously within the picture.

Gorky's use of free verbal and mental associations to name paintings crops up again in *The Liver Is the Cock's Comb*, and his description of it conveys the spirit of its manifold images and multileveled meanings: "The song of a cardinal, liver, mirrors that have not caught reflection, the aggressively heraldic branches, the saliva of the hungry man whose face is painted with white chalk."[75] One of Gorky's largest and most significant pictures, 74

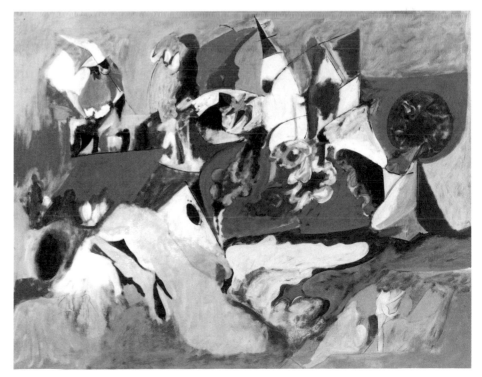

70. *The Leaf of the Artichoke Is an Owl*, 1944
Oil on canvas, 28 x 35⅞ in.
The Museum of Modern Art, New York; Gift of Sidney Janis

71. *Golden Brown Painting*, c. 1943–44
Oil on canvas, 43 x 56 in.
Washington University Gallery of Art, St. Louis

71

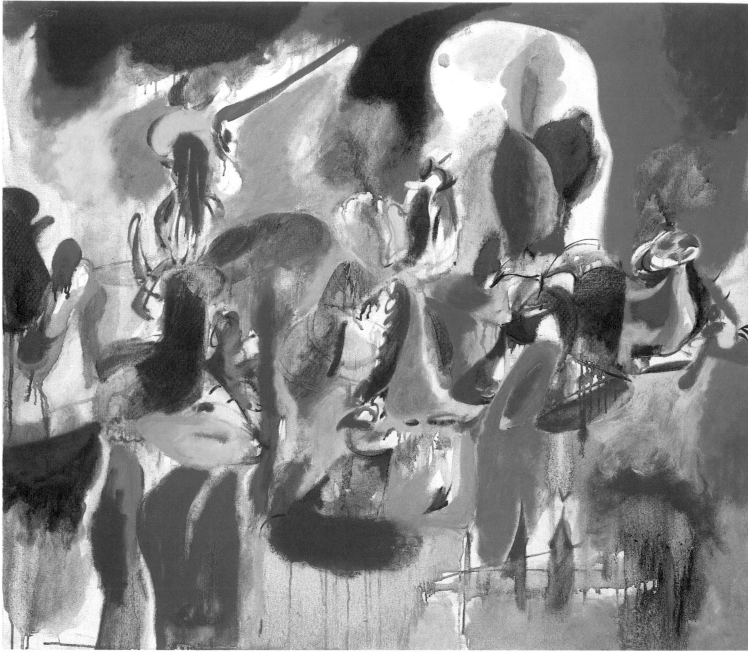

72

73 based specifically on a 1943 drawing, *The Liver Is the Cock's Comb* is a panoramic view of biological organisms, integrated within an environment of abstract color-forms. Like a fantastic ballet, plumes of red, blue, and yellow float weightlessly before a ground of ochers and scumbled blue-whites. Some of the interspersed motifs bring to mind human or animal anatomy, including sexual organs, affording strong thematic overtones of procreation and the natural life processes. The juxtaposition of human with botanical motifs evokes a sense of the wondrous and the unexpected; the exaggerated scale and the inconsistent proportions between images, or between images and space, are disconcerting.

Works such as *The Liver Is the Cock's Comb* evolved alongside

72. *Water of the Flowery Mill,* 1944
Oil on canvas, 42½ x 48¾ in.
The Metropolitan Museum of Art, New York;
George A. Hearn Fund, 1956

73. *Study for "The Liver Is the Cock's
Comb,"* 1943
Ink, pencil, and crayon on paper, 19 x 25 in.
Weisman Family Collection/Marcia S.
Weisman

74. *The Liver Is the Cock's Comb,* 1944
Oil on canvas, 73 x 98⅜ in.
Albright-Knox Art Gallery, Buffalo;
Gift of Seymour H. Knox, 1956

73

74

75

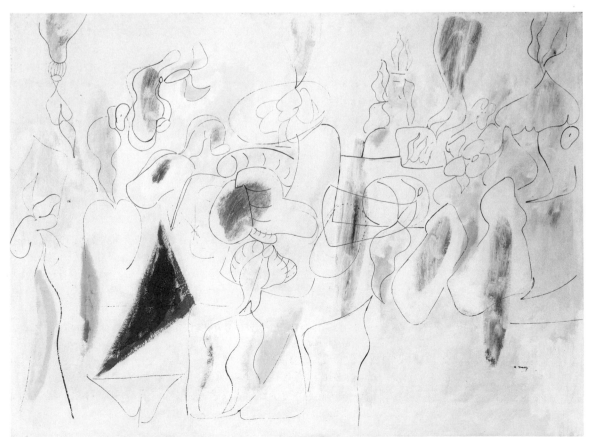

76

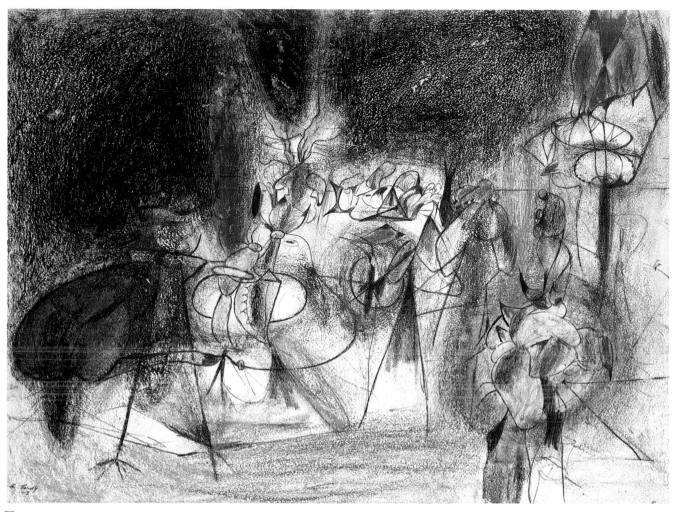

77

75. *Good Afternoon, Mrs. Lincoln*, 1944
Oil on canvas, 30 x 38 in.
Allan Stone Gallery, New York

76. *Untitled (Virginia Landscape)*,
c. 1943–44
Oil on canvas, 34⅛ x 46 in.
Hirshhorn Museum and Sculpture Garden,
Smithsonian Institution, Washington, D.C.

77. *Untitled*, 1943
Wax crayon and pencil on paper,
20 x 26¾ in.
Solomon R. Guggenheim Museum, New
York; Gift of Mrs. Rook McCulloch

Gorky's more painterly style and register his continued interest in forms suggestive of living organisms. The images within this and other paintings, however, are smaller and more numerous than in any of his previous works, and the composition is more intricate. The style came about as a direct result of the drawings Gorky had created at the Magruder homestead, Crooked Run Farm, in 1943. There Gorky had worked in the fields and meadows, peering at nature's forms at close range and discovering the complex formal relationships among the blades of grass, the flowers, the weeds, and the insects, and these drawings became the basis for numerous oils over the next few years.

Composition I (1943) is an earlier example of Gorky's botanical-organic landscapes out of which *The Liver Is the Cock's Comb* and other paintings grew. A horizon line that indicates a broad vista is clearly visible, and the terrain it establishes is populated with fanciful small organisms. Images that suggest flowers, heads, hands, arms, torsos, sexual organs, and viscera are woven into an intricate design that lacks the openness and the atmospheric lightness of the "veiled" landscape paintings.

The Surrealist leader André Breton wrote a statement for the publication accompanying Gorky's first one-man show at the

78

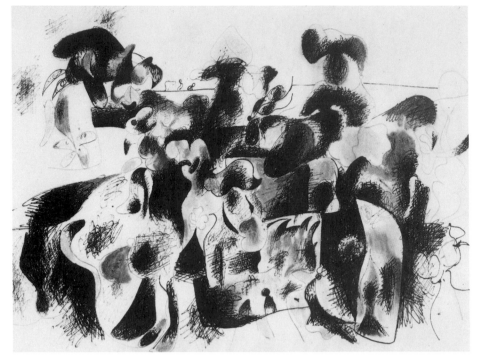

78

Julien Levy Gallery, where Gorky's new works first appeared. He and Gorky had met in late 1944 or 1945 and quickly became good friends, despite the fact that Breton spoke no English and Gorky no French. Breton's statement claimed Gorky for the Surrealists and pronounced him "the first painter to whom the secret has been completely revealed." He declared that Gorky was the only Surrealist who maintained direct contact with nature, penetrating nature's secrets to discover the "guiding thread" that links together "the innumerable physical and mental structures." In addition, Breton referred to Gorky's images as "hybrids," defining them as "the end result produced by the contemplation of a natural spectacle blended with the flux of childhood and other memories provoked by intense concentration upon this spectacle by an observer endowed with quite exceptional emotional gifts."[76] Breton, it seems, perfectly understood Gorky's method and objectives.

In spite of Gorky's flirtation with the Surrealist movement in the 1930s and '40s, his relationship to it was always ambivalent, and he never considered himself a member. He recognized that certain Surrealist tactics, such as removing an object from its context in order to emphasize its importance and intensify its "reality," could be powerfully effective. Moreover, the fantastic, poetic forms that drift in unstructured space in many Surrealist paintings appealed to Gorky, who sought to capture his own memories and dreams by painting abstract images in a limitless space. But on a number of crucial issues, Gorky—always an independent thinker—parted company with these European modernists.

He objected vehemently, for instance, to the Surrealists' celebration of the unconscious as a source for art. Perhaps referring di-

79

78. *Composition I*, 1943
Pencil, ink, and wax crayon on paper,
18 x 24 in.
Private collection

79. *Untitled (Landscape)*, 1943
Oil and pencil on canvas, 19½ x 25 in.
Cleveland Museum of Art; Contemporary
Collection

80. *Composition II*, 1943
Pencil and wax crayon on paper,
22¾ x 29 in.
Barbara and Donald Jonas

81. *Anatomical Blackboard*, 1943
Pencil and wax crayon on paper,
20 x 27⅜ in.
Mr. and Mrs. Walter Bareiss

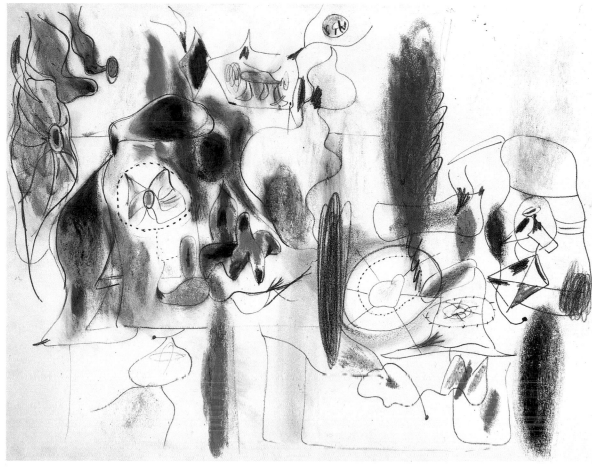

80

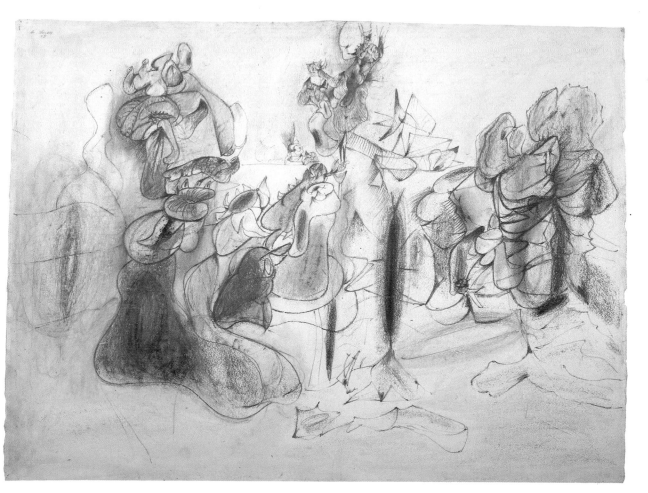

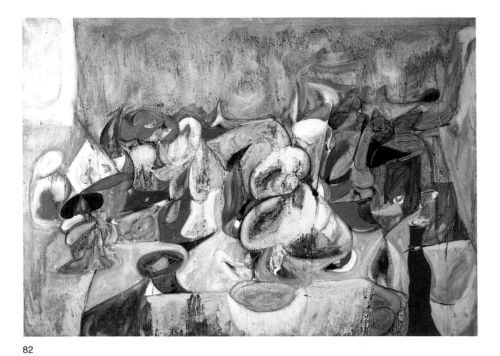

82

83

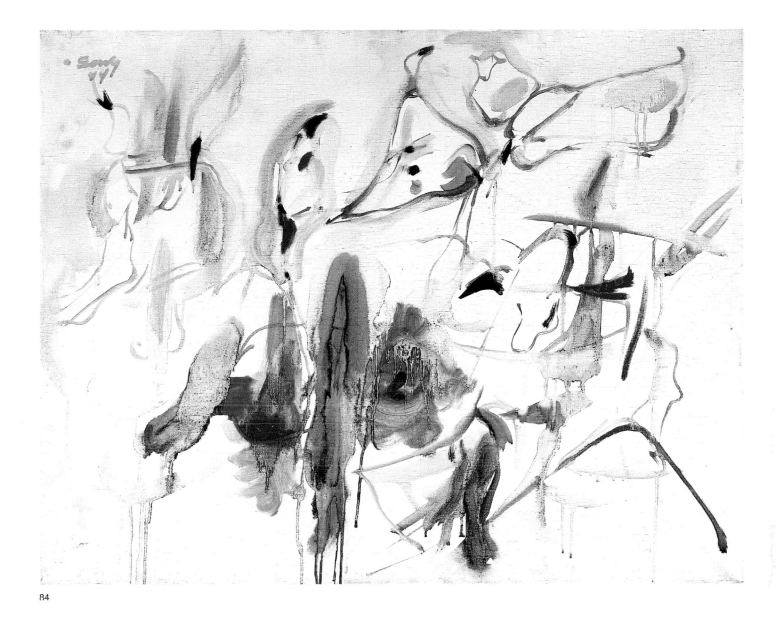

84

82. *Scent of Apricots on the Fields,* 1944
Oil on canvas, 31 x 44 in.
Mr. and Mrs. Joseph Randall Shapiro

83. *To Project, To Conjure,* 1944
Oil on canvas, 35¾ x 46¾ in.
Stephen and Nan Swid, New York

84. *Love of the New Gun,* 1944
Oil on canvas, 30 x 38 in.
Menil Foundation, Houston

rectly to Surrealist automatism, he said in 1939 that "art must be a facet of the thinking mind." He felt that the overthrow of conscious control produced anarchy—not art—and reflected a cynical disbelief in man's intellectual ability "to master complexities" through perception, organization, and skill. "Unrelenting spontaneity is chaos. Such anarchy negates aesthetic art. Great art insists upon consciousness."[77] Late in 1947 he was finally to denounce Surrealism as academic, anti-aesthetic, and antithetical to modern art. He decried the ideas behind the movement as "strange, and somewhat flippant, almost playful," in contrast to his own devout search for beauty.[78] Yet in 1945 Gorky must have welcomed Breton's kind support and friendship, for it provided him with much-needed encouragement, recognition, and the promise of international exposure.

In his 1945 show Gorky exhibited mainly his "veiled" paintings of 1942–44, including *Water of the Flowery Mill, How My Mother's Embroidered Apron Unfolds in My Life, The Pirate I,*

85. *The Sun, The Dervish in the Tree,* 1944
Oil on canvas, 35¾ x 47 in.
Graham Gund

86

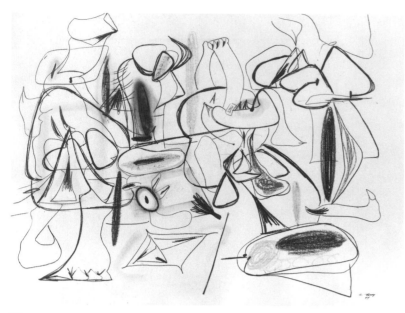

86. *Study for "They Will Take My Island,"* 1944
Wax crayon and pencil on paper,
22¼ x 30 in.
The Brooklyn Museum; Dick S. Ramsay Fund

87. *They Will Take My Island,* 1944
Oil on canvas, 38 x 48 in.
Art Gallery of Ontario; Toronto Purchase with
assistance from the Volunteer Committee
Fund, 1980

88. *Painting,* 1944
Oil on canvas, 65¾ x 70¼ in.
Solomon R. Guggenheim Museum, New York;
The Peggy Guggenheim Collection, Venice;
The Solomon R. Guggenheim
Foundation, New York

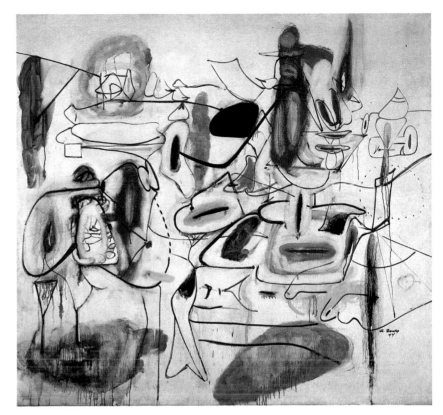

88

One Year the Milkweed, Love of the New Gun, and *The Sun, The* 84, 85
Dervish in the Tree. Although these paintings are today considered among Gorky's most original and provocative works of the period, they met with negative and even hostile criticism at this show. One critic derided them as "incoherent 'accident' pictures,"[79] while another, Clement Greenberg, condemned Gorky's blatant dependence on the Surrealists for inspiration. Significantly, however, Greenberg noted that one painting in the show signaled Gorky's "return to serious painting" and promised a new originality.[80] This was Gorky's *They Will Take My Island* (1944), 87 in which he abandoned the improvisational and spontaneous qualities typical of his other 1944 works and harked back to the 1943–44 landscape drawings. A thin, energetic line moves over the surface defining organic forms and providing a transition between compositional elements. Superimposed on this framework are floating oval, rectangular, columnar, and circular stains and washes of oil pigment that replace the textural crayoned areas of the drawings. Gorky had pursued a completely new direction, however, in making his images larger in scale and more simplified, while leaving vast areas of the white canvas untouched by his brush. This tendency toward simplification of form and economy of means laid the stylistic foundation for many of the painter's late works of 1945–48.

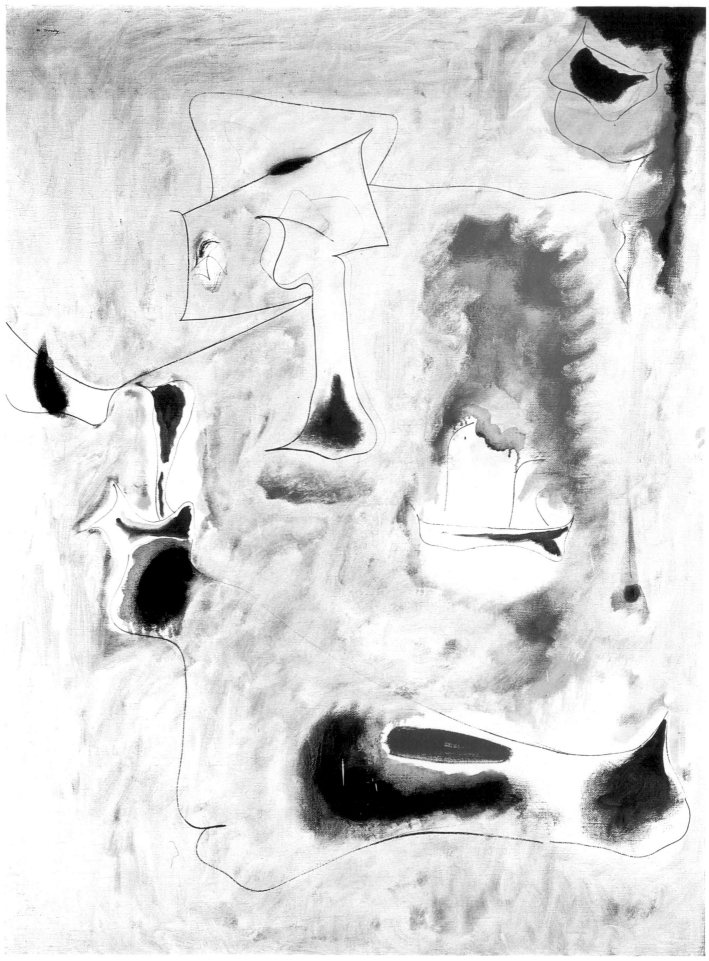

89

5 The Last Works

In August of 1945 Gorky's second daughter, Natasha, was born, and about a month later the Gorky family moved from David Hare's home in Roxbury to nearby Sherman, Connecticut. There, they lived with some friends, the Hebbelns, while Henry Hebbeln, an architect, renovated a neighboring house for them. In the meantime Gorky continued painting and drawing, using as his studio a converted barn on the Hebbeln property. This cavernous structure caught fire in late January of the next year, destroying nearly all of Gorky's paintings and drawings, as well as his library. About thirty paintings were lost, all produced since the family had moved to Roxbury. Many of them had been in the new style of *They Will Take My Island*, the work that Greenberg had praised the year before.

Following the fire, the Gorkys returned to New York, where the artist tried to complete, in time for his next show at Levy's gallery, enough new works to replace those that had burned in the fire. Two of the works he produced, *Charred Beloved I* and 89 *Charred Beloved II*, simplified his new style still more. Only three or four motifs, which are defined by thin, brittle lines and open-edged patches of color, extend over most of the canvas. The tensile line meanders over the surface and through the shallow atmospheric haze of the scumbled brown and ocher field. The dominant tones are subdued and somber, but fiery yellows and oranges and intense blacks provide dramatic contrast. Clearly, the colors refer to the tragic fire, and it is easy to see from the "charred and burning" areas of the painting that the artist has depicted his theme almost literally. In this respect, the work is unusual, for Gorky rarely made his subject matter this obvious in his late paintings. It should be noted, however, that even though the theme of the fire is legible, the meaning of the abstract motifs in these paintings is not. These mysterious forms, which were to appear again in several of the artist's works over the next few years, are Miroesque in spirit but grew stylistically out of Gorky's works from the preceding year, such as *The Unattainable, Landscape* 92, 93 *Table*, or *Impatience*. 90

The fire was only the first of a series of tragedies to strike

89. *Charred Beloved I*, 1946
Oil on canvas, 58⅝ x 39¾ in.
Gerald S. Elliot

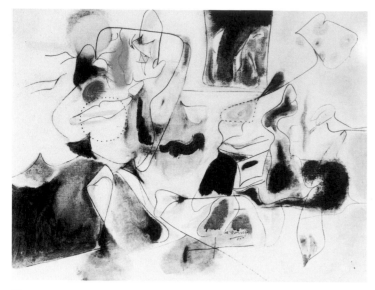

90

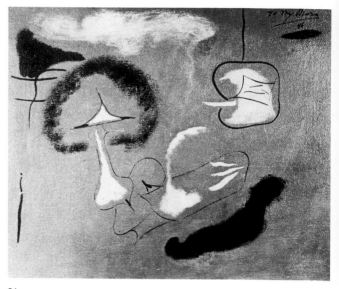

91

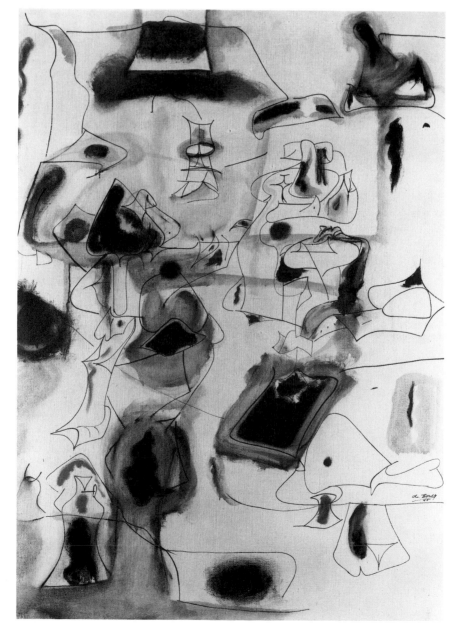

92

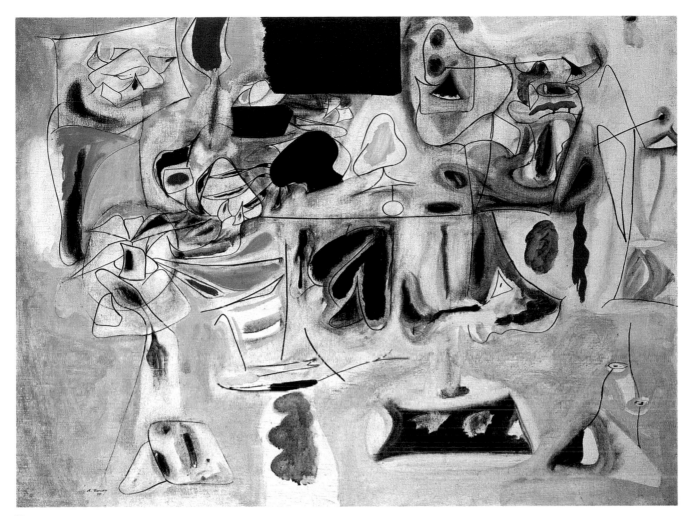

93

Gorky. A second occurred in late February 1946, when he underwent surgery for cancer. Coming immediately after the fire, the operation must have increased his anxieties about the future and overshadowed, if not nullified, the joy and optimism that he had relished for the previous five years. Perhaps this change in mood partially accounts for the gravity of a number of his 1946 works, such as the gloomy *Nude* and *Delicate Game.* But the fire and the cancer do not entirely explain his subdued tone, for Gorky's palette had already begun to darken in 1945. This can be seen in *The Diary of a Seducer,* a work whose title, invented by Gorky with the assistance of Max Ernst, makes reference to a chapter title in Sören Kierkegaard's *Either/Or.* The painting's mood is somber and nocturnal, suggesting that it evolved from the mood of the Nighttime, Enigma, Nostalgia series of the previous decade. Restricted to blacks, grays, and whites, the reductive coloration has the powerful effect of maximizing expression, as it does also in Picasso's *Guernica* of 1937.

Gorky many times expressed his belief that suffering resulted in the ability to feel more deeply and to perceive more keenly, and, in fact, his own creativity seemed to flourish after the unhappy events of 1946. That summer Gorky and his family returned to the

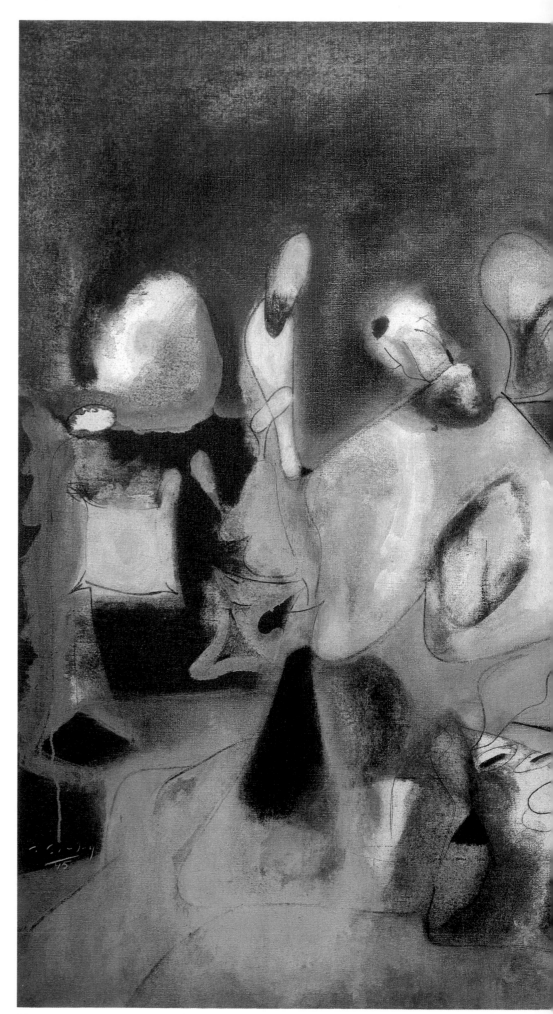

94. *The Diary of a Seducer,* 1945
Oil on canvas, 50 x 62 in.
Mr. and Mrs. William A. M. Burden,
New York

94

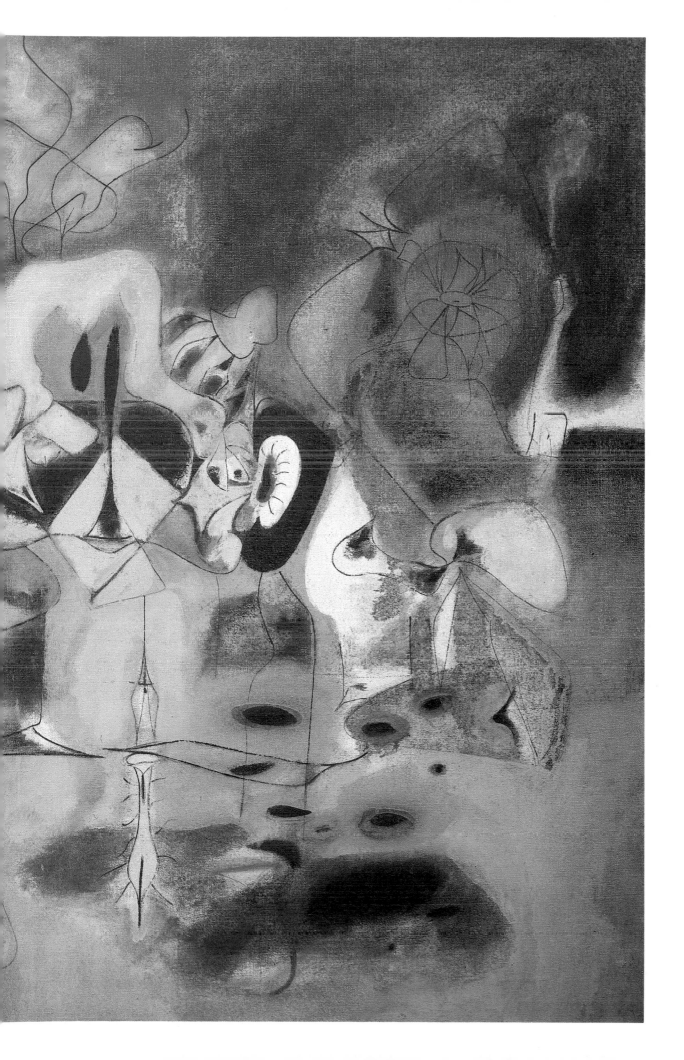

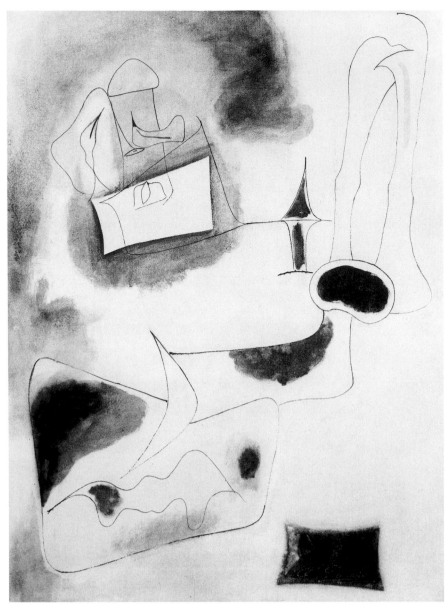

95

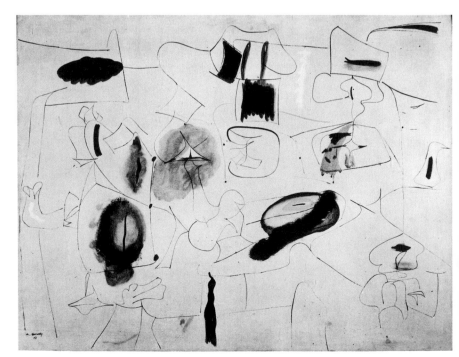

96

96

Magruder farm in Virginia, where he produced no fewer than 292 drawings, which he assessed as "truly excellent."[81] Many of them were again created from nature, but others apparently were drawn inside the Magruder home. These interiors resulted in still another series (about four oil paintings and a charcoal drawing) that has come to be known as The Calendars, though the actual titles include *Making the Calendar, Days etc.,* and *The Opaque,* all of 1947. Consistent from one version to another is the linear structure by which planes that suggest walls or floors meet at angles and along diagonals to establish a shallow Cubist space. Uniform, too, are the many ambiguous shapes that may allude to furniture, people, or animals within that expanse. Differing from work to work, however, is the manner in which various colors have been applied in thin washes or in more opaque feathered brushstrokes. The latter technique creates a thicker, more structured space in contrast to the washes or the translucent veils of the "improvisational" paintings that he had done just a short time before.

95. *Nude,* 1946
Oil on canvas, 50⅛ x 38⅛ in.
Hirshhorn Museum and Sculpture Garden,
Smithsonian Institution, Washington, D.C.

96. *Delicate Game,* 1946
Oil on canvas, 34 x 44 in.
Edwin Janss, Thousand Oaks, California

97. *A Fireplace in Virginia,* c. 1946
Pen, pencil, and wash on paper,
12½ x 9½ in.
Duncan MacGuigan, New York

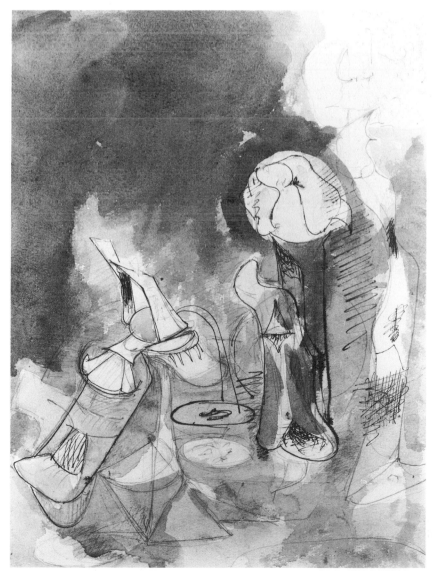

97

Gorky continued to make use of this heavier, feathered texture in some works of 1947, such as *The Limit* and *The Plow and the Song*, but shifted their location from inside to the outdoors. *The Limit* is cool and reserved, Gorky having restricted his palette to icy blues, bluish whites, dark blues, and black, with slight accents of warmer reds and yellows. The space is laterally expansive, but the opaque color fields glide into one another and lock into position, establishing an extremely limited depth of field. Line cuts through the expanses of color, but it has become much more tensile as it defines tortured forms with pinched corners. The overall effect of *The Limit* is one of a precarious balance between the tension-ridden forms, the primary color accents, and the more sedate milky white and blue of the expansive color fields.

101, 100

98

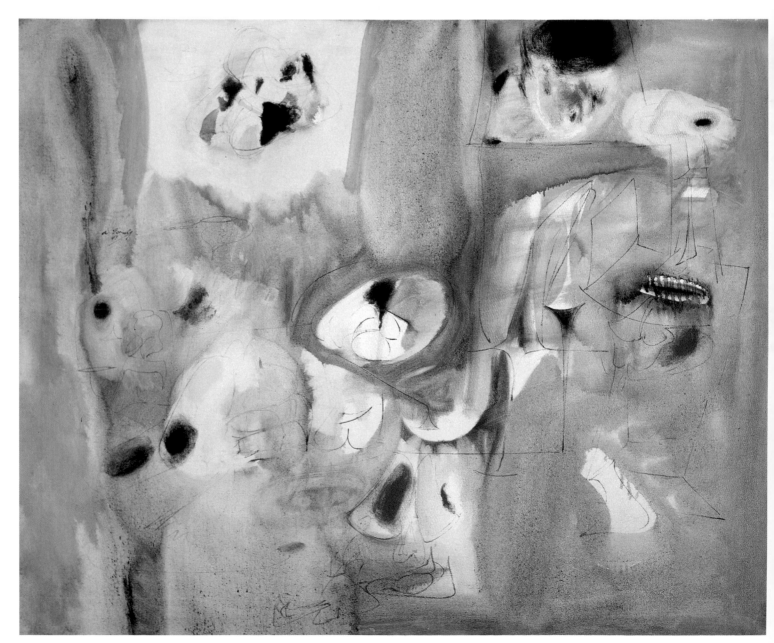

99

98

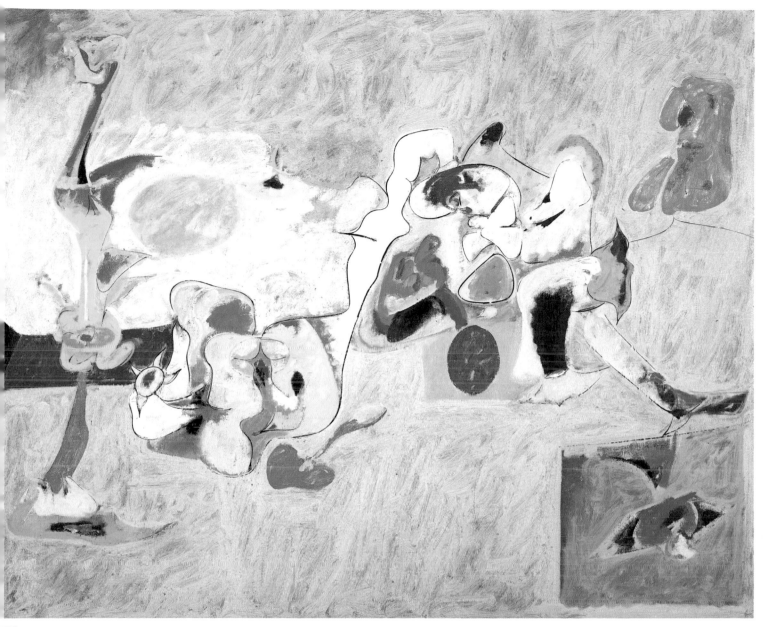

100

98. *Study for "The Calendars,"* 1946
Charcoal and colored chalk on paper mounted
on board, 33 x 40¼ in.
Fogg Art Museum, Harvard University;
Gift of Lois Orswell

99. *Making the Calendar,* 1947
Oil on canvas, 34 x 41 in.
Munson-Williams-Proctor Institute, Utica, New
York; Edward W. Root Bequest

100. *The Plow and the Song,* 1947
Oil on canvas, 52⅛ x 64 in.
Private collection

The Plow and the Song is the title of still another series of
works by Gorky, including at least three drawings and an equal
number of oils over a three-year period. The theme had first begun
to preoccupy him in late 1944, when he wrote to Vartoosh:

I have been occupied in drawing the Armenian plows which we used in
our Adoian fields near our house. . . . You cannot imagine the fertility of
forms that leap from our Armenian plows, the plows our ancestors used
for thousands of years in toil and gaiety and hardship and poetry. The
Armenian man from Khorkom demands a plow as his apt tombstone. I
smell the apricots hot on our orchard trees and they move for me in
dances of old. And the songs, our ancient songs of the Armenian people,
our suffering people. This I am painting and I am convinced you will ap-
preciate it. So many shapes, so many shapes and ideas, happily a secret
treasure to which I have been entrusted the key.[82]

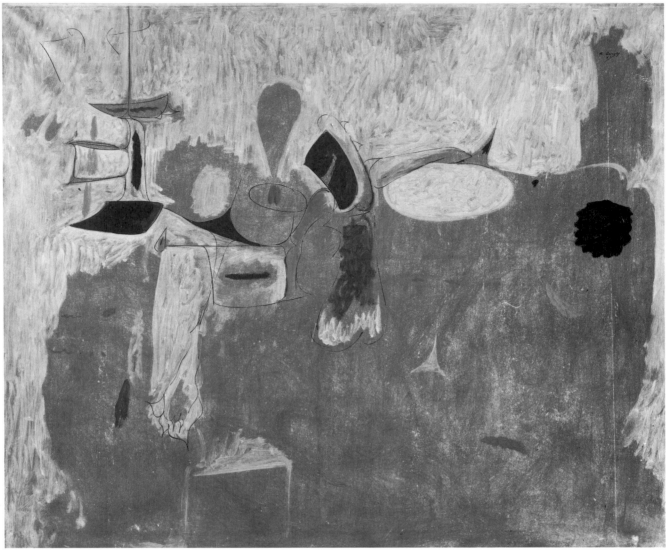

101

There is no reason to doubt that the images in The Plow and the Song paintings and drawings stem from these memories and associations, though it is difficult to pinpoint exact references. Large pointed shapes reminiscent of Gorky's Armenian slipper motif simultaneously connote the wooden blades of a peasant plow that furrows the earth in preparation for planting. This same shape is visually interchangeable with the organic tubes and sacks that Gorky also used to refer to the natural processes of penetration, fertilization, birth, and growth.

During 1947 Gorky worked feverishly, producing hundreds of drawings and numerous oil paintings. Late in the year, he and his family moved permanently to the rented farmhouse that Hebbeln had remodeled for them in Sherman, Connecticut. The move may account in part for the artist's continued creativity, but other factors undoubtedly also gave him encouragement. Late in 1946, for example, a selection of Gorky's major works from the 1940s plus *The Artist and His Mother* had been chosen for the *Fourteen Americans* exhibition held at the Museum of Modern Art. This

101. *The Limit,* 1947
Oil on paper mounted on canvas,
50¾ x 62 in.
Private collection

102. *Summation,* 1947
Pencil, pastel, and charcoal on buff paper
mounted on composition board,
79⅝ x 101¾ in.
The Museum of Modern Art, New York;
Mr. and Mrs. Gordon Bunshaft Fund

was followed by a show of his colored drawings at Levy's gallery in February and March of 1947 and by the inclusion of *The Calendars* in the Whitney annual in January 1948. Greenberg, reviewing the Whitney show, praised Gorky's work as "the best painting in the exhibition and one of the best paintings ever done by an American."[83]

These promising events seemed to more than compensate for the misfortunes of early 1946, but apparently Gorky was still swept by undercurrents of anxiety, frustration, and sadness that produced states of deep depression. Elements of this tension found their way into two of Gorky's major canvases of 1947: *The Betrothal II* and *Agony*. In *The Betrothal II*, which evolved through numerous studies, several motifs that are ambiguously human, animal, or botanical are again brought together. There has been much debate over the meaning of this congregation of forms. Some have seen references in the work to the art of Uccello, particularly to the gallant horse and rider figures in *The Rout of San Romano*, which Gorky admired. Harry Rand's more recent interpretation of the scene as a marriage between Gorky and an imagi-

103
104

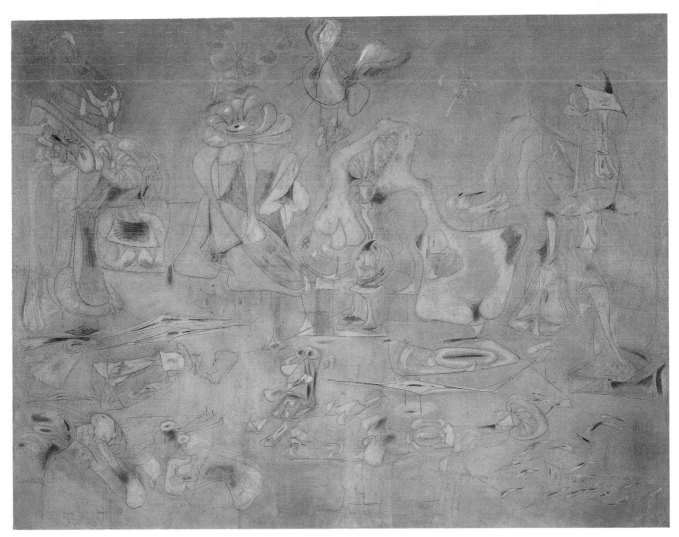

102

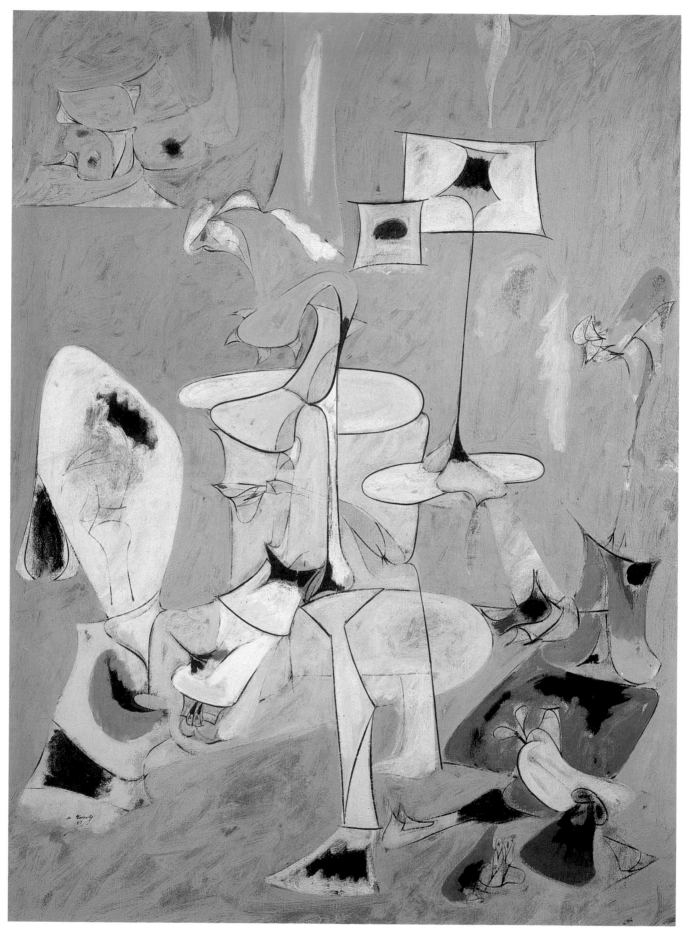

nary bride is difficult to accept visually, but the marital theme is tempting, given the painting's title, lyrical composition, and delicate hues.[84] A note of stress does also appear in the painting. The seductive colors and swaying composition are countered by the attenuated linearity and squeezed extremities of some of the forms. Gorky's marriage seems to have been troubled during the last few years of his life, and this may account for the dissonant notes that disturb the overall harmony of *The Betrothal II.*

No lyricism survives in the passionate and tormented expressionism of *Agony.* Extremely brittle lines define forms, which are generally composed of distorted rectangles, pinched triangles, and clawlike projections. Spottings of color contained within the thin lines, and the richly brushed and modulated areas of reds, oranges, and browns that spread beyond them, enhance the complex composition and create a powerful mood of distress and desperation.

On the occasion of Gorky's fourth one-man show at the Julien

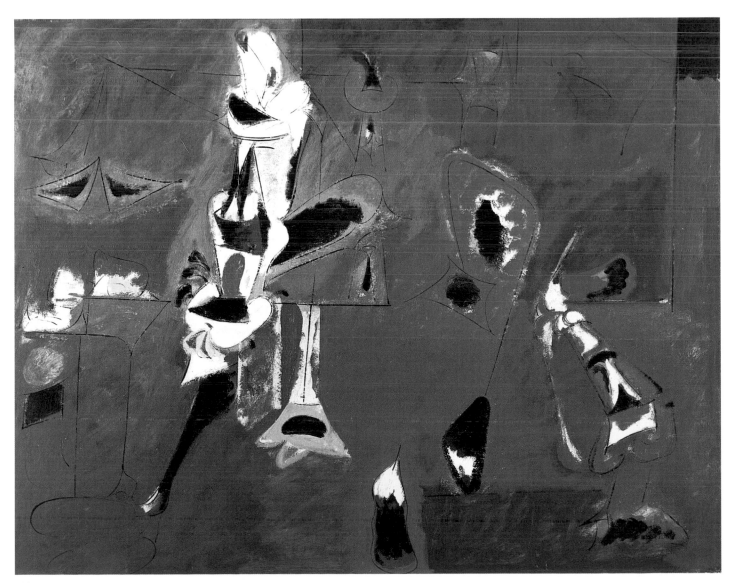

104

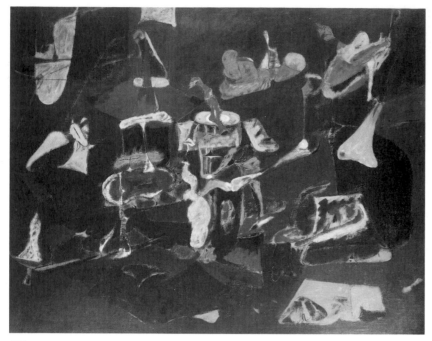

105

Levy Gallery, the painter became despondent over the lack of understanding and appreciation of his art.[85] After more than twenty years in New York, he had failed to gain the recognition he felt he deserved as an artist of true creative talent. His distress was not new, since he had spoken negatively about the plight of art in America on several previous occasions. He had been severely critical of the "commercial philistinism" in the United States that robs art of its humanity and "strangles new thoughts and instead strives relentlessly to serve up the old standardized food on a new dish and pretend that such is creativity, when in fact it is mere novelty."[86] Such an attitude, he felt, grew from a society rich in technology, but poor in humanism:[87] "This people cannot feel with naturalness because it has denied itself poetic momentum. This people cannot understand sensitivity's broad range of feeling since its culture has never experienced such from the very soul."[88] In 1948 he complained of art criticism that was based solely on a critic's unwillingness to accept new ideas, and he condemned the critics who refused to acknowledge cultural progress as suffering from unrelenting ignorance.[89]

The last few months of Gorky's life were plagued by yet other misfortunes. While riding with Julien Levy, he was injured in an automobile accident near New Milford, Connecticut, on June 26, 1948. Gorky was seriously hurt: his neck was broken, which would incapacitate him for months, and his painting arm was temporarily paralyzed. Gorky gradually began to regain the use of his arm, but the agony of not being able to move freely without pain became unbearable. His black moods and deep depression, complicated by jealousy and doubt directed toward Agnes, threatened his domestic life and permeated the suppressive and claustrophobic *Last Painting* (1948). Around the middle of July

106

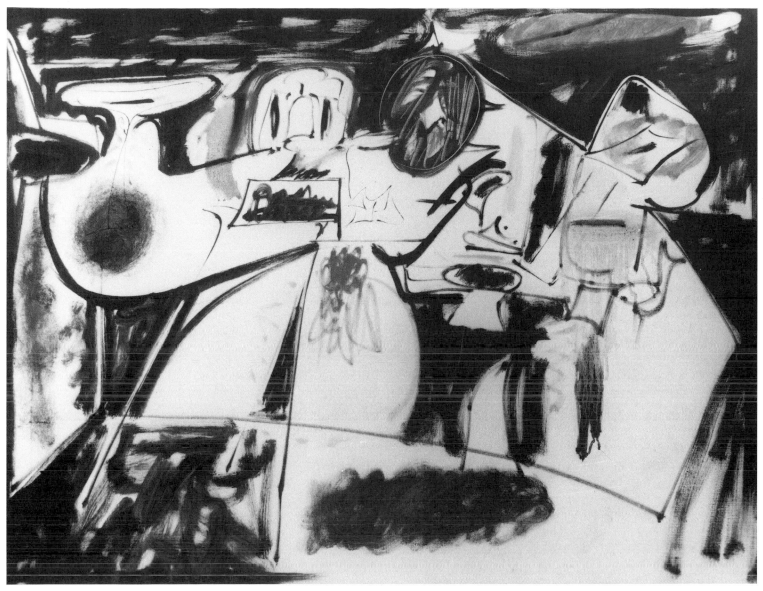

106

his wife took the children and left Connecticut for her parents' home in Virginia. The painter spent a day or two in New York, then returned to Sherman, having been driven back by his friend Isamu Noguchi. A few days later, on July 21, Gorky hanged himself, leaving the message "Goodbye My Loveds" scrawled on a nearby wooden box.

Gorky was only forty-four years old when he died. Within his relatively short life, he had suffered more than his share of tragedy, but he had also tasted joy. He well recognized that life consisted of both experiences and that either could be communicated through art. His triumph was the ability to do so.

105. *Dark Green Painting*, c. 1948
Oil on canvas, 44¾ x 56 in.
Mrs. H. Gates Lloyd, Haverford, Pennsylvania

106. *Last Painting*, 1948
Oil on canvas, 30¾ x 39¾ in.
Thyssen-Bornemisza Collection,
Lugano, Switzerland

NOTES

1. See William Rubin, "Arshile Gorky, Surrealism and the New American Painting."

2. Quoted ibid., p. 28.

3. Arshile Gorky, quoted in Karlen Mooradian, *The Many Worlds of Arshile Gorky*, p. 51.

4. Willem de Kooning, quoted ibid., p. 128.

5. The development of Gorky scholarship parallels the increasing recognition of Gorky's importance. In 1957 Ethel Schwabacher wrote the first monograph on Gorky, establishing him as a major force in the development of contemporary art. In the 1960s historians and critics made further attempts to place Gorky within the context of the avant-garde, as in Robert Reiff's study of the late canvases (Reiff, *A Stylistic Analysis of Arshile Gorky's Art from 1943–1948*), and William Rubin's article "Arshile Gorky, Surrealism and the New American Painting." In the 1970s research into Gorky's art and life was carried out in greater depth, and new approaches were taken. Karlen Mooradian focused on Gorky's Armenian heritage, and Harry Rand interpreted the imagery iconographically. For other iconographical studies see Hayden Herrera, "Gorky's Self-Portraits: The Artist by Himself"; Diane Karp, "Arshile Gorky's Iconography"; Melvin P. Lader, "Arshile Gorky's *The Artist and His Mother*"; and Eliza E. Rathbone, "Arshile Gorky: The Plow and the Song."

6. Gorky, quoted in Malcolm Johnson, "Cafe Life in New York," *New York Sun*, August 22, 1941.

7. Gorky to Vartoosh, November 2, 1946, quoted in Karlen Mooradian, *Many Worlds*, pp. 309–10.

8. Ibid., p. 2.

9. See Gorky to his family, July 1943, ibid., p. 280; and Gorky to Vartoosh, December 1944, ibid., p. 289.

10. Gorky to his family, September 26, 1939, ibid., p. 265.

11. Gorky to Vartoosh, February 25, 1941, ibid., p. 270.

12. Gorky, quoted in Karlen Mooradian, "Where the Great Centuries Danced: The Armenian Years," in *Arshile Gorky: Drawings to Paintings*, p. 22.

13. For month-by-month accounts of the situation in Armenia, see *Ararat*, a journal devoted to Armenia that is published in England.

14. Arshile Gorky, "Fetish of Antique Stifles Art Here," p. 17.

15. Mooradian, *Many Worlds*, p. 6.

16. Diane Waldman, *Arshile Gorky 1904–1948: A Retrospective*, pp. 257 and 258.

17. Gorky, "Fetish of Antique Stifles Art Here."

18. Jim M. Jordan and Robert Goldwater, *The Paintings of Arshile Gorky: A Critical Catalogue*, p. 19.

19. Waldman, *Gorky*, p. 258.

20. Harry Rand, *Arshile Gorky: The Implications of Symbols*, p. 3.

21. Mark Rothko, quoted in Mooradian, *Many Worlds*, p. 197.

22. Gorky, "Fetish of Antique Stifles Art Here."

23. Revington Arthur, quoted in Mooradian, *Many Worlds*, p. 93.

24. See, for example, Julien Levy, *Memoir of an Art Gallery* (New York: G. P. Putnam's Sons, 1977), p. 283.

25. Gorky to Vartoosh, January 17, 1947, in Mooradian, *Many Worlds*, p. 315.

26. Ethel K. Schwabacher, *Arshile Gorky*, 1957, p. 16.

27. Gorky, "Fetish of Antique Stifles Art Here."

28. For the dates of Gorky's paintings, I have generally relied on those given in Jordan and Goldwater, *The Paintings of Arshile Gorky*.

29. Jordan dates *Landscape in the Manner of Cézanne* to c. 1927. Based on the similarities between it and Cézanne's *Rocks in the Forest*, which was acquired by the Metropolitan Museum in 1929, I would suggest a c. 1929 date.

30. Meyer Schapiro, "Gorky: The Creative Influence," p. 29.

31. The similarity between Gorky's *Self-Portrait at the Age of Nine* and Cézanne's *Louis Guillaume* has been noted by others. See, for example, Jordan and Goldwater, *Paintings*, pp. 21–22. Mr. Nick Wilder, who owns the painting by Gorky, has recently suggested that it may be a study for *The Artist and His Mother*. Conversation with the author, July 26, 1984.

32. Gorky to Vartoosh, June 14, 1945, quoted in Mooradian, *Many Worlds*, p. 292.

33. De Kooning, quoted in Mooradian, *Many Worlds*, p. 127.

34. Ibid., p. 268.

35. Ibid., p. 315. For a detailed discussion of *The Artist and His Mother*, see Melvin P. Lader, "Arshile Gorky's *The Artist and His Mother*," pp. 96–104.

36. Arshele (sic) Gorky, "Stuart Davis," p. 213.

37. Gorky to Vartoosh, Moorad, and Karlen, July 3, 1937, quoted in Mooradian, *Many Worlds*, pp. 252–53.

38. John D. Graham, *System and Dialectics of Art* (New York: Delphic Studios, 1937), p. 24.

39. Gorky, "Stuart Davis," p. 213.

40. Harold Rosenberg, *Arshile Gorky: The Man, the Time, the Idea*, p. 35.

41. Gorky to Vartoosh, June 3, 1946, quoted in Mooradian, *Arshile Gorky Adoian*, pp. 293–94.

42. De Kooning, quoted ibid., p. 130.

43. Raphael Soyer, quoted ibid., p. 210.

44. Gorky to Vartoosh, Moorad, and Karlen, September 26, 1939, quoted in Mooradian, *Many Worlds*, p. 264.

45. Waldman, *Gorky*, p. 28.

46. Gorky to Vartoosh, February 9, 1942, quoted in Mooradian, *Many Worlds*, p. 277.

47. Jordan and Goldwater, *Paintings*, p. 43.

48. Francis V. O'Connor, "Arshile Gorky's Newark Airport Murals: The History of Their Making," in Ruth Bowman, *Murals without Walls: Arshile Gorky's Aviation Murals Rediscovered*, p. 23.

49. Gorky, quoted ibid., p. 22.

50. See Bowman, *Murals without Walls*.

51. Arshile Gorky, "My Murals for the Newark Airport: An Interpretation," reprinted ibid., p. 15.

52. Gorky to Vartoosh, February 9, 1942, quoted in Mooradian, *Arshile Gorky Adoian*, p. 276.

53. Gorky to Vartoosh, April 18, 1938, quoted ibid., p. 259.

54. Gorky to his family, February 28, 1938, quoted ibid., p. 257.

55. Gorky to his family, July 1943, quoted ibid., p. 280. For a fascinating interpretation of the *Garden in Sochi*, see Rand, *Implications of Symbols*, pp. 71–82.

56. Gorky, statement for the Museum of Modern Art, reprinted in Schwabacher, *Gorky*, 1957, p. 66.

57. Ibid.

58. Gorky to Vartoosh, December 1944 and June 14, 1945, quoted in Mooradian, *Many Worlds*, pp. 289 and 291 respectively.

59. Gorky to Vartoosh, October 28, 1940, quoted ibid., p. 266.

60. Gorky, "Camouflage."

61. Gorky to his family, August 4, 1941, quoted ibid., p. 273.

62. Gorky to his family, September 17, 1941, quoted ibid., p. 275.

63. See Nick Dante Vaccaro, "Gorky's Debt to Gaudier-Brzeska," pp. 33–34.

64. Gorky to his family, July 1943, quoted in Mooradian, *Many Worlds*, pp. 281–82.

65. Gorky to Vartoosh, April 22, 1944, quoted ibid., p. 287.

66. Julien Levy, *Arshile Gorky*, p. 24.

67. Ibid.

68. William C. Seitz, *Arshile Gorky: Paintings, Drawings, Studies*, p. 31.

69. Reiff, *Stylistic Analysis*, p. 181.

70. Gorky to Vartoosh, December 1944, quoted in Mooradian, *Many Worlds*, p. 289.

71. Gorky, "Fetish of Antique Stifles Art Here."

72. Efforts to see rocks, ledges, water formations, trees, a couple embracing, or a dog in a landscape are, without further substantiation, unconvincing. See Schwabacher, *Gorky*,

1957, p. 94, and Rand, *Implications of Symbols*, pp. 87–88.

73. Gorky to Vartoosh, February 14, 1944, quoted in Mooradian, *Many Worlds*, p. 285.

74. Levy, *Gorky*, p. 35.

75. Quoted in Sidney Janis, *Abstract and Surrealist Art in America* (New York: Reynal & Hitchcock, 1944), p. 120.

76. André Breton, "The Eye-Spring: Arshile Gorky," statement for the checklist for Gorky's one-man exhibition at the Julien Levy Gallery, March 6–31, 1945.

77. Gorky to Vartoosh, Moorad, and Karlen, September 26, 1939, quoted in Mooradian, *Arshile Gorky Adoian*, p. 263.

78. Gorky to Vartoosh, January 17, 1947, quoted ibid., p. 314.

79. Maude Riley, "The Eye-Spring: Arshile Gorky," p. 10.

80. Clement Greenberg, "Art," *Nation* 160 (March 24, 1945): 342–43.

81. Gorky to Vartoosh, November 17, 1946, quoted in Mooradian, *Many Worlds*, p. 311.

82. Gorky to Vartoosh, December 1944, quoted ibid., p. 288.

83. Clement Greenberg, "Art," *Nation* 166 (January 10, 1948): 52.

84. Rand, *Implications of Symbols*, pp. 147–68.

85. Schwabacher, *Gorky*, 1957, p. 137.

86. Gorky to Vartoosh, June 3, 1946, quoted in Mooradian, *Many Worlds*, p. 298.

87. Gorky to his family, January 26, 1944, ibid., p. 282.

88. Gorky to his family, January 6, 1947, quoted ibid., p. 312.

89. See Gorky's letters dated January 6, 1948, and February 2, 1948, in Mooradian, *Many Worlds*, pp. 322–25.

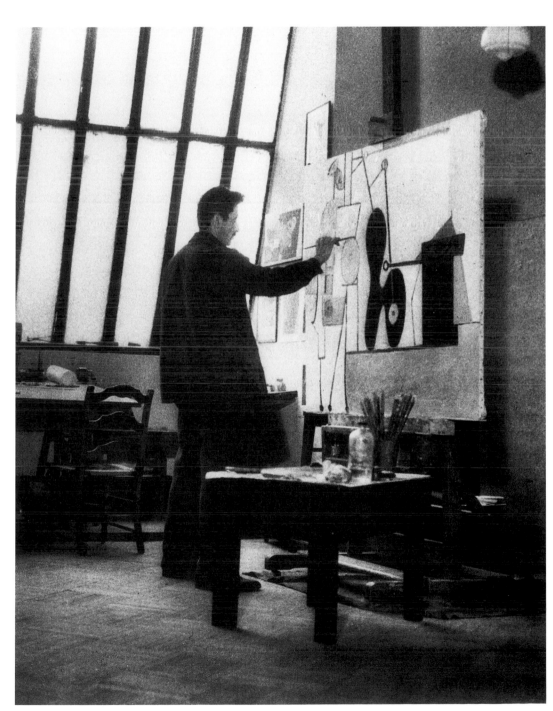

107. Arshile Gorky working on *Organization*, 1934–35

108

Artist's Statements

But a real artist, of course, cares not what he sells any more than where he is. If a painting of mine suits me, it is right. If it does not please me, I care not if all the great masters should approve it or the dealers buy it. They would be wrong. How could there be anything fine in my painting unless I put it there and see it?

"Fetish of Antique Stifles Art Here," *New York Evening Post*, September 15, 1926.

Yet there are large numbers of critics, artists, and public suspended like vultures, waiting in the air for the death of the distinctive art of this century, the art of Léger, Picasso, Miró, Kandinsky, Stuart Davis. They forget that while the artist never works outside his time, yet his art will go on to be merged gradually into the new art of a new age. . . . We shall not, contrary to the expectation of these people, hear of the sudden death of Cubism, abstraction, so-called modern art.

"Stuart Davis," *Creative Art* 9 (September 1931): 213.

The following passages are from Gorky's letters to his family, as published by Karlen Mooradian in *Arshile Gorky Adoian* © Karlen Mooradian (Chicago: Gilgamesh Press Ltd., 1978).

My feeling is that form is the language of a given time and must be pursued relentlessly. Many emotions and experiences are timeless, some more readily conveyed than others. What else is an artist but a creator who wants to share? I seek a form or language that will express my ideas for our time.

July 3, 1937, pp. 252–53.

Beloveds, some people say art is eternal, that it never changes. Nonsense. Art does change. Man changes. Man changes the world and in the process himself and his art. That is basic to my outlook. It is, I think, objectively true and not simply a subjective attitude. . . . Also, just as I oppose anarchy in politics, I oppose anarchy in art. There must be structure in art, some thread. Pure anarchy is inhuman because it is animalistic, unthinking, unmental. Art, for me, must be a facet of the thinking mind. There can be no anarchy

108. Arshile Gorky, c. 1936

109

in art. If there is, then it is not art. Anarchy results from pure cynicism. That is, a disbelief in the intellectual capacity of man's mind to master complexities through his organizational and perceptive abilities and skills. Unrelenting spontaneity is chaos. Such anarchy negates aesthetic art. Great art insists upon consciousness. Otherwise everything can be claimed as art and without any differentiation. There are, however, distinctions. There is no equality in art, but there is instead superiority. There is good art and bad art. Quality is not the result of abandon.

 September 26, 1939, pp. 262–63.

Great art's problem, that is to say my goal, is to enable those who have not experienced certain elements of reality to experience them through the power of my work on their mind and eyes and imagination. To enable them to come as close to achievement of reality as possible simply through my work.

 November 24, 1940, p. 267.

Beloveds, the stuff of thought is the seed of the artist. Dreams form the bristles of the artist's brush. And, as the eye functions as the brain's sentry, I communicate my innermost perceptions through art, my worldview. In trying to probe beyond the ordinary and the known, I create an interior infinity. I probe within the finite's confines to create an infinity. Liver. Bones. Living rocks and living plants and animals. Living dreams. . . . Drawing is the basis of art. A bad painter cannot draw. But one who draws well can always paint. . . . Drawing gives the artist the ability to control his line and hand. It develops in him the precision of line and touch. This is the path toward masterwork.

 February 9, 1942, pp. 275–76.

109. *Untitled,* 1932
Ink and pencil on paper, 18 x 24 in.
Private collection

110. *Argula,* 1938
Oil on canvas, 15 x 24 in.
The Museum of Modern Art, New York;
Gift of Bernard Davis

I seek that moment when my picture suddenly echoes to me, when it seems breathless, that instant when it is suffocating for love of air and gasps to fulfill its passion to communicate. The torturous second of that throb for life announces its consummation. I lay down my brush. Perfection.

> July 1943, p. 278.

Beloveds, I don't think there is any absolutely original art in the purest sense of that term. Everyone derives from the accumulated experiences of his own culture and from what he himself has observed. Art is a most personal, poetic vision or interpretation conditioned by environment.

> April 22, 1944, p. 284.

Every artist has to have tradition. Without tradition art is no good. Having a tradition enables you to tackle new problems with authority, with solid footing.

> January 6, 1945, p. 287.

Aesthetic or true art is art with depth and feeling. . . . It is saturated with thought and must force the viewer to contribute a part of himself in order to extract as much as possible out of the particular work. . . . Real art should stimulate man's greatest possession. Namely, his mind. And it should help man understand himself. The real artist is the person who understands man better than individual man can understand himself. Achieving great art requires a joint effort, and as all efforts it can prove laborious and often discouraging until success is attained. A combined effort on the part of the artist and his eventual viewers. The subtleties and sensibilities of the creator and the thinking viewers who, in penetrating to the marrow of the work, achieve that accomplishment so important to mankind. The ability to understand through the persistent exertion of the mind.

> June 3, 1946, pp. 293–94.

Art knows no rest. It is never calm because art can never attain a finite state. There are too many infinities. We artists must be enthusiastic, must believe in our work, and search.

> October 11, 1946, p. 297.

Abstraction allows man to see with his mind what he cannot see physically with his eyes.

> February 17, 1947, p. 304.

When something is finished, that means it's dead, doesn't it? I believe in everlastingness. I never finish a painting—I just stop working on it for a while. I like painting because it's something I can never come to the end of. Sometimes I paint a picture, then I paint it all out. Sometimes I'm working on 15 or 20 pictures at the same time. I do that because I want to—because I like to change my mind so often. The thing to do is to always keep starting to paint, never finish painting.

> Quoted in Talcott B. Clapp, "A Painter in a Glass House," *Sunday Republican Magazine* (Waterbury, Conn.), February 9, 1948, p. 121.

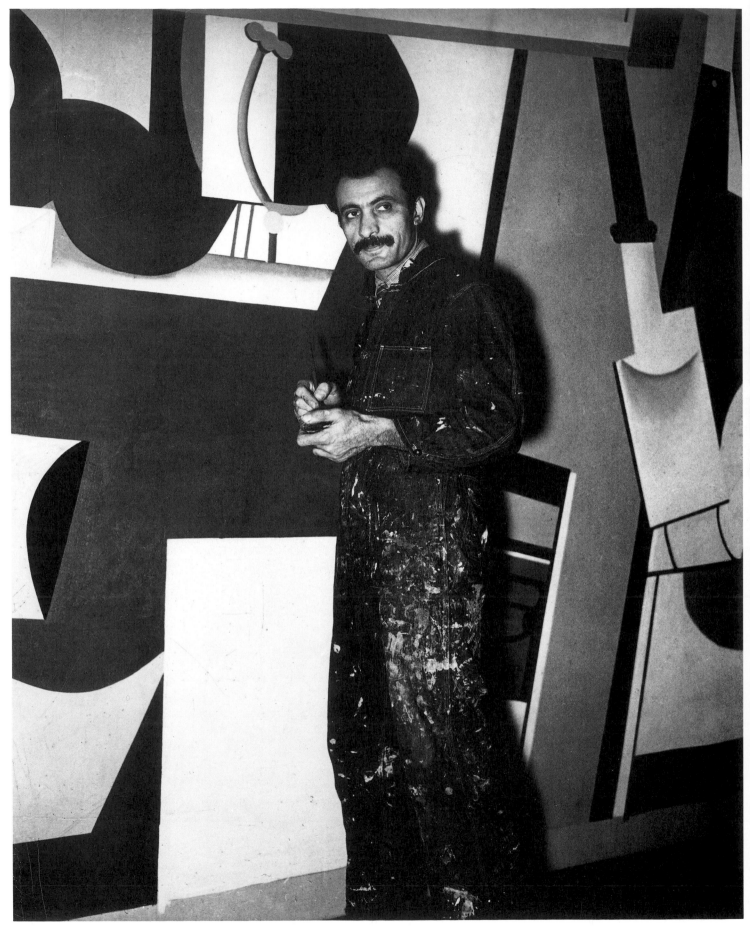

Notes on Technique

112

For Gorky, craftsmanship, artistry, and a full consciousness of one's actions and their relationship to the history of art were indispensable to the creation of great work. He considered himself a traditional painter, and the techniques he used were almost invariably based on the methods of the old masters. Gorky painted almost exclusively in oil on canvas, though he did from time to time produce compositions on Masonite or board. He made only one known collage (*Still Life*, c. 1934–35), in which he introduced a commercially printed label into an otherwise typical oil painting. In view of Gorky's infatuation with Synthetic Cubism, the movement that had introduced the use of collage into fine art, it seems curious that he did not do more collages until we remember that such techniques represented a departure from tradition. There are also in Gorky's oeuvre a few mixed-media works, such as his *Head* 112 *of an Antique Youth*, c. 1932–34, for which he employed pen and ink over oil on canvas, but these, too, are anomalous.

Gorky's technique did, of course, change over time and, in fact, differed among the works created during any one period. Nevertheless, these changes remained within certain conservative limits. Generally speaking, his oil paintings of the 1920s are small, like the canvases of the masters he chose to emulate. Like Cézanne, his major source at this time, Gorky used a palette knife or brush to apply his pigment, building up a rich surface of constructed forms. Near the end of the 1920s, as the influence of the Cubists became more evident, the pigment in some of Gorky's canvases became more textural and sensual, reminiscent particularly of those by Georges Braque; but he was hesitant to introduce sand or other extraneous substances to create texture, as the Cubists had done.

A work begun at the same time that Gorky was doing these Cézannean-Cubist paintings was the Whitney Museum's *The Artist and His Mother*, which represents a distinctly different approach to painting. This large-scale canvas, which he worked on from about 1926 to 1934, has a smoothly polished surface, with no obvious signs of the artist's brushwork. This classical purity of surface evolved during a painstakingly slow process that involved successive stages of painting, scraping, washing, and repainting, a method similar to that of the old masters. At intervals, Gorky al- 26

111. Arshile Gorky working on *Aviation* mural, 1934–35

112. *Head of an Antique Youth*, c. 1932–34
Oil on canvas with superimposed ink drawing, 15 x 23½ in.
Christopher C. Schwabacher

lowed the paint to dry thoroughly before scraping the surface with a razor blade until it was impeccably smooth. He then wiped away all the excess paint and dust with a damp cloth before beginning to paint again. Repeating these steps over a period of time resulted in a painting whose images are like phantoms hovering mysteriously along the surface.

The care that Gorky took in creating *The Artist and His Mother* was similar to the way he kept his studio spotlessly clean. Each week he scraped the wooden floors to remove any pigment and dust, then scrubbed them with a brush until they were bleached and pure, like works of art themselves.

Gorky continued to layer his pigment in other works throughout the 1930s, but the process of repeated scrapings and repaintings required to create the visionary effects of *The Artist and His Mother* seems not to have been used again. Instead, he simply placed layer of pigment upon layer of pigment, building up a thick, crusty surface. This was particularly true of the Cubist-inspired paintings such as *Organization* that were revised over several years' time. The picture grew so massive that it resembled a bas-relief, with the pigment measuring more than a half-inch thick. Gorky boasted about the amount of materials he had used in such works and jokingly judged their worth by how much it cost to create them. He said, in reference to these Cubist paintings, "Form . . . must be touched."[1] The weight of Gorky's paintings was increased by the amount of pigment he used, but it also increased as the size of his canvases grew during the decade. His major canvases from the 1930s generally measured about 36 by 48 inches, and the artist took great delight in watching others struggle to move his heavy pictures.[2]

Strangely enough, the quantities of painted canvas that Gorky used during the Depression increased as his economic situation worsened. Although at times he barely had enough money to buy food, he refused to let his large amounts of art supplies dwindle or to stint on their quality. Friends were amazed to discover on visits to his studio that he could afford hundreds of tubes of Winsor-Newton paints, numerous sable brushes, rolls of canvas, and other staples of first quality, while he otherwise pleaded poverty. Gorky would not compromise on his art, no matter what the cost.

Gorky's WPA murals of the mid-1930s were actually large-scale oil paintings on canvas, rather than traditional murals with pigment applied directly to the wall. This departure from convention seems to contradict the artist's normal adherence to traditional definitions of art, but philosophically his position was clear: he opposed the loss of a painting's identity that would occur if it were absorbed by the wall as architectural decoration. Painting, he felt, must stand on its own merit and must preserve its individuality as an art form.[3] In placing his monumental canvases on the walls of the Newark Airport, Gorky was anticipating Pollock's concept of the portable mural and the idea that contemporary painting should function halfway between traditional easel pictures and mural paintings.

As the 1940s approached, line and color in Gorky's work began to develop as independently functioning elements; the pigment

113

114

grew thinner and linear structure was relaxed. Such "landscapes" as *Waterfall* or *The Pirate I* of the early 1940s announce this more light-handed approach. For these works, the artist mixed turpentine freely with the oil pigments, thinning them into fluids that the canvas seems to absorb; the layering of the pigment here produces not a thick impasto, but a diaphanous curtain of superimposed color stains. The viscosity of the thinned medium invited accidental runs, splatters, and drips, which Gorky exploited for their expressive freshness and vitality but rarely seems to have used as a basis for further elaboration of form, as the Surrealists had done. 67, 64

The painterliness of these works laid the foundation for the styles of Gorky's late paintings. After about 1944–45 he continued applying the pigment in an expressive manner but relied less on the spontaneous and the improvisational. Often he rubbed the pigment into the canvas with his brush, creating a "dry stain" effect, as in *The Unattainable, They Will Take My Island*, and *Delicate Game*, while at other times he applied the paint in short, feathery brushstrokes, as in *The Plow and the Song* and *The Limit*. The works of about 1947–48 are rich in a coloration that is complemented by thin, clean lines. To achieve this precise linearity, in the early 1940s Gorky began using a commercial sign painter's long, pointed brush. 92, 87, 96 100, 101

For his drawings Gorky normally used a very sharply pointed pencil to outline form and to model shapes delicately by shading or hatching. During the 1930s he also worked extensively in pen and ink on paper, as evidenced by the series Nighttime, Enigma, Nostalgia. In addition, he executed one drawing in charcoal, *The Artist's Mother*, in 1938. Beginning in the 1940s Gorky frequently introduced color into his drawings, using wax crayons or, less often, pastels, which he rubbed or smudged into the paper to create the "floating" forms equivalent to the expressive stains found in his paintings of the same period. On a number of occasions, Gorky superimposed a grid upon his drawings, suggesting that they are final studies of subjects to be translated into paintings. 40–42 51

Gorky rarely attempted to create sculpture, but he did produce a few examples: a primitive head carved from stone, an assemblage entitled *Dead Bird*, and a number of wood carvings, including the beautifully crafted Armenian plows. He remained, however, primarily a draftsman and a painter. 113 114 4

1. Max Schnitzler, quoted in Karlen Mooradian, *The Many Worlds of Arshile Gorky*, p. 208.
2. Ibid.
3. Arshile Gorky, "My Murals for the Newark Airport: An Interpretation," reprinted in Ruth Bowman, *Murals without Walls: Arshile Gorky's Aviation Murals Rediscovered*, p. 13.

113. *Head*, n.d.
Stone, dimensions unknown
Mrs. Rook McCulloch, Lyme, Connecticut

114. *Dead Bird*, 1948
Mixed media, 36 x 46 in.
Private collection

Chronology By Anna Brooke

1904 April 15—Vosdanik Adoian born to Sedrak Adoian and Shushanik der Marderosian Adoian in village of Khorkom, Vari Haiyotz Dzor, province of Van, East Armenia. Later is given the middle name Manuk. Has one older half-sister, Akabi (Ahko), born 1896, and an older sister, Satenik, born 1901. His father is a farmer and occasional trader and carpenter.

1906 September 27—sister Vartoosh is born.

1908 His father leaves family and flees to America to avoid Turkish military service; settles in Providence, Rhode Island.

1908–9 Begins to draw, paint, and carve.

1909 Attends St. Vardan's Armenian Apostolic School in Khorkom, where he studies drawing.

1910 September—family moves to Van City; he attends Husisian Armenian Apostolic School. November—family moves to Aikesdan, where he attends American Mission School.

1912 In Van poses for photograph with his mother to send to his father.

1914 November—Turks shell Aikesdan and the Adoian home.

1915 June 15—family flees from Van to Yerevan in Caucasian Armenia. Attends Temagan Boys' School and works at carpentry, comb carving, and printing.

1916 October—his older sister and half-sister emigrate to America.

1918 August 18—family leaves Yerevan for the nearby village of Shahab. Mother becomes ill. December—they return to Yerevan.

1919 March 20—Mother dies of starvation. With Vartoosh he goes to Tiflis, then Batum, Constantinople.

1920 January 25—they leave Constantinople for Athens and Patras. February 9—they leave Patras on S.S. Presidente Wilson. February 26—they arrive in New York City. Akabi's husband meets them and takes them to his home in Watertown, Massachusetts. April—Gorky goes to live with his father in Providence, Rhode Island. Attends Old Beacon Street School.

1921 January–June—attends Bridgham Junior High School in Providence. Spring—father remarries, which alienates his son. Summer—Gorky returns to Watertown and works at Hood Rubber Company factory for two months. Fall—returns to Providence and studies at Technical High School.

1922–24 Studies and teaches at New School of Design in Boston and washes dishes in a restaurant.

1924 Spring—paints *Park Street Church, Boston*, and signs it *Arshele Gorky*. Becomes assistant instructor of life drawing at New England School of Design. Moves to New York City.

1925 January 9—enrolls at National Academy of Design in life drawing class taught by Charles Hawthorne; leaves after one month. Teaches at the New York branch of the New School of Design. October—enrolls at Grand Central School of Art; becomes instructor of sketch class. Adopts name *Arshile Gorky*. Finds a studio at 47A Washington Square South.

1926 September—becomes instructor of painting at Grand Central School of Art (until 1931). Hans Burkhardt is one of his students.

1927 Meets David Burliuk and Willem de Kooning about this time.

1928 Meets John Graham about this time.

1929 Meets Stuart Davis.

1930 April—is included in his first group exhibition, *Exhibition of Work of 46 Painters and Sculptors under 35 Years of Age*, Museum of Modern Art, New York. Moves to studio at 36 Union Square.

1931 December 7—exhibits lithographs at Downtown Gallery, New York.

1932 March 3—delivers lecture with Professor Frank Jewett Mather, Jr., at Wells College, Aurora, New York. May 10—Vartoosh and her husband, Moorad Mooradian, return to Armenia.

1933 December 20—joins Public Works of Art Project (PWAP) (until April 29, 1934) and submits proposal for a mural.

1934 January—Ethel K. Schwabacher and Mina Metzger study with him (until summer 1935). February 2—his first solo exhibition opens at Mellon Galleries, Philadelphia. Gorky joins Artists Union. Friendship with Stuart Davis ended by political differences. December—Vartoosh and Moorad return from Armenia.

1935 March—son, Karlen, born to Vartoosh. July—Gorky applies to Emergency Relief Bureau for home relief. August—assigned to Mural Division of the Works Progress Administration/Federal Art Project and begins Aviation mural designs; originally intended for Floyd Bennett Field, New York, they were installed in the Newark Airport Administration Building in Newark, New Jersey. September—gives lecture on abstract painting at Boyer Galleries, Philadelphia, in

116

115. Arshile Gorky, 1937. Courtesy the Arshile Gorky and 36 Union Square Archives (1922–43) by Moorad Mooradian. © 1982 by Karlen Mooradian

116. *Portrait of the Artist's Wife "Mougouch,"* c. 1943
Pen and India ink with sepia and wash on paper, 13¾ x 9 in.
The Baltimore Museum of Art; Thomas E. Benesch Memorial Collection; Gift of Mr. and Mrs. I. W. Burnham II

naturalized United States citizen. June 9—reinstated on WPA/FAP. August 31—transferred to New York City Art Project.

1940 November 8—resigns from WPA; December 17—reinstated on WPA.

1941 July 2—resigns from WPA/FAP. Drives to San Francisco with Agnes Magruder, Isamu Noguchi, Noguchi's sister, and two other friends. August 9—solo exhibition opens at San Francisco Museum of Art. August—murals installed in Ben Marden's Riviera restaurant, Fort Lee, New Jersey. September 13—marries Agnes Magruder in Virginia City, Nevada.

1942 Summer—spends three weeks at Saul Schary's farm in New Milford, Connecticut; makes studies from nature.

1943 April 5—first daughter, Maro, is born. July—family visits Agnes's parents at Crooked Run Farm, Hamilton, Virginia.

1944 Spring—returns to Crooked Run Farm for nine months. Meets André Breton about this time.

1945 Lives for nine months in Roxbury, Connecticut, in a house owned by David Hare. August 8—daughter, Natasha, is born. September—moves to Sherman, Connecticut, to live with Henry and Jean Hebbeln; barn is converted into a studio.

1946 January 26—fire destroys studio and about thirty paintings. February—is operated on for cancer. Receives grant of $1,500 a year from New Land Foundation. Summer—returns to Crooked Run Farm and makes 292 drawings. November—returns to New York. Makes drawings for André Breton's *Young Cherry Tree Secured against Hares*, New York.

1947 Moves to Sherman but retains studio in New York.

1948 June 26—neck is broken and painting arm paralyzed in an automobile accident. July—Agnes leaves with their children. July 21—Gorky commits suicide.

conjunction with his solo exhibition. Marries Marny George; marriage ends in divorce the next year.

1936 November—Vartoosh and her family move to Chicago, having lived at Gorky's studio since 1935.

1937 June 9—Newark Airport murals unveiled at Administration Building. Summer—begins to paint in his studio (until summer 1941) while employed by WPA/FAP Mural Division. *Painting* is bought by Whitney Museum of American Art, New York, his first work to enter a museum.

1938 January—begins studies for murals for New York World's Fair Marine and Aviation Buildings; study for Marine Building rejected. May—included in *Trois siècles d'art aux Etats-Unis*, Musée du Jeu de Paume, Paris, his first foreign group exhibition.

1939 January 16—leaves WPA/FAP. Spring—mural for Aviation Building, New York World's Fair, is installed. May 20—becomes

Exhibitions

Solo Exhibitions

1934
Arshile Gorky, Mellon Galleries, Philadelphia, February 2–15.

1935
Arshile Gorky, Boyer Galleries, Philadelphia, September–October.

Abstract Drawings by Arshile Gorky, Guild Art Gallery, New York, December 16–January 5, 1936.

1938
Arshile Gorky, Boyer Galleries, New York.

1941
Arshile Gorky, San Francisco Museum of Art, August 9–24.

1945
Arshile Gorky, Julien Levy Gallery, New York, March 6–31.

1946
Paintings by Arshile Gorky, Julien Levy Gallery, April 9–May 4.

1947
Arshile Gorky, Colored Drawings, Julien Levy Gallery, February 18–March 8.

1948
Arshile Gorky, Julien Levy Gallery, February 29–March 20.

Arshile Gorky 1905–1948, Julien Levy Gallery, November 16–December 4.

1950
Selected Paintings by the Late Arshile Gorky, Kootz Gallery, New York, March 28–April 24.

1951
Arshile Gorky: Memorial Exhibition, Whitney Museum of American Art, New York, January 5–February 18.

Drawings in Color by Arshile Gorky, Kootz Gallery, January 23–February 10.

1952
Arshile Gorky: Paintings and Drawings 1928–1937, Paul Kantor Gallery, Los Angeles, opened June 12.

Arshile Gorky: A Loan Exhibition of Paintings and Drawings, Art Museum, Princeton University, Princeton, New Jersey, October 5–26.

1953
Arshile Gorky in the Final Years, Sidney Janis Gallery, New York, February 16–March 14.

1954
Gorky: Works of the Middle Period, Martha Jackson Gallery, New York, March 31–April 24.

1955
Drawings for Principal Paintings by Gorky, Sidney Janis Gallery, September 26–October 22.

1957
Arshile Gorky, Galleria dell'Obelisco, Rome, opened February 4.

Disegni di Arshile Gorky, La Loggia, Bologna, March 28–April 9.

Thirty-three Paintings by Arshile Gorky, Sidney Janis Gallery, December 2–28.

1958
Paintings by Arshile Gorky, Pasadena Art Museum, Pasadena, California, January 3–February 2.

1959
Late Drawings by Arshile Gorky, Sidney Janis Gallery, September 28–October 24.

1960
Gorky Drawings, University Gallery, University of Minnesota, Minneapolis, October 27–December 2.

1962
Arshile Gorky: Drawings 1929 to 1934, David Anderson Gallery, New York, February 3–March 1.

Paintings by Arshile Gorky from 1929 to 1948, Sidney Janis Gallery, February 5–March 3.

Arshile Gorky: 40 Drawings from the Period 1929 through 1947, Everett Ellin Gallery, Los Angeles, April 9–May 5.

Arshile Gorky: Drawings, Newcomb College, Tulane University, New Orleans, September 23–October 14, and International Council of the Museum of Modern Art tour to Chatham College, Pittsburgh, Pennsylvania; Watkins Institute, Nashville, Tennessee; Spiva Art Center, Joplin, Missouri; Smith College Museum of Art, Northampton, Massachusetts; Marshall College, Huntington, West Virginia; Seibu Department Store, Tokyo; Westmar College, Le Mars, Iowa; Washington University, St. Louis; Arts Club of Chicago; Indiana University, Bloomington; Wells College, Aurora, New York; Northern Illinois University, DeKalb; Jewish Museum, New York; United States Information Service tour to Badischer Kunstverein, Karlsruhe; Hamburger Kunstverein, Hamburg; Amerika Haus, Berlin; Museum Folkwang, Essen; Arts Council of Great Britain tour to York City Art Gallery; Institute of Contemporary Arts, London; Midland Group Gallery, Nottingham; City Gallery of Art, Bristol; Scottish National Gallery of Modern Art, Edinburgh; Palais des Beaux-Arts, Brussels; Museum Boymans-van Beuningen, Rotterdam; Museum des 20. Jahrhunderts, Vienna; Sociedade Nacional de Belas Artes, Lisbon; Kunstnerns Hus, Oslo; Lunds Konsthall, Lund, Sweden; Kunstmuseum Basel, Offentliche Kunstsammlung, Basel; Galerija Grada Zagreba, Zagreb, Yugoslavia; Galerija Doma Omladine, Belgrade, Yugoslavia; Galleria Nazionale d'Arte Moderna, Rome; Centro de Artes Visuales del Instituto

Torcuato di Tella, Buenos Aires; Museo de Bellas Artes, Caracas; Biblioteca Luis Angel Arango, Bogota; Galeria Universitaria Aristos, Mexico City.

Arshile Gorky: Paintings, Drawings, Studies, Museum of Modern Art, New York, December 19–February 12, 1963, and tour to Washington Gallery of Art, Washington, D.C.

1963

Arshile Gorky: Paintings and Drawings 1927–1937 from the Collection of Mr. and Mrs. Hans Burkhardt, La Jolla Museum of Art, La Jolla, California, February 21–April 7.

1965

Arshile Gorky: Paintings and Drawings, Tate Gallery, London, April 2–May 2.

Arshile Gorky: Paintings and Drawings 1927–1937, University Art Gallery, University of California, Berkeley, May 7–31.

Arshile Gorky: Paintings and Drawings from 1927–1937, Gallery Lounge, San Francisco State College, September 14–October 10.

1967

Paintings and Drawings by Arshile Gorky, West Gallery, Pennsylvania Academy of the Fine Arts, Philadelphia, November 8–December 10.

1969

Arshile Gorky: Drawings from the Julien Levy Collection, Richard Feigen Gallery, Chicago, March 18–April 26.

The Drawings of Arshile Gorky, J. Millard Tawes Fine Arts Center, University of Maryland Art Department and Art Gallery, College Park, March 20–April 27.

The Drawings of Arshile Gorky, Hathorn Gallery, Skidmore College, Saratoga Springs, New York, October 21–November 9.

117. *Imastaseruhi (The Philosopheress)*, 1932
Pencil on paper, 10¾ x 8 in.
Courtesy Arshile Gorky Adoian. © 1978 by Karlen Mooradian

117

Gorky: Drawings, M. Knoedler and Company, New York, November 25–December 27.

1970

Arshile Gorky: Drawings, J. L. Hudson Company Gallery, Detroit, January 7–February 7.

1971

Arshile Gorky: Zeichnungen und Bilder aus der Collection von Julien Levy, Galerie Dieter Bursberg, Hanover, June 8–August 31.

1972

Arshile Gorky, Galleria Galatea, Turin, February 29–March 27.

Arshile Gorky, 1904–1948, Dunkelman Gallery, Toronto, October 14–28.

Arshile Gorky: Paintings and Drawings, Allan Stone Gallery, New York, November 14–December 22.

1973

Arshile Gorky: Drawings and Paintings from 1931 to 1940, Ruth S. Schaffner Gallery, Santa Barbara, California, March 25–April 29.

An Exhibition of Drawings by Arshile Gorky, Oklahoma Art Center, Oklahoma City, October 28–November 25, and tour to Arkansas Art Center, Little Rock; New Orleans Museum of Art; Amarillo Art Center, Amarillo, Texas; University Museum, Illinois State University, Normal.

1975

Arshile Gorky: Works on Paper, M. Knoedler and Company, January 9–February 1.

Arshile Gorky: Drawings to Paintings, University Art Museum, University of Texas at Austin, October 12–November 23, and tour to San Francisco Museum of Modern Art; Newberger Museum, Purchase, New York; Museum of Art, Munson-Williams-Proctor Institute, Utica, New York.

1976

Arshile Gorky: Paintings and Drawings 1975–76, Museum of Modern Art, Oxford, December 19–January 16, 1977, and Arts Council of Great Britain tour to Serpentine Gallery, London.

1978

Arshile Gorky: In Memory, Washburn Gallery, New York, November 2–28.

Murals without Walls: Arshile Gorky's

Aviation Murals Rediscovered, Newark Museum, Newark, New Jersey, November 15–March 15, 1979, and American Federation of Arts tour to Memorial Art Gallery, University of Rochester, New York; Hirshhorn Museum and Sculpture Garden, Smithsonian Institution, Washington, D.C.; Museum of Contemporary Art, Chicago; Museum of Fine Arts, Houston; Newport Harbor Art Museum, Newport Beach, California; Solomon R. Guggenheim Museum, New York.

1979

Arshile Gorky: Important Paintings and Drawings, Xavier Fourcade Gallery, New York, April 3–28.

Arshile Gorky: The Hirshhorn Museum and Sculpture Garden Collection, Hirshhorn Museum and Sculpture Garden, Smithsonian Institution, October 4–November 25.

1981

Arshile Gorky 1904–1948: A Retrospective, Solomon R. Guggenheim Museum, New York, April 24–July 19, and tour to Dallas Museum of Fine Arts; Los Angeles County Museum of Art.

Selected Group Exhibitions

1930

Exhibition of Work of 46 Painters and Sculptors under 35 Years of Age, Museum of Modern Art, New York, April 12–26.

1931

Twenty-fifth Annual Exhibition of Selected Paintings by American Artists, Buffalo Fine Arts Academy-Albright Art Gallery, Buffalo, New York, April 26–June 22.

1934

First Municipal Art Exhibition: Paintings, Sculpture, Drawings, Prints by Living American Artists Identified with the New York Art World, The Forum, RCA Building, New York, February 28–March 31.

1935

Abstract Painting in America, Whitney Museum of American Art, New York, February 12–March 22.

1936

131st Annual Exhibition in Oil and Sculpture, Pennsylvania Academy of the Fine Arts, Philadelphia.

New Horizons in American Art, Museum of Modern Art, September 14–October 12.

Third Biennial Exhibition of Contemporary American Painting, Whitney Museum of American Art, November 10–December 10 (also included in 1937, 1938, 1939, 1940, 1941, 1943, 1945, 1946, 1947, 1948 exhibitions).

118

1938

Exhibition of Contemporary American Painting, University of Illinois, Champaign-Urbana, January 1–27, and tour.

Trois siècles d'art aux Etats-Unis, Musée du Jeu de Paume, Paris, May–July.

1941

New Acquisitions: American Painting and Sculpture, Museum of Modern Art, March 10–May 3.

A Special Exhibition of Contemporary American Painting in the United States, Metropolitan Museum of Art, New York, April 19–27.

1942

Thirty-sixth Annual Exhibition: Trends in American Paintings of Today, City Art Museum, St. Louis, Missouri, January 25–February 28 (also included in 1946 exhibition).

New Rugs by American Artists, Museum of Modern Art, June 30–August 9.

Twentieth-Century Portraits, Museum of Modern Art, December 9–January 24, 1943.

1943

Recent Acquisitions: The Work of Young Americans, Museum of Modern Art, June 17–July 25.

1944

Anniversary Exhibition: Art in Progress, Museum of Modern Art, May 24–October 15.

Abstract and Surrealist Art in America, Mortimer Brandt Gallery, New York, November 29–December 30.

1945

Contemporary American Painting, California Palace of the Legion of Honor, San Francisco, May 17–June 17.

Painting in the United States, 1945, Car-

118. *Landscape, 1933*
Oil on canvas, 24¾ x 21 in.
The Metropolitan Museum of Art, New York;
Gift of Dr. Meyer A. Pearlman, 1964

negie Institute, Pittsburgh, Pennsylvania, October 11–December 9.

1946

Fourteen Americans, Museum of Modern Art, September 10–December 8.

1947

Bloodflames, Hugo Gallery, New York, February 15–28.

Drawings in the Collection of the Museum of Modern Art, Museum of Modern Art, April 15–June 1.

Fifty-eighth Annual Exhibition of American Painting and Sculpture: Abstract and Surrealist American Art, Art Institute of Chicago, November 6–January 11, 1948 (also included in 1949 exhibition).

Second Annual Exhibition of Paintings, California Palace of the Legion of Honor, November 19–January 4, 1948.

1948

XXIV Venice Biennale, June 6–September 30 (also included in 1950 and 1962 exhibitions).

1950

American Painting 1950, Virginia Museum of Fine Arts, Richmond, April 22–June 4.

1951

Surrealisme et abstraction: Choix de la collection Peggy Guggenheim; Surrealism & Abstractie: Keuze uit de Verzameling Peggy Guggenheim, Stedelijk Museum, Amsterdam, January 19–February 26, and tour.

Abstract Painting and Sculpture in America, Museum of Modern Art, January 23–March 25.

Revolution and Tradition: An Exhibition of the Chief Movements in American Painting from 1900 to the Present, Brooklyn Museum, New York, November 15–January 6, 1952.

1955

Cinquante ans d'art aux Etats Unis, Musée National d'Art Moderne, Paris, March 30–May 15, and International Council of the Museum of Modern Art tour.

1956

Expressionism 1900–1955, Walker Art Center, Minneapolis, Minnesota, January 26–March 11.

1958

Nature in Abstraction, Whitney Museum

of American Art, January 14–March 16, and tour.

Die neue amerikanische Malerei, Basel Kunsthalle, April 19–May 26, and International Council of the Museum of Modern Art tour.

1959

Documenta 2, Museum Fridericianum, Kassel, Germany, July 11–October 11.

1960

Sixty American Painters 1960: Abstract Expressionist Painting of the '50s, Walker Art Center, March 6–April 3.

G. David Thompson Collection, Kunstmuseum, Düsseldorf, December 14–January 29, 1961.

1961

American Abstract Expressionists and Imagists, Solomon R. Guggenheim Museum, October–December.

1963

Twentieth-Century Master Drawings, Solomon R. Guggenheim Museum, November 6–January 5, 1964.

1964

Max Ernst, Arshile Gorky from the Collection of Julien Levy, Yale University Art Gallery, New Haven, Connecticut, March 19–May 3.

Within the Easel Convention: Sources of Abstract Expressionism, Fogg Art Museum, Harvard University, Cambridge, Massachusetts, May 7–June 7.

American Drawings, Solomon R. Guggenheim Museum, September 17–October 22, and tour.

1965

New York School: The First Generation: Paintings of the 1940s and 1950s, Los Angeles County Museum of Art, July 16–August 1.

Roots of Abstract Art in America 1910–1930, National Collection of Fine Arts, Smithsonian Institution, Washington, D.C., December 2–January 9, 1966.

1966

Two Decades of American Painting, National Museum of Modern Art, Tokyo, October 15–November 27, and International Council of the Museum of Modern Art tour.

1967

Kompas III, Stedelijk van Abbe-Museum, Eindhoven, The Netherlands, November 9–December 17.

1968

The Sidney and Harriet Janis Collection, Museum of Modern Art, January 17–March 4, and tour.

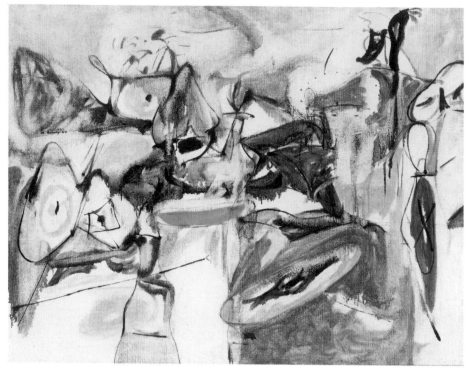

119

119. *Cornfield of Health II (Housatonic),* 1944
Oil on canvas, 30⅛ x 37¾ in.
The Nelson-Atkins Museum of Art, Kansas City, Missouri; Gift of the Friends of Art

Dada, Surrealism, and Their Heritage, Museum of Modern Art, March 27–June 9, and tour.
The 1930s: Painting and Sculpture in America, Whitney Museum of American Art, October 15–December 1.

1969

Works from the Peggy Guggenheim Foundation, Solomon R. Guggenheim Museum, January 16–March 23.
New York Painting and Sculpture, Metropolitan Museum of Art, October 18–February 1, 1970.
Painting in New York: 1944–1969, Pasadena Art Museum, Pasadena, California, November 24–January 11, 1970.

1972

Abstract Expressionism: The First and Second Generations in the Albright-Knox Art Gallery, Albright-Knox Art Gallery, Buffalo, New York, January 19–February 20.

1973

American Art at Mid-Century I, National Gallery of Art, Washington, D.C., October 28–January 6, 1974.

1974

Surrealität Bildrealität 1924–1974, Städtische Kunsthalle Düsseldorf, December 8–February 2, 1975, and tour.

1976

Twentieth-Century American Drawing: Three Avant-garde Generations, Solomon R. Guggenheim Museum, January 23–March 21.
The Golden Door: Artist Immigrants of America 1876–1976, Hirshhorn Museum and Sculpture Garden, Smithsonian Institution, Washington, D.C., May 20–October 20.
The Natural Paradise: Painting in America 1800–1950, Museum of Modern Art, October 1–November 30.
Acquisition Priorities: Aspects of Postwar Painting in America, Solomon R. Guggenheim Museum, October 15–January 16, 1977.

1977

Graham, Gorky, Smith and Davis in the Thirties, Bell Gallery, Brown University, Providence, Rhode Island, April 30–May 22.
Paris–New York, Musée National d'Art Moderne, Centre National d'Art et de Culture Georges Pompidou, Paris, June 1–September 19.
Modern Spirit: American Painting 1908–1935, Royal Scottish Academy, Edinburgh, August 20–September 11.
Perceptions of the Spirit in Twentieth-Century American Art, Indianapolis Museum of Art, Indianapolis, Indiana, September 20–November 27, and tour.

1978

Abstract Expressionism: The Formative Years, Herbert F. Johnson Museum of Art,

Cornell University, Ithaca, New York, March 30–May 14, and tour.
American Art 1934–1956, Montgomery Museum of Fine Arts, Montgomery, Alabama, April 26–June 11, and tour.
American Art at Mid-Century: The Subjects of the Artist, National Gallery of Art, Washington, D.C., June 1–January 14, 1979.

1979

2 Jahrzehnte amerikanische Malerei 1920–1940, Städtische Kunsthalle Düsseldorf, June 10–August 12, and tour.
Master Drawings and Watercolors of the Nineteenth and Twentieth Centuries, Solomon R. Guggenheim Museum, August 24–October 6, and tour.
The Spirit of Surrealism, Cleveland Museum of Art, Cleveland, Ohio, October 3–November 25.
Abstract Expressionism: A Tribute to Harold Rosenberg, David and Alfred Smart Gallery, University of Chicago, October 11–November 25.

1980

Works from the 20th-Century Collection of Indiana University Art Museum, Arts Club of Chicago, November 12–December 31.

1984

Artistic Collaboration in the 20th Century, Hirshhorn Museum and Sculpture Garden, Smithsonian Institution, June 9–August 19, and tour.

Public Collections

Atlanta, Georgia, High Art Museum
Austin, Texas, University of Texas at Austin
Baltimore, Maryland, Baltimore Museum of Art
Bloomington, Indiana, Indiana University
Brooklyn, New York, Brooklyn Art Museum
Buenos Aires, Argentina, Instituto Torcuato di Tella
Buffalo, New York, Albright-Knox Art Gallery
Cambridge, Massachusetts, Fogg Art Museum, Harvard University
Canberra, Australia, Australian National Gallery
Chicago, Illinois, Art Institute of Chicago
Cincinnati, Ohio, Cincinnati Art Museum
Cleveland, Ohio, Cleveland Museum of Art
Dallas, Texas, Dallas Museum of Fine Arts
Jerusalem, Israel, Israel Museum
Kansas City, Missouri, Nelson-Atkins Museum of Art
La Jolla, California, La Jolla Museum of Contemporary Art
Lincroft, New Jersey, Monmouth Museum
London, England, Tate Gallery
Los Angeles, California, Los Angeles County Museum of Art
Lowell, Massachusetts, Lowell Art Association
Montclair, New Jersey, Montclair Museum
New Haven, Connecticut, Yale University Art Gallery
New York, New York, Grey Art Gallery and Study Center, New York University
New York, New York, Metropolitan Museum of Art
New York, New York, Museum of Modern Art
New York, New York, Solomon R. Guggenheim Museum

New York, New York, Whitney Museum of American Art
Oberlin, Ohio, Allen Memorial Art Museum
Ottawa, Canada, National Gallery of Canada
Paris, France, Musée National d'Art Moderne, Centre National d'Art et de Culture Georges Pompidou
Philadelphia, Pennsylvania, Philadelphia Museum of Art
Pullman, Washington, Washington State University, Washington Art Consortium
Richmond, Virginia, Virginia Museum of Fine Arts
Saint Louis, Missouri, Washington University Gallery of Art

San Francisco, California, San Francisco Museum of Modern Art
Seattle, Washington, Seattle Art Museum
Toronto, Canada, Art Gallery of Ontario
Tucson, Arizona, University of Arizona Museum of Art
Utica, New York, Munson-Williams-Proctor Institute
Venice, Italy, Peggy Guggenheim Collection
Washington, D.C., Hirshhorn Museum and Sculpture Garden, Smithsonian Institution
Washington, D.C., National Gallery of Art
Washington, D.C., National Museum of American Art, Smithsonian Institution

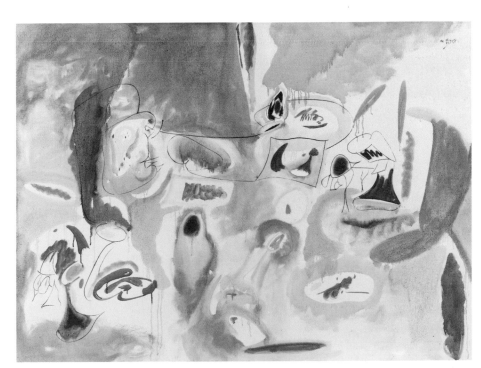

120. *Plumage Landscape,* 1947
Oil on canvas, 38 x 51 in.
Australian National Gallery, Canberra

120

Selected Bibliography

Interviews and Statements

Gorky, Arshile. "Fetish of Antique Stifles Art Here Says Gorky Kin." *New York Evening Post,* September 15, 1926, p. 17. Reprinted in Harold Rosenberg, *Arshile Gorky: The Man, the Time, the Idea,* pp. 123–26.

———. "Thirst." *Grand Central School of Art Quarterly* (New York), November 1926. Reprinted in Ethel K. Schwabacher, *Arshile Gorky,* 1957, p. 21.

———. "Stuart Davis." *Creative Art 9* (September 1931): 213–17. Reprinted in Rosenberg, *Arshile Gorky,* pp. 127–29.

———. General description of Newark Airport murals, December 1936, unpublished. On file at Whitney Museum of American Art, New York. Reprinted in Schwabacher, *Arshile Gorky,* 1957, pp. 70–74; Rosenberg, *Arshile Gorky,* pp. 130–32; Herschel B. Chipp, *Theories of Modern Art,* Berkeley: University of California Press, 1968, pp. 534–35; Francis V. O'Connor, *Art for the Millions,* Greenwich, Conn.: New York Graphic Society, 1973, pp. 72–73.

———. "Garden in Sochi," June 26, 1942, unpublished. On file at Museum of Modern Art, New York. Reprinted in Schwabacher, 1957, *Arshile Gorky,* p. 66; Chipp, *Theories of Modern Art,* pp. 535–36.

———. "Camouflage." *Grand Central School of Art Course Announcement,* 1942. Excerpt reprinted in Schwabacher, *Arshile Gorky,* 1957, p. 82; entirely reprinted in Rosenberg, *Arshile Gorky,* pp. 133–35.

———. "Toward a Philosophy of Art" (excerpts from Gorky's letters, compiled by Karlen Mooradian). In *Arshile Gorky: Drawings to Paintings,* pp. 31–36.

Books and Solo-Exhibition Catalogs

A. Gorky Drawings. New York: Walker and Company, 1970.

Arshile Gorky: Drawings to Paintings, exhibition catalog. Austin: University of Texas at Austin, 1975. Includes essays by Donald B. Goodall, Isobel Grossman, Karlen Mooradian, Arshile Gorky, Hayden Herrera, Harry Rand, Alice Baber, Jim M. Jordan, Ethel K. Schwabacher, Reuben Nakian.

Arshile Gorky, 1904–1948, exhibition catalog. Madrid: Fundación Caja de Pensiones, 1989–1990. Includes essays by John Golding, Robert Storr, and Matthew Spender.

Arshile Gorky: Three Decades of Drawings, exhibition catalog. Santa Fe: Gerald Peters Gallery in association with John Van Doren, New York, 1990. Includes essay by Melvin P. Lader.

Basaldella, Afro. *Arshile Gorky,* exhibition catalog. Rome: Galleria dell'Obelisco, 1957.

Bowman, Ruth. *Murals without Walls: Arshile Gorky's Aviation Murals Rediscovered,* exhibition catalog. Newark, N.J.: Newark Museum, 1978. Includes texts by Jim M. Jordan, Samuel C. Miller, Francis V. O'Connor, Frederick Kiesler, and Arshile Gorky.

Breton, André. "The Eye-Spring: Arshile Gorky." In *Arshile Gorky,* exhibition catalog, New York: Julien Levy Gallery, 1945.

——— and de Kooning, Willem. *Arshile Gorky: In Memory,* exhibition catalog. New York: Washburn Gallery, 1978.

Burkhardt, Hans. *Arshile Gorky: Paintings and Drawings 1927–1937 from the Collection of Mr. and Mrs. Hans Burkhardt,* exhibition catalog. La Jolla, Calif.: La Jolla Museum of Art, 1963.

Cahill, Holger. *Abstract Drawings by Arshile Gorky,* exhibition catalog. New York: Guild Art Gallery, 1935.

———; Davis, Stuart; Kiesler, F. J.; and Janowatz, Harriet. *Arshile Gorky,* exhibition catalog. Philadelphia: Mellon Galleries, 1934.

Chiaretti, Tommaso. *Arshile Gorky,* exhibition catalog. Turin: Galleria Galatea, 1972.

Golding, John. Introduction to *Arshile Gorky: Paintings and Drawings 1975–76,* exhibition catalog. London: Arts Council of Great Britain, 1975.

Gottlieb, Adolph. Introduction to *Selected Paintings by the Late Arshile Gorky,* exhibition catalog. New York: Kootz Gallery, 1950.

Jordan, Jim M. *Gorky: Drawings,* exhibition catalog. New York: M. Knoedler and Company, 1969.

——— and Goldwater, Robert. *The Paintings of Arshile Gorky: A Critical Catalog.* New York University Press, 1982.

Joyner, Brooks. *The Drawings of Arshile Gorky,* exhibition catalog. College Park, Md.: University of Maryland Art Department and Art Gallery, 1969.

Levy, Julien. *Arshile Gorky.* New York: Harry N. Abrams, 1966.

Melville, Robert. Introduction to *Arshile Gorky: Paintings and Drawings.* London: Arts Council of Great Britain, 1965.

Mooradian, Karlen. Introduction to *An Exhibition of Drawings by Arshile Gorky,* exhibition catalog. Oklahoma City: Oklahoma Art Center, 1973.

———. *Arshile Gorky Adoian.* Chicago: Gilgamesh Press, 1978.

———. *The Many Worlds of Arshile Gorky.* Chicago: Gilgamesh Press, 1980.

O'Hara, Frank. Introduction of *Arshile Gorky: Drawings,* exhibition catalog. London: Arts Council of Great Britain, 1964–65. Organized by the International Council of the Museum of Modern Art. Different versions of this catalog were published for the exhibition in Tokyo, Karlsruhe, Rotterdam, Vienna, Lisbon, Oslo, Lund, Basel, Zagreb, Rome, Buenos Aires, Caracas, and Bogota.

Rand, Harry. *Arshile Gorky: The Implications of Symbols.* Montclair, N.J.: Allanheld and Schram, 1980.

Reiff, Robert F. *A Stylistic Analysis of Arshile Gorky's Art from 1943–1948*. New York: Garland Publishing, 1977.

Rosenberg, Harold. *Arshile Gorky: The Man, the Time, the Idea*. New York: Horizon Press, 1962. Includes statements.

Rosenzweig, Phyllis. *Arshile Gorky: The Hirshhorn Museum and Sculpture Garden Collection,* exhibition catalog. Washington, D.C.: Smithsonian Institution Press, 1979.

Schwabacher, Ethel K. *Arshile Gorky: Memorial Exhibition,* exhibition catalog. New York: Whitney Museum of American Art, 1951.

_____. *Arshile Gorky.* New York: Macmillan and Company for the Whitney Museum of American Art, 1957. Includes statements.

Seitz, William C., and Levy, Julien, foreword. *Arshile Gorky: Paintings, Drawings, Studies,* exhibition catalog. New York: Museum of Modern Art and Washington, D.C.: Washington Gallery of Modern Art, 1962.

Waldman, Diane. *Arshile Gorky 1904–1948: A Retrospective,* exhibition catalog. New York: Harry N. Abrams and Solomon R. Guggenheim Museum, 1981.

Periodicals, Books, and Group-Exhibition Catalogs

Alloway, Lawrence. "Gorky." *Artforum* 1 (March 1963). 28–31. Review of exhibition at Museum of Modern Art.

"Arshile Gorky Dies." *Art Digest* 22 (August 1, 1948): 27.

"Arshile Gorky Exhibits." *Art Digest* 10 (January 1, 1936): 21. Review of exhibition at Guild Art Gallery.

Arti Visive 6–7 (Summer 1957). Entire issue devoted to Gorky.

Ashbery, John. "Sweet Arshile, Bless Your Dear Heart." *New York Magazine* 12 (February 5, 1979): 52–53.

Ashton, Dore. "Gorky and Contemporary American Painting." *Arts and Architecture* 75 (January 1958): 6, 34.

_____. "Arshile Gorky, peintre romantique." *XXe Siècle* 19 (June 1962): 76–81.

Balamuth, Lewis. "I Met A. Gorky: 1938." *Color and Rhyme* 19 (1949): 2, 3.

Barr, Alfred H., Jr. "Gorky, De Kooning, Pollock." *Artnews* 49 (Summer 1950): 22, 60.

Bond, Ralph C. "Murals without Walls." *Artweek* 11 (May 31, 1980): 1. Review of exhibition at Newport Harbor Art Museum.

Bordeaux, Jean Luc. "Arshile Gorky: His Formative Period (1925–1937)." *American Art Review* 1 (May–June 1974): 94–108.

Brach, Paul. "Gorky's Secret Garden." *Art in America* 69 (October 1981): 122–25. Review of exhibition at Solomon R. Guggenheim Museum.

Breton, André. "Arshile Gorky." In *Surrealism and Painting.* New York: Harper and Row, 1972, pp. 199–201.

Buettner, Stewart. "Arshile Gorky and the Abstract Surreal." *Arts Magazine* 50 (March 1976): 86–87. Entire issue devoted to Gorky.

Burliuk, Mary. "Arshile Gorky." *Color and Rhyme* 19 (1949): 1, 2.

Davis, Gene. "Gorky Taught Me That: A Remembrance of Arshile Gorky." *Arts Magazine* 50 (March 1976): 81. Entire issue devoted to Gorky.

Davis, Stuart. "Arshile Gorky in the 1930s: A Personal Recollection." *Magazine of Art* 44 (February 1951): 56–58. Written on the occasion of the exhibition at the Whitney Museum of American Art.

de Kooning, Elaine. "Gorky: Painter of His Own Legend." *Artnews* 49 (January 1951): 38–41, 63–66. Written on the occasion of the exhibition at the Whitney Museum of American Art.

Dennison, George. "The Crisis-Art of Arshile Gorky." *Arts Magazine* 37 (February 1963): 14–18. Review of exhibition at Museum of Modern Art.

Finkelstein, Louis. "Becoming Is Meaning: Gorky as a Draftsman." *Artnews* 68 (December 1969): 44–47. Review of exhibition at M. Knoedler and Company.

Fitzgerald, Michael. "Arshile Gorky's 'the Limit.'" *Arts Magazine* 54 (March 1980): 110–15.

_____. "Arshile Gorky." *Arts Magazine* 55 (June 1981): 23. Review of exhibition at Solomon R. Guggenheim Museum.

Fitzsimmons, James. "57th Street: The Late Gorky." *Art Digest* 27 (March 1, 1953): 16. Review of exhibition at Sidney Janis Gallery.

Frank, Elizabeth. "How Arshile Gorky Finally Became Himself." *Artnews* 80 (September 1981): 168–70. Review of exhibition at Solomon R. Guggenheim Museum.

Galassi, Susan Grace. "Arshile Gorky." *Arts Magazine* 53 (February 1979): 139, 144. Review of exhibition of Washburn Gallery.

Goldwater, Robert. "The Genius of the Moujik." *Saturday Review* 45 (May 19, 1962): 38.

Goodman, Paul. "Portrait of the Artist." *Partisan Review* 29 (Summer 1962): 448–50.

_____. "A Reply." *Partisan Review* 29 (Fall 1962): 592–93.

Goodrich, Lloyd. "Eight Works by Arshile Gorky with Notes by Lloyd Goodrich." *Magazine of Art* 44 (February 1951): 59–61.

"Gorky: Was He Tops or Second Rate?" *Art Digest* 25 (January 15, 1951): 9, 30.

Greenberg, Clement. "Art." *Nation* 162 (May 4, 1946): 552–53. Review of exhibition at Julien Levy Gallery.

_____. "Art." *Nation* 166 (March 20, 1948): 331–32. Review of exhibition at Julien Levy Gallery.

_____. "Art Chronicle." *Partisan Review* 17 (May–June 1950): 512–13. Review of exhibition at Kootz Gallery.

Greene, Balcomb. "Memories of Arshile Gorky." *Arts Magazine* 50 (March 1976): 108–10. Entire issue devoted to Gorky.

Herrera, Hayden. "Arshile Gorky: Works on Paper." *Artnews* 74 (March 1975): 97–105.

_____. "Gorky's Self-Portraits: The Artist by Himself." *Art in America* 64 (March 1976): 56–64.

_____. "The Sculptures of Arshile Gorky." *Arts Magazine* 50 (March 1976): 88–90. Entire issue devoted to Gorky.

Hess, Thomas B. "Arshile Gorky Flies Again." *New York Magazine* 10 (September 12, 1977): 84–89.

Hoffeld, Jeffrey. "Arshile Gorky: Collecting and Connoisseurship." *Arts Magazine* 50 (March 1976): 106–7. Entire issue devoted to Gorky.

Jordan, Jim M. "Arshile Gorky at Crooked Run Farm." *Arts Magazine* 50 (March 1976): 99–103. Entire issue devoted to Gorky.

_____. "Gorky at the Guggenheim." *Art Journal* 41 (Fall 1981): 261–65. Review of exhibition at Solomon R. Guggenheim Museum.

Kainen, Jacob. "Memories of Arshile Gorky." *Arts Magazine* 50 (March 1976): 96–98. Entire issue devoted to Gorky.

_____. "Posing for Gorky: A Memoir of the New York Master." *Washington Post,* June 10, 1979, sec. 1, p. 1.

Karp, Diane. "Arshile Gorky's Iconography." *Arts Magazine* 50 (March 1976): 82–85. Entire issue devoted to Gorky.

Kiesler, Frederick J. "Murals without Walls: Relating to Gorky's Newark Project." *Art Front* 2 (December 18, 1936): 10–11. Reprinted in Ruth Bowman, *Murals without Walls: Arshile Gorky's Aviation Murals Rediscovered,* pp. 30–33.

Kozloff, Max. "New York Letter: Gorky." *Art International* 6 (April 1962): 42. Review of exhibitions at Anderson and Janis galleries.

Kramer, Hilton. "Drawings from Gorky's Last Years at the Janis Gallery." *Arts Magazine* 30 (October 1955): 48–49. Review of exhibition at Sidney Janis Gallery.

_____. "Arshile Gorky: Between Two Worlds." *New York Times,* December 7, 1969, sec. D, p. 29. Review of exhibition at M. Knoedler and Company.

_____. "Gorky—Separating the Artist from the Myth." *New York Times,* February 22, 1976, pp. 31, 33. Review of exhibition at University of Texas.

_____. "The Pictures in the Paintings." *New York Times,* June 21, 1981, pp. 3, 18. Review of four books on Gorky.

_____. "The Case of the Purloined Image." *New York Times,* June 25, 1981, sec. C, p. 15.

Kuspit, Donald. "Arshile Gorky: Images in Support of the Invented Self." In *Abstract Expressionism: The Critical Developments,* exhibition catalog. New York: Harry N. Abrams; Buffalo: Albright-Knox Art Gallery, 1987, pp. 49–63.

Lader, Melvin P. "Graham, Gorky, de Kooning, and the 'Ingres Revival' in America." *Arts Magazine* 52 (March 1978): 94–99.

_____. "Arshile Gorky: The Artist and His Mother: Further Study of Its Evolution, Sources and Meaning." *Arts Magazine* 58 (January 1984): 96–104.

Larson, Kay. "The Man Who Would Be Best." *New York Magazine* 14 (May 11, 1981): 73–74. Review of exhibition at Solomon R. Guggenheim Museum.

MacMillan, Duncan. "The Outsider: Gorky and America." *Art International* 23 (Summer 1979): 104–6.

Mellow, James R. "Late Drawings of Arshile Gorky." *Arts Magazine* 34 (October 1959): 55–56. Review of exhibition at Sidney Janis Gallery.

Miller, Jo. "The Prints of Arshile Gorky." *Brooklyn Museum Annual* 6 (1964–65): 57–61.

Mooradian, Karlen. "Arshile Gorky." *Armenian Review* 8 (Summer 1955): 49–58.

_____. "The Unknown Gorky." *Artnews* 66 (September 1967): 52–53, 66–68.

_____. "The Gardener from Eden." *Ararat* 9 (Winter 1968): 2–13.

_____. "The Philosophy of Arshile Gorky." *Armenian Digest* 2 (September–October 1971): 52–74.

_____. "A Special Issue on Arshile Gorky." *Ararat* 12 (Autumn 1971): 1–56. Includes interview with Vartoosh Mooradian.

_____. "The Crisis of Cultural Identity in the Art of Arshile Gorky and Reuben Nakian." *Armenian Digest* 3 (October 1973): 36–40, 61.

_____. "The Wars of Arshile Gorky." *Ararat* 24 (Autumn 1983): 2–16.

Nercessian, N. N. "The Defeat of Arshile Gorky." *Armenian Review* 36 (1983): 89–99. Review of three books on Gorky.

O'Connor, Francis V. "The Economy of Patronage: Arshile Gorky on the Art Projects." *Arts Magazine* 50 (March 1976): 94–95. Entire issue devoted to Gorky.

Osborne, Margaret. "The Mystery of Arshile Gorky: A Personal Account." *Artnews* 61 (February 1963): 42–43, 58–61. Review of exhibition at Museum of Modern Art.

Quaytman, Harvey. "Arshile Gorky's Early Paintings." *Arts Magazine* 50 (March 1976): 104–5. Entire issue devoted to Gorky.

Rand, Harry. "The Calendars of Arshile Gorky." *Arts Magazine* 50 (March 1976): 70–80. Entire issue devoted to Gorky.

_____. "Gorky in Virginia." *Arts Virginia,* no. 1 (1986): 2–13.

Rathbone, Eliza E. "Arshile Gorky: The Plow and the Song." In *American Art at Mid-Century: The Subjects of the Artist,* exhibition catalog. Washington, D.C.: National Gallery of Art, 1978, pp. 61–90.

Reiff, Robert. "The Late Works of Arshile Gorky." *Art Journal* 22 (Spring 1963): 148–52.

_____. "Arshile Gorky's Object Matter." *Arts Magazine* 50 (March 1976): 91–93. Entire issue devoted to Gorky.

Rose, Barbara. "Arshile Gorky and John Graham: Eastern Exiles in a Western World." *Arts Magazine* 50 (March 1976): 62–69. Entire issue devoted to Gorky.

_____. "Tragic Poet of Abstract Expressionism: Gorky." *Vogue* 169 (October 1979): 354, 386.

Rosenberg, Harold. "Arshile Gorky: The Last Move," *Hudson Review* 13 (Spring 1960): 102–11.

_____. "Arshile Gorky, His Art and His Influence." *Artnews Annual* 5 (1962): 100–114.

_____. "Gorky and History: An Exchange." *Partisan Review* 29 (Fall 1962): 587–93. Reply to book review by Paul Goodman.

_____. "Arshile Gorky: Art and Identity: The Unfinished Masterpiece." *New Yorker* 38 (January 5, 1963): 70–77. Reprinted in Harold Rosenberg, *The Anxious Object,* New York: Horizon Press, 1964, pp. 98–106.

Rosenblum, Robert. "Arshile Gorky." *Arts Magazine* 32 (January 1958): 30–33. On the occasion of the publication of *Arshile Gorky* by Ethel K. Schwabacher.

Rubin, William S. "Arshile Gorky, Surrealism and the New American Painting." *Art International* 7 (February 25, 1963): 27–38. Reprinted in Henry Geldzahler, *New York Painting and Sculpture 1940–1970,* New York: E. P. Dutton and Company, 1969, pp. 372–402.

Russell, John. "Guggenheim Retrospective Charts Arshile Gorky's Passion for Art." *New York Times,* April 24, 1981, sec. C, pp. 1, 20.

Schapiro, Meyer. "Gorky: The Creative Influence." *Artnews* 56 (September 1957): 28–31, 52.

Schwartz, E. "Gorky Murals: A Bit of Detective Work." *Artnews* 78 (February 1979): 136–37.

Seitz, William C. "Arshile Gorky's 'The Plow and the Song,'" *Allen Memorial Art Museum Bulletin* 12 (Fall 1954): 4–15.

Shiry, David L. "Gorky's Airport Murals at the Newark Museum." *New York Times,* June 13, 1982, p. 26.

Vaccaro, Nick Dante. "Gorky's Debt to Gaudier-Brzeska." *Art Journal* 23 (Fall 1963): 33, 34.

Whelan, Richard, "Arshile Gorky." *Artnews* 78 (January 1979): 139, 144. Review of exhibition at Washburn Gallery.

Films

Windows to Infinity: The Life and Work of Arshile Gorky. Armenian General Benevolent Union of America, Spotlight on Armenians Series. March 9, 1979. Videotape. Includes interviews.

Murals without Walls. Produced by Elizabeth Davis. WNET Thirteen, Dateline New Jersey, 1979. Videotape.

Arshile Gorky. Directed by Charlotte Zwerin. Produced by Courtney Sale. Cort Productions, 1982.

Index

Abstract Composition, 42
Abstract Expressionism, 7, 8, 30, 42, 45–46
Abstraction with Palette, 36, 39, 41, 43
Adoian, Satenik (sister), 13
Adoian, Sedrak (father), 11–12, 15, 63, 65
Adoian, Vartoosh (sister), 7, 13, 15, 58, 61, 63, 99
Aerial Map, 55
Agony, 101, *103*
Amerian, Akabi (half-sister), 13, 15
American Abstract Artists (AAA), 45, 46
Anatomical Blackboard, 83
Argula, 66, *111*
Arp, Jean, 55
Art Front (union newspaper), 38
Artist and His Mother, The (c. 1926–34), *32*, 35, 47, 57, 65, 100, 113, 114
Artist and His Mother, The (c. 1929–36), *33*, 35, 47, 57, 65
Artist and His Mother, The (1934 drawing), *34*, 35, 57
Artist's Mother, The, 56, 57, 115
Aviation: Evolution of Forms under Aero-dynamic Limitations, 54, 55, 112

Baptism (Armenian manuscript), *13*
Battle at Sunset with the God of the Maize (Composition No. 1), 50, 65
Bay from L'Estaque, The (Cézanne), 24
Baziotes, William, 8, 31
Beach Scene, 16, 18–19
Betrothal II, The, 101, *102*, 103
Boy in Red Jacket (Cézanne), 29
Braque, Georges, 20, 21, 23, 24, 37, 38, 113
Breton, André, 20, 22, 41, 65, 81–82, 85
Bull in the Sun, 68
Burliuk, David, 21, 22

Cahiers d'art (magazine), 20
Calendars, The, 97, 101
Cézanne, Paul, 7, 20, 22–24, 29, 35, 37, 49, 113
Charred Beloved I, *90*, 91
Charred Beloved II, 91
Chirico, Giorgio de, 51
Composition (c. 1928–29), *27*
Composition (1937–38), *51*
Composition (The Raven), 42
Composition I, 81, *82*
Composition II, 83

Composition with Head, *43*, 44, 45
Conquest of the Air, *55*, 65
contemporary art, 7, 20
Cornfield of Health II (Housatonic), *122*
Cubism, 7, 20, 22, 26, 33, 35, 37, 38, 39, 42, 43, 45, 46, 49, 55, 57, 109, 113, 114

Dark Green Painting, 104
Davis, Bernard, 66
Davis, Stuart, 22, 37–38, 53, 55, 109
Davis, Wyatt, 53
Days etc., 97
Dead Bird, 115
de Kooning, Willem, 8, 22, 31, 38, 39, 46
Delicate Game, 93, *96*, 115
Diary of a Seducer, The, 93, *94–95*
Diller, Burgoyne, 55
Drawing, 9
Drawing after Millet, 57
Dutch Interior (Miró), 35, 65

Eggbeater series (Davis), 38
Enigmatic Combat, 45, 46, 66
Ernst, Max, 49, 64, 65, 93

Fatal Temple, The (de Chirico), 51
Fauvism, 20, 22
Ferren, John, 39
Fireplace in Virginia, A, 97
Francis, Sam, 8
Frankenthaler, Helen, 8

Gallatin, Albert E., 21, 42
Gallery of Living Art (New York University), 21, 42
Garden in Sochi (c. 1940–41), *64*
Garden in Sochi (1941–44), 62, 65, 66, 73
Garden in Sochi series, 63–64, 65, 68, 71
Garden in Sochi (title), 63
Gaudier-Brzeska, Henri, 69
George, Marny, 69
Golden Brown Painting, 77
Good Afternoon, Mrs. Lincoln, *80*
Gorky, Agnes (wife), 66, 68–69, 71, 72, 104–5, *118*
Gorky, Arshile: adopts name, 18–19; Armenian background, 11–13, 33, 35, 63, 65; assessment of American art, 20; automobile accident, 104; birth, 11; cancer

and, 93; Cézanne's influence on, 22–24, 29; collage, 113; death, 105; early years in America, 15–16; fire destroys work of, 91, 93; friends, 37–39; historical importance, 7; influence on Abstract Expressionists, 8; instructor at Grand Central School of Art, 19–20, 31, 41, 66; late works, 91–105; marriages, 68–69, 103; Matisse's influence on, 30; maturity, 63–89; murals, 53–57, 66, 112, 114; New York City and, 18; 1920s and, 15–35; 1930s and, 37–61; originality, 7; parents, 11–13; photographs of, *16*, *20*, *33*, *38–39*, *52*, *107*, *108*, *112*, *116*; Picasso's influence on, 24, 26, 29; quoted on art, 22, 23, 37, 85, 104, 109–11; sculpture, 115; self-portraits, *10*, *11*, *28*, *29*, *30*, *31*; status as a painter, 7; style, 77, 81, 91, 115; trip to California, 66, 68; trips to the country, 71
Gorky, Maro (daughter), 71
Gorky, Maxim, 19
Gorky, Natasha (daughter), 91
Gottlieb, Adolph, 8, 30
Graecen, Edmund, 66
Graham, John, 21, 22, 37, 51
Grand Central School of Art (New York), 19, 31, 41, 66
Greenberg, Clement, 89, 101
Greene, Balcomb, 39
Green Stripe (Madame Matisse) (Matisse), 61
Guernica (Picasso), 93
Guggenheim Museum, 72

Hague, Raoul, 39
Haikakan Gutan I (The Armenian Plow I), *12*
Hare, David, 71, 91
Hawthorne, Charles, 19
Head, 115
Head of an Antique Youth, 113
Hofmann, Hans, 31
How My Mother's Embroidered Apron Unfolds in My Life, 73, *74*, 75, 85

Image in Khorkom, 45, 61
Imastaseruhi (The Philosopheress), *120*
Impatience, 91, *92*
Impressionism, 16–17, 22
Ingres, Jean Auguste Dominique, 37, 58
Inscape (Psychological Morphology No. 104) (Matta Echaurren), 72

Kainen, Jacob, *58*
Kandinsky, Wassily, 7, 19, 21, 22, 72–73, 74, 77, 109
Khorkom, 47
Kierkegaard, Sören, 93

Landscape, 121
Landscape, Staten Island, 14
Landscape in the Manner of Cézanne, 23, 24, 25
Landscape Table, 91, 93
Last Painting, 104, *105*
Laurens, Albert Paul, 19
Leaf of the Artichoke Is an Owl, The, 76
Léger, Fernand, 55, 109
Le Nain, Louis, 57
Levy, Julien, 42, 71, 77, 91, 101, 103–4
Limit, The, 98, 100, 115
Liver Is the Cock's Comb, The, 77–78, *79*, 81
Louis Guillaume (Cézanne), 29
Love of the New Gun, 85, 89
Luxe II, Le (Matisse), 61

Making the Calendar, 97, 98
Marden, Ben, 57
Masson, André, 42, 64, 65
Matisse, Henri, 20, 30, 35, 61
Matta Echaurren, Roberto, 65, 72, 74
Mechanics of Flying, 54
Millet, Jean-François, 57
Miró, Joan, 7, 21, 35, 42, 49, 55, 64, 65, 68, 91, 109
Mitchell, Joan, 8
Mojave, 66–67, 68
Mondrian, Piet, 37, 43, 45
Monet, Claude, 16, 17
Mooradian, Karlen, 8, 18, 109, 118
Mooradian, Moorad, 116, 118
Moore, Henry, 49
Motherwell, Robert, 8
Mountain Landscape, 69, 71
Museum of Modern Art (New York), 42, 43, 64, 66, 100
Musical Instruments (or *Mandolin and Music Stand*) (Picasso), 26

Nakian, Reuben, 39
National Academy of Design (New York), 19
Newark Airport murals, 53–55, 114
New School of Design (Boston and New York), 15, 19
New York School, 7, 8
New York World's Fair (1938), 57, 65, 66
Nighttime, Enigma, and Nostalgia (c. 1931–32), 48
Nighttime, Enigma, and Nostalgia (1933–34), 49
Nighttime, Enigma, Nostalgia series, 47–48, 51, 93, 115
Nighttime, Enigma, Nostalgia (title), 49, 51
Noguchi, Isamu, 39, 66
Nostalgia of the Infinite, The (de Chirico), 51
Nude, 93, 96

Objects, 66
One Year the Milkweed, 74, 75, 89
Opaque, The, 97
Organization, 38–39, *40–41*, 43, 45, 107, 114

Painting (1936–37), 50, 51, 61, 66
Painting (1944), 89
Park Street Church, Boston, 17
Pears, Peaches, and Pitcher, 21, 23
Picasso, Pablo, 7, 20, 21, 22, 24, 26, 29, 37, 38, 41, 43, 51, 72, 93, 109
Pidzak, Sarkis, 66
Pirate I, The, *70–71*, 72, 75, 85, 115
Plow and the Song, The, 98, *99*, 100, 115
Plumage Landscape, 123
Pollock, Jackson, 8, 22, 31, 114
Portrait of Jacob Kainen, 58
Portrait of Master Bill, 6
Portrait of Mougouch, 31
Portrait of Myself and My Imaginary Wife, 29
Portrait of the Artist's Wife "Mougouch," 118
Portrait of Vartoosh, 58, 61
Public Works of Art Project, 52–53, 55

Rand, Harry, 8, 101
Raphael, 58
realism, 18, 39, 53
Regionalists, 39
Renoir, Auguste, 16, 17
Révolution surréaliste, La, 21
Reynal, Jeanne, 66
Rhode Island School of Design, 19
Rocks in the Forest (Cézanne), 24
Rosenberg, Harold, 7
Roslin, Toros, 66

San Francisco Museum of Art, 66
Scent of Apricots on the Fields, 84
Schapiro, Meyer, 26
Schary, Saul, 71, 75
Schwabacher, Wolfgang, 66
Seated Woman (Miró), 68
Self-Portrait (c. 1928), 28, 29, 30
Self-Portrait (1928), 30
Self-Portrait (c. 1936), 58, *60*
Self-Portrait (1937), *59*
Self-Portrait at the Age of Nine, *10*, 29
Self-Portrait at the Age of Twenty-Four (Ingres), 58
Shushanik der Marderosian, Lady (mother), 11, 12, 13, 15, 32, 33, 34, 35, 52, 56, 57, 73
Smith, David, 22, 39
Social Realism, 39
Soyer, Isaac, 21
Soyer, Moses, 21
Soyer, Raphael, 21, 39
Staten Island, 23, 24
Still, Clyfford, 8
Still Life (c. 1928–29), 23
Still Life (1929–32), 26, *27*
Still Life (1934–35), 113
Still Life (*Composition with Vegetables*), 26
Still Life with Fishes (Picasso), 26
Still Life with Skull, *22–23*
Studio, The (Picasso), 41, 43
Study for "Aviation: Evolution of Forms under Aerodynamic Limitations," 53
Study for "Nighttime, Enigma, and Nostalgia," 48
Study for "The Calendars," 98
Study for "The Liver Is the Cock's Comb," 79
Study for "They Will Take My Island," 88
Summation, 101

Sun, The Dervish in the Tree, The, *86–87*, 89
Surrealism, 7, 8, 20, 35, 41–42, 43, 46, 49, 51, 53, 55, 64–65, 82, 85, 115

Tête de marin (Picasso), 29
They Will Take My Island, 88, 89, 91, 115
"Three Musketeers, The," 37
To My Maro, 92
To Project, To Conjure, 84
Twachtman, John, 16, 76

Uccello, Paolo, 37, 101
Unattainable, The, 91, 92, 115
Untitled (1932), 110
Untitled (1943), 80
Untitled (*Landscape*), 82
Untitled (*Virginia Landscape*), 81
Untitled Watercolor (Kandinsky), 72, 74

Vasilieff, Nicolas, 21

Washing of the Feet and Communion of the Apostles (Armenian manuscript), 65
Waterfall, 73, 75–76, 77, 115
Water of the Flowery Mill, 75, 77, 78
West, Michael, 69
Whistler, James McNeill, 16
Whitney Museum of American Art, 51, 66, 113
Works Progress Administration/Federal Art Project (WPA/FAP), 53, 55, 57, 114

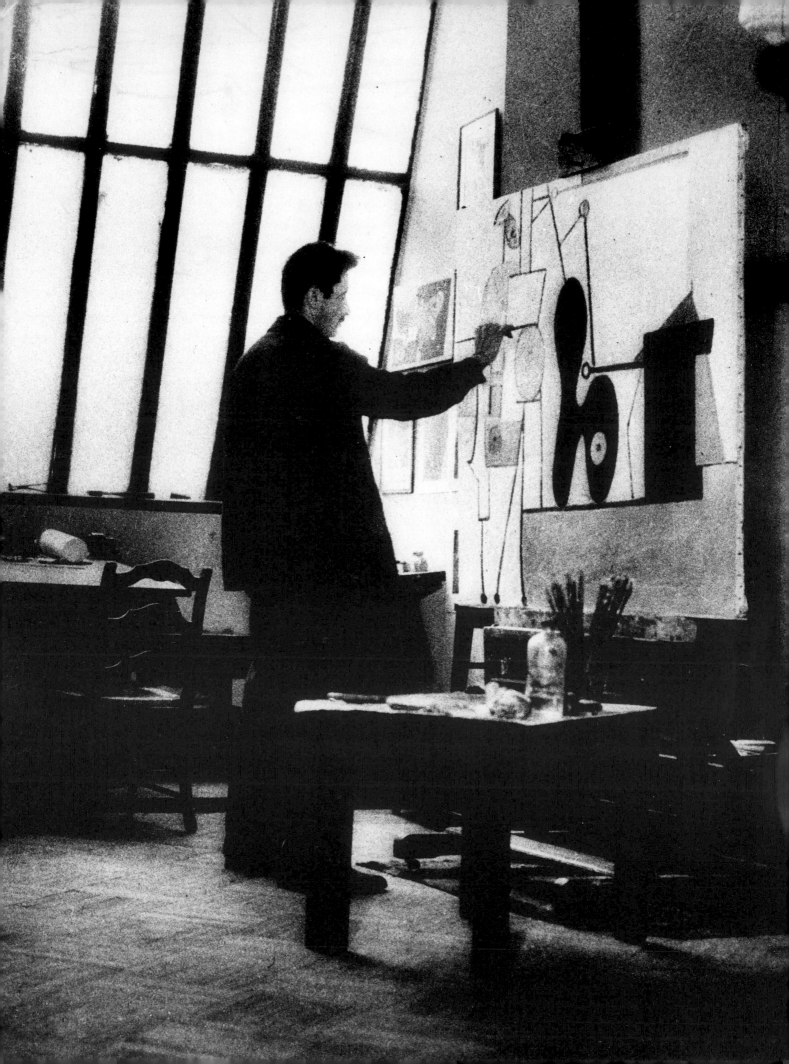